DEAN GUNNARSON:
THE MAKING OF AN ESCAPE ARTIST

DEAN GUNNARSON:
THE MAKING OF AN ESCAPE ARTIST

CAROLYN GRAY

GREAT PLAINS
PUBLICATIONS

Great Plains Publications
233 Garfield Street
Winnipeg, MB R3G 2M1
www.greatplains.mb.ca

Great Plains Publications gratefully acknowledges the financial support provided for its publishing program by the Government of Canada through the Canada Book Fund; the Canada Council for the Arts; the Province of Manitoba through the Book Publishing Tax Credit and the Book Publisher Marketing Assistance Program; and the Manitoba Arts Council.

Design & Typography by Relish New Brand Experience
Back cover photograph of Dean Gunnarson by Ken Gigliotti/*Winnipeg Free Press*
Printed in Canada by Friesens

LIBRARY AND ARCHIVES CANADA CATALOGUING IN PUBLICATION

Gray, Carolyn, 1966-, author
 Dean Gunnarson : the making of an escape artist / Carolyn Gray.

ISBN 978-1-927855-35-5 (paperback)

 1. Gunnarson, Dean. 2. Escape artists--Canada--Biography.
I. Title.

GV1545.G86G73 2015 793.8092 C2015-903708-5

ENVIRONMENTAL BENEFITS STATEMENT

Great Plains Publications saved the following resources by printing the pages of this book on chlorine free paper made with 100% post-consumer waste.

TREES	WATER	ENERGY	SOLID WASTE	GREENHOUSE GASES
14	6,428	7	430	1,186
FULLY GROWN	GALLONS	MILLION BTUs	POUNDS	POUNDS

Environmental impact estimates were made using the Environmental Paper Network Paper Calculator 3.2. For more information visit www.papercalculator.org.

FSC
www.fsc.org
MIX
Paper from responsible sources
FSC™ C016245

for Allan Hudson Gray

"You know how often the turning down of this street or that, the accepting or rejecting of an invitation may deflect the whole current of our lives into some other channel."

SIR ARTHUR CONAN DOYLE

AUTHOR'S NOTE

Ladies and Gentlemen, for my next experiment, I would appreciate the loan of any small personal object from your pocket: a key, a box of matches, or a coin. Now hold that key ten feet over your head and watch out for the slightest hint of hanky panky and behold, before our very eyes, a transformation. We've changed your key into a coin. What happened to your key? It's been returned to you. Look closely, you'll find the key back in your pocket and that coin now in your hand—keep your eyes on that coin now, don't blink, but it has been returned to you as your key. How did I do it? I'm a charlatan. Did I used to be a magician? I'm still working on it. I was a theatre artist. Have you heard of Robert-Houdin? One of the greatest magicians to ever live. He said, "A magician is just an actor playing the part of a magician." I am a theatre artist playing the part of a biographer.

I met Dean Gunnarson when he did the magic effects for my play *The Elmwood Visitation*. I forgot I was the playwright and ran around after him with a staple gun and paintbrush assisting him make the séance phenomena come to life. That was my first production as the sole writer. I saw every show. Each night afterwards in the lobby someone new told me breathlessly they saw real spirits on stage. Though I only saw the actors and the tricks. Years later Dean called me up and told me he had a tale to tell. "It's a good story," he said. "If you like it, you could write it for me." I liked it. Very much.

But I am a playwright. Not a biographer. I conducted interviews. I made copious notes. But there was so much I didn't know, and such lack of detail from years gone by, how could I proceed? But then I reasoned, this book is about finding your escape. And trickery. Besides, isn't almost any story some kind of lie? Didn't I see it for myself in my research? He saw the events one way but the old news clippings said something else altogether. She said this, but he said that. And there was my escape hatch right before me. I would write the story as I see it—just me. That's a kind of truth. And for the parts that no one could know, I'd write those as I want to see them. In fact, it was time for me to put on a play. I took out my staple gun and brush and made the story come to life. This is truly a creative interpretation, inspired by real events. But you really must regard what you are about to read as a certain kind of solid fact. Even though the contents May Contain Illusions. After all, it is Dean Gunnarson approved. Though admittedly, he is a man to appreciate a good trick.

Special thanks to: Dean Gunnarson, Bev Gunnarson, Marilyn and Gordon Hornan, Marlis Schroeder, Mickey Cuthbert, Maurice Mierau, Grant Guy, Anita Daher, Graham Ashmore, Minnie Gray, Krista Jackson, Melanie Wight, and Ingeborg Boyens.

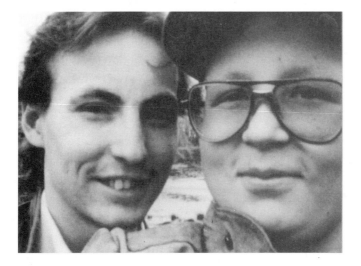

INTRODUCTION

by Dean Gunnarson

My friend Phil.
It's sometimes amazing when you look back on your life and realize it was the little things that made a difference in your lives and help shape who you are. You think you're doing good or helping someone, and afterwards you feel like you got much more out of it than you could have ever imagined possible.

I have had to overcome many challenges, obstacles, and set-backs in my life. It seems life is never easy. One of my earliest struggles was my battle with cancer when I was twelve years old. I was diagnosed with leukemia and given a twenty percent chance to live. The three years of chemotherapy and radiation to my head was the most painful and grueling challenge of my young life. My career as an escape artist nearly ended before it started. But in a strange way, I probably wouldn't be who I am

today if I hadn't faced and endured what I did. Everything that happens to us in life shapes who we are for good or bad. My cancer experience is one that I would *never* ever want to repeat, but I am so glad it happened to me for what it taught me about life and myself. This year marks my fortieth year as a cancer survivor. I like to think I learned it was not just a case of surviving life but *Thriving in Life*. I learned to smell the fresh air, how great those moments in life are without pain, how cruel people can be, and to have empathy for other people.

I am now the same age as the great Harry Houdini was when he died on Halloween day in 1926. At the age of fifty-two, I can look back on my life and see the past more clearly, as most people do as they age. I have had many great adventures over my career travelling around the world escaping, seeing and doing things that most people only dream of. I have done things that nobody on earth has ever even attempted. I'm sure 99.9 percent of the people wouldn't want to either and would prefer to watch.

I have conquered all of Houdini's most dangerous escapes and many more. Hanging by my toes and getting out of a straightjacket seven hundred and twenty-six feet above the Hoover Dam in Las Vegas, locked in a coffin thrown in the ocean surrounded by man-eating sharks, locked in a car in a car crusher, chained and thrown out of an airplane at 13,500 feet, escaping while covered in chicken blood as one hundred and thirty alligators tried to rip my head off, buried alive in a metal coffin for two days with no food and water, etc, etc, etc. Why do I do this? For the money? No. There is never enough money to risk your life. For the fame? That never drove me either, and I think I am the same person now that I was well before I performed in front of millions of people around the world live and on TV. Do I have a death wish? Actually I have a life wish. A wish to fulfil my greatest challenges and beat the obstacles.

Anybody who knows me will tell you that I have had the same passion and desire since I was a teenager. And as a teenager I had a young friend named Philip Hornan that saw my vision and dream of becoming the World's Greatest Escape Artist, and he shared that dream with me and knew I could do it. That by never giving up, never surrendering, by long hours of hard work and consistent practice, study, and dedication to a long-dead art form of entertainment, anything could be achieved. Phil helped me to believe in the magic of my dreams and shared many adventures with me. This a true story of a lot of learning and two teenagers trying to become great escape artists. It's a story about over-coming challenges, of happiness, pain, and the thrill of victory and the agony of defeat. It is a story of real magic that shaped and changed my life; this is the story of me and my friend Phil...

This story has been with me my entire adult life, and only now am I at a place in my life were I feel I have the courage to tell it, and I choose to share it with Carolyn Gray. I thank her immensely for the countless hours, weeks, months, and years she has spent trying to tell this story. The hours having coffee listening to me ramble on and tale my tales. For going and inter-viewing my mom, Marilyn Hornan, Dr. Schroeder and everyone else and getting their input. I know how hard it was for her to choose which stories to tell and how best to shape them. I have always been a talker, not a writer. I can never thank her enough for writing this in the unique and magical in the way she has. She has had to tell my story as seen through her eyes.

I would also like to thank my mom and dad for instilling in me the values that make me who I am. The belief and desire that I could achieve anything in life if I truly believed I could, even if it was becoming the world's greatest escape artist. They have always been supportive of me along with my sister Loree and brother Todd, even though it was, and is, extremely hard at times.

And my dear grandmother Dorothy Chivers. A strong, tough-as-nails Welsh woman with a pure heart of love who always stood in my corner. She taught me to never surrender and never listen to those who were jealous or tried to bully me. More than a few times earlier in my career she would call up a journalist and put a mouthful in their ear for being mean to me or saying something negative. It is never easy to watch your child struggle, fight, and risk their life as a long as I have. Only recently did I realize how hard that truly is by having my daughters Shayla and Kali May. They are the loves of my life, my guardian angels, and my reason to always escape and come home safe.

Dean Gunnarson
Riding Mountain, Manitoba, 2015

CHAPTER 1

The boy ran everywhere. He was fast. Tiny legs a blur, golden hair flying in the wind like a flag. You had to be quick to catch Dean. He ran under skies so clear and blue you could see right up to heaven if you looked. But why would a little boy look to heaven? The world and all its pleasures were right before him at eye level.

Were all boys as hyper as Dean? His mother was the last person to know. Beverly was only seventeen, and the last little one she'd rocked to sleep before Dean had been her doll. Moments ago, it seemed, her life had been shoeless summers, the sound of skate blades carving swiftly over the ice rink, chalk dust in school rooms, playing grown-up with friends, and life with her family. Time was not measured. Life simply was. Sometimes though, she'd notice her body blooming slowly, petal by delicate petal. Fine, elegant features, high cheekbones, alert brown eyes, her lanky frame was turning to graceful curves. Sometimes even she was surprised by the flowering young woman looking back from the mirror. She didn't know who that girl was. Beverly would

shake her head and run outside to play. Meeting that new girl was for another day.

And then she was told her dad was sick. To Beverly, getting sick meant getting well again. Why was her father's sickness going on so long? Terrible moments; seeing him begin to weaken, a sturdy man faltering in his gait, seeing him so strangely thin under light blue sheets in his hospital bed. How could a child not believe her dad wouldn't get well again? She *did* believe he was getting better. He must be. She had no experience otherwise. How could a child imagine life being anything other than it had always been? Mom and Dad were the perennials in her garden. But even so, her father died. Beverly lost her dad to leukemia when she was fourteen.

First she screamed. Then she was certain it could not be true.

"Express your grief," she was told. "You have to let it out to move on."

"You must be strong for your mother. She needs you right now, more than ever."

Friends and family meant well. The words didn't, couldn't sink in.

Death separated her from her pack of friends. She looked at them through a cobweb of confusion and endless, unexpressed grief. She didn't really want to be with them anyway. Something inside her that she hadn't known existed was broken. She wanted to tell her friends how she felt but the things she said never came out right anyway. Then she got angry at herself for not being able to make anyone understand. But honestly, did they even want to hear it? And if she was different, then they were different too. She felt like she scared them in a way. Her pals acted nervous around her. Anyway, what did it matter? The fact was, after play they were going home to their dads. She'd never have her dad again.

Her mother and brother were grieving, all staggering down their own desolate paths trying to make it through the days.

Curtains were drawn against the light, home became a dark and shadowy place. They didn't hang out in the yard socializing with neighbours anymore. Doors were locked up for the night early. Despair lingered in the rooms and hallways. Soon the garden was overgrown. Beverly was lonely but didn't know it because misery was her constant sidekick. But then there was one friend...

In this new world where everything had changed, there was one person just for Beverly. The much older Garry Gunnarson regularly visited his sister nearby, and he knew the family. They ran into each other, and his sister introduced them. Garry never mentioned her dad. He never told her to deal with her grief, and there was no conversation about death. What a respite, what welcome relief he was to her! He did, however, pay her such compliments that her senses tingled. He wanted to see her as much as possible. And he needed her. No one before in her whole experience of life had tilted on his axis and orbited her sun. She was giddy with the feeling.

Her grief was not pretty, but Garry didn't know she could be anything but pretty.

Running to their house after school, she felt herself smile again. The feeling of being beautiful was intoxicating. To be in his company was to live again, because she had felt dead. And he was strong and vital, like her dad had been before the disease. Nothing felt more natural. They walked hand in hand, talking.

"I want us to be together all the time," he said. "No more of this you running home at night."

"I'm only sixteen you know."

"Talk to your mom. See what she says."

"You want to come with me?"

"No, you know her, you'll know how to put it over best."

Beverly steeled herself on the walk home. She had been a tomboy last time she'd really talked to her mother. But she'd turned into a woman without anyone at home noticing. How did you

explain that to your mother? She was going to be furious and ground her and she'd lose Garry forever, Bev just knew it. He was in his twenties. He could have anyone he wanted.

"Mom," Bev said, busying herself wiping down the kitchen counter, which was rather out of character for her, but the activity hid her blush, "I've been seeing Garry Gunnarson for a while, and we're in love and want to be together, forever."

"You're only sixteen," said Dorothy.

"I know, but I'm a mature sixteen, and I really, really want to be with him and he wants to be with me, and we want to get married."

"That's...wonderful then. My little girl is getting married!"

Beverly felt the world spinning faster, like riding the Crack-the-Whip at the Red River Exhibition. Was it really that easy to go from daughter to wife? Hang on tight, keep riding.

"Mom, are you sure?" Mom hadn't been herself since her dad died, that was plain. But she was smiling now.

"I'm so relieved, darling. You'll have someone to really look after you now. I'm having such a hard time," she said with a choke. "Now I can rest assured—you'll be taken care of. It'll be better for you than it was for me. When I came over here as a war bride, I thought the streets would be paved with gold. That's was they told me, Bev. And look at me now...a widow. With nothing..." Dorothy began to weep again.

First Beverly was a teen bride, and then, at seventeen, the mother of Dean.

And that boy was beautiful. She was biased of course, but anyone could see, his features were so delicately chiselled. "He's going to break some hearts!" ladies she didn't even know could be relied upon to say. Her pride promenading the Winnipeg streets with her infant son in his stroller was immense. She walked straight and tall with her head high, for the child she made was perfect.

Then those proud promenading days were over. He began to get active.

Beverly would stand by his bed and stare at him while he slept, the only time he was still now. She touched her own cheek, and gently touched his, feeling the warmth. They were so similar, with their high, smooth cheekbones. She was in him and he was in her. But who was she? She had been a schoolgirl. Where had that person disappeared to? Bev had liked that girl. She hadn't even had a chance to say goodbye.

Sometimes passing a schoolyard, she'd swear she saw herself, playing in a group. Bev would cross the street and hurry over. Absolutely—there she was with the others. Reedy with brown hair. Motherhood the furthest thing from her mind. The girl she should have been. Grabbing the fence, white-knuckled, Bev silently begged the girl to turn around and smile so that everything would be okay between them. But this girl was incredibly obstinate. She was always sure to keep her back to Bev. Was the girl teasing by keeping her back to her, or angry and ignoring her? Bev rattled the fence. "Hello there! You, the skinny girl. Do you know me?" Blank faces would turn. Bev faced some girl with green eyes, freckles and a pug nose. The spectre had vanished from the group. All who remained were a bunch of normal kids playing hopscotch and tag, looking at her like she was weird. Well, wasn't she? She was a mother while her friends were still playing games. And she was seeing ghosts, everywhere. But there was no time to think too deeply about it—her baby boy Dean was up and running again.

For if you turned away from him for just one second, you left yourself open to disaster. Was this normal? She asked her mother, who was getting more and more depressed, and she answered slowly, as if from the bottom of a well. "Sure. He's normal."

"But he puzzles me when he—"

"Of course he's normal."

Dean puzzled her at every turn, however. Do babies always crawl that quickly? Do most kids come to walk this early? I don't see any other boys his age running like a shot across the grass! Thank God his hair is glowing golden; she should always be able to spot him. No time to think, no time to reflect, no time to cry about her dad anymore. No time to smile at the phantom girl playing in a schoolyard. Run, run as fast as you can, after your little boy.

Beverly was relieved to see velocity wasn't the only aspect of her boy she could boast about. He loved to watch people do things and then copy them. A regular little actor. He could ace any game or sport, he loved to hear and tell stories, he loved jokes, he had compassion for animals. The total package of her number one son Dean was promising. But that speed. It amazed her.

"Garry, have you ever seen a kid move as fast as Dean? Honestly?"

He hadn't. Garry wasn't a talkative man and he was more comfortable when his wife knew the answers to child-rearing questions. He was the youngest child from a family of fourteen. His father had an idea that being the youngest, his mother was pampering him, so he made up for it by being extra rough on Garry. He left him a cabin alone for a week when he was twelve to fend for himself and learn to be a man.

As an adult, Garry had remained single, occupied by his military career. He was as far from prepared for his new life as his young wife was. Garry was astounded by the agility of his first son, and relieved his wife was young and agile enough to keep up with him. He sure couldn't. As Dean grew and his energy increased seemingly by the minute, an idea struck him.

Garry had a brother and sister in Texas. They suggested Garry, Bev and Dean come down to live and take advantage of all the opportunities. The idea revved Garry up.

"The three of us should move to San Marcos for the family support," he said to Bev. "You'll get a lot of help with the boy there."

"But...my mother. I don't want to leave her alone. She's so...sad."

"You've lived your whole life in Manitoba. Get ready to kiss these Winnipeg winters goodbye. You're going to love it there. And there'll be a lot of construction work. It's a boom. We'll have good money for once."

He was sorting their belongings as he spoke. He'd decided. She pursed her lips, watching him in amazement. Was he really packing without her approval? For a moment, she was the schoolgirl again, riding the wave of parental decisions without any say. But she was not a schoolgirl, she quickly reasoned. Moving with the husband and son to benefit from a strong Texas family network felt like a wifely thing to do. They needed money desperately. And she was a wife now. Being a wife, didn't it follow she should bend to her husband's will and leave her mother? Yes, it did. In a way. Surely, it was the mature thing to do, to follow what her husband advised for the benefit of her child. And this move was meant for the benefit of her child. Wasn't it?

Her head began to spin. Her marriage felt as if she was on a runaway sled hurling down an ice hill, out of control. Texas must be part of the whole wild ride. And the one thing she loved about the ride—you didn't have to think too hard. You just had to ride and hang on.

Telling her recently widowed mother she and her first grandson were leaving the country was dangerously close to the sled stopping dead. Dorothy's face fell. She didn't say much. Bev felt anxious to leave and be gone. Garry was hard at work on that, packing the trailer to the brim with his brother's help, tying it half-closed with rope. At the border, they found out they couldn't enter without a visa.

"What do you mean, we need a visa?" Garry asked angrily.

"What's a visa?" asked Bev, holding the wriggling Dean, who seemed anxious to get to Texas.

They had no option but to turn around. They hopped a bus back to Winnipeg while Garry's brother drove the truck and all their possessions on to Texas.

"I thought you'd changed your mind and come back," said Dorothy with that dull sadness that so disconcerted Bev.

"We won't be bothering you for long," said Garry. "They need labourers down there. I bet they'll rush the paperwork through."

"So I get to say goodbye twice," said Dorothy, moving aside and ushering them into her home.

Their clothes were in Texas and their money was thin. Fall turned to winter. They layered on sweaters of Bev's mom and deceased dad. They shivered and waited. Garry scraped up all the work he could get, which wasn't much. The visa came through at Christmastime, when they had only one ninety-dollar cheque to their names from Garry's last job. They made their break.

"We can't leave until we cash it," said Bev in a panic. "I'm not going to Texas on a Greyhound bus with a baby without a dime in my purse!"

"Well I'm not going to wait for two weeks for a personal cheque to go through the bank when all our stuff is in Texas!" said Garry.

"Come on, let's try something," said Bev, and they all walked down the street to the drugstore that had been their regular family drugstore their whole lives.

"Please, could you cash this for me?" asked Bev. "You know where my mom lives if there's a problem. But we're desperate."

The drugstore cashed the cheque.

"We can go!" said Garry, relieved. He didn't notice how Bev and Dorothy sagged at the news. Dorothy drove them to the bus station. As they puttered down the street, Bev could hear the

sound of her own frightened breathing. They glided through the only neighbourhood she'd ever known, down past the school on the way to the main thoroughfare. A flash of brown caught her eye. A little girl was sitting on a teeter-totter with no one to balance her out, brown hair blowing in the wind. Why was she all alone in the schoolyard? How could such a lovely young girl appear so lonely? Bev waved but the girl just stared back at her with an empty expression.

"Unfriendly," Bev said under her breath.

"Who?" asked Garry.

"Oh, it's nothing," said Bev. I'm sick of ghosts, she thought, jerking her head away from the window to gaze upon her husband's handsome, lined face. Goodbye, Winnipeg. Good riddance.

At the Greyhound station, Bev whispered in her mother's ear as they embraced, "I don't want to go."

"Don't look so sad, you two," said Garry. "My brother did great for himself out there. We're finally going to have money!"

As the bus pulled away, Bev couldn't look back at her mother whom she knew was standing on the corner waving. She broke out in a hot sweat, stricken with terror imagining the image of her mother getting smaller.

Texas was hotter than the hottest Winnipeg summer. Winter was temperate, warm. She loved the weather, Garry had been right about that. But did she miss the snow? He loved to say she didn't when people they socialized with learned they were from Canada.

"She always hated those winters. Look at her now. Tanned as brown as a nut all year long. She loves it. We love it." He looked at her with pride.

Did she really always hate the winter? Funny, she couldn't remember saying that. Odd he spoke for her too, because he hadn't known her long enough to say "always". But his pride in her made her content. And besides, she didn't have time to think

about how she felt about a dim memory of snow when she was warm all the time. And Garry was definitely right about one thing: there was family around, good times, and even work for Garry. Groups of friends; barbequing, drinking, everyone together all of the time under the big Texas sky. The constant mass of people was so unlike Winnipeg. She felt pleasantly part of the group and yet anonymous.

Dean did well at school. She was pleased to see how good he was with people. His schoolmates called him, "that crazy Canuck." But truth be told, Dean didn't remember much about Canada. He'd been a toddler, after all. Now he was a big boy. He was approaching the double digits. He loved the Texas heat and all the games he could play with his friends.

Two more children, Loree and Todd, had followed Dean. Time flew and Beverley flew after her kids—especially the first one, her little juggernaut. She was getting used to children, and to Dean. There were a lot of kids in the family, and lots of friends with kids, so she could plainly see he was unusual, as she had thought. No one had more speed, energy, or hunger for sports than Dean. What came to surprise her the most was how well matched she and her first boy actually were. If Dean was insatiable for activity, Bev was as sharp and fast as Dean in finding outlets for him. Games, sports, clubs, swimming, playdates. Anything to tire him out. She worked for years to tire him out. It never worked—but he never got bored. And neither did she.

When he was ten, Bev bought him *The Great Houdini*, the classic Scholastic book, the twelfth edition with the yellow cover. There was no particular reason for the gift, other than it was part of a book club selection. She thought he might be interested. And he was, though he only gave it a superficial read, skimming for the action parts. But something did surprise Dean about the book. He told her about it as she tucked a light yellow cotton sheet up to his chin at bedtime.

"The suspense part of the escapes were good."

"But you said you loved it. That doesn't sound like you loved it," said Bev.

"That's not the part I loved. There were two parts that were the best."

"What's the first?"

"Houdini did things that were *impossible*. That proves that the impossible can be done. So I can do the impossible, too, I just know it."

"What's number two?"

"Did you know Houdini was an immigrant boy? No one thought he'd have a chance at doing anything important."

"I guess I didn't know that."

"Mom, I'm *just* like him. Loree and Todd were born here, but I came from Canada. I'm an immigrant boy too, the same as Houdini. He followed his dreams with all his heart and he won the world. He beat the odds. He wanted to be famous. World famous. Houdini was cool, Houdini was amazing."

"So you want to be a magician like him now, and do impossible things?" she smiled, running her hand through his golden, silky hair.

"If I could be like one person on earth, I'd do even better than Houdini. Guess who."

"Uh...that football player you like?"

"He's good, but no."

"Okay, you tell me.

"Mom! The most amazing man on earth—Evel Knieval. I want to be just like him."

Evel Knieval was the American daredevil who made it into the *Guinness World Book of Records* for having sustained 433 bone fractures. He was Dean's hero in 1975.

"Mom, I'm going to get into the *Guinness World Book of Records*, too, one day, just like Evel Knieval."

"Oh yeah? What will be your record?"

"Hmmm... I could get in if I broke 434 bones."

"Maybe you should concentrate more on Houdini. He did a lot of card tricks, didn't he?"

"Mom, do you realize if I broke 434 bones, then I could beat Evel Knieval and I'd have the most broken bones in the world, and break the world record?"

At moments like that, Bev would look down at her first-born and wonder how his life would turn out. But Bev knew his primary interest was football. Dean breathed in sports like air and he'd become hopelessly obsessed with the game of football. His greatest dream of all time, he said, was to be a football player with the Dallas Cowboys. He played football with everyone and anyone he could. She was willing to bet this Evel Knieval was just one of his many infatuations. Her educated guess was football would be his destiny in some way. Everything else in his life was just an interruption.

In ten years, Texas had changed for the Gunnarsons from the limitless horizons of opportunity to balancing on the edge of a cliff. The US entered a recession and the cost of basics shot up. You waited in line to buy gas. No one was hiring carpenter/handymen when they were just trying to survive. Garry had been expecting a paycheque and had come home with a German Shepherd on a blue leash instead.

"What are you doing with a dog?" asked Bev.

"Payment in kind," said Garry, his mouth turned down.

Bev and Garry and the kids were chowing down on barbequed hamburgers in the backyard in the bright, hot evening. This could have been any night for the Gunnarsons in 1975. It was a comfortable life. Garry lazed back, drinking a cold beer and letting Bev do the talking.

"Guess what, kids? We're moving back to Canada," she said. "We always knew we'd go back eventually. We figured we'd do it now before you kids get any older."

"It's not back for us!" cried Loree.

"It's only back for you and Dad and Dean," said Todd.

"What's the football there like?" asked Dean. "I only want to go if the football is good."

"Kids, we got to follow the construction work," said Garry. "You three eat a lot of burgers."

"What is it like in Canada?" asked Loree.

"It's beautiful and uh...very, very cold in the winter. But it's a way better place to grow up and live. And you'll have your Canadian Grandma Dorothy and an uncle to spoil you."

"What do you mean, very, very cold?" asked Todd. "Like how cold?"

"There are such fantastic things to do in winter you won't regret leaving Texas for one minute. I grew up there, and I survived." Mentioning survival sounded too much like a weak justification. Bev forced herself to recline comfortably in her chair and took on an easy-going attitude to distract them. "All you have to do is layer your winter clothes. It's a Canadian trick. You have to wear plaid and flannel. Don't worry, I'll show you everything."

"I'm not afraid of any cold," said Dean. "I like this idea. I want to build a snowman. The biggest snowman that was ever built on the planet earth."

The Winnipeg winter. That was exactly what terrified Bev about the move. How do you initiate small children to the brutality of the Manitoba cold? It was like delivering your kids unto a bully. She never let on to Dean, Loree or Todd that she had a care in the world. After she'd puzzled over the logistics, weighed the pros and cons, she had to confess, she had no idea how this was going to work. One thing was in her favour: Beverley Gunnarson

was an expert at jumping in headfirst. And she was adamant: she wanted her kids to grow up in Canada. For the health care, education, the landscape, fresh air, and the good people of Friendly Manitoba. And once again, they needed money. Packing up and herding her unwieldy brood was a huge undertaking. She did the lion's share of the work, but Bev knew how to work.

Her legs were strong from running after Dean, her arms and hands were muscled from raising three children. She stood tall with pride at the woman she'd become, and all that she'd accomplished. She had three excellent children. She had gone back to night school and earned her high school diploma. She no longer looked for her younger self in schoolyards. She thought of that young woman with compassion. Bev was 28 now, and far from sliding out of control, she was setting her course. And she really wanted to be with her mom again. The husband had brought them to Texas, the wife was returning them to Canada.

They got back to Winnipeg in July, just enough time to settle in a bit before school began. Fall was cool, sometimes rainy, sometimes rain turned to sleet, and sometimes the sleet turned to snow earlier than anyone would believe. Bev was always prepared when it came to her kids. All lined up neatly in the hallway of their new Winnipeg home were new rubber boots and winter boots, raincoats, lighter warm coats, and warm winter coats. Bev bought knitted hats, scarves and mittens in preparation. Sweaters waited patiently on hooks to layer on the bitterest of days. The kids saw their first plaid flannel jacket, a staple of Winnipeg clothing.

The morning the Gunnarson children woke up to their first snow, Beverly knew it was going to be all right. Kids spilled out the door into the frozen landscape, with Bev right on their heels. The joy of seeing her children experience something for the first time was one of her favourite parts of being a mom. Garry watched them from the other side of the living room window,

sipping coffee from his mug as he got ready for work. He was no fan of the climate, especially working construction outside. He didn't have the inclination to celebrate.

Together, mother and children danced through the prettily falling flakes, and they laughed and stuck out their tongues to drink tiny drops of cold sweet water.

"Can we build a snowman?" cried Loree.

"I read a book about them," said Todd. "We need a piece of coal, a carrot, and an old hat, Mom."

"I am sure we can pull those together," said Bev. "But we need a lot more snow first."

"I think I remember this stuff. Hey, Mom—I'm sure of it. I remember snow!" cried Dean. "Mom, could I remember something from when I was a baby?"

"Anything is possible with you, Dean," said Beverly. And she meant it.

Dean caught a cold that April and it just wouldn't go away.

"This is what we call a classic spring cold in Manitoba," she said to the kids, ever-educating them in the nuances of living in Winnipeg. "It's the extreme change of weather that does it. There's a spring cold, and a summer cold, and—"

"A winter cold. We get it, Mom," said Todd.

Oddly, Dean didn't join in with the wisecracking. Dean was not himself that spring.

Dean lying on the couch. Dean lying on the floor. Dean sleeping on and on in his bed until Bev had to shake him to get him to sit up and take some thin broth.

"Dean, I feel like I'm really able to look at you for the first time in twelve years," said Beverly. "I have never seen you lie around this much in your whole entire life, and I'm counting from when you were a newborn!"

"I'm so tired, I can barely move."

"I'm going to make you up the same hot lemon drink my mom used to make me when I was your age. That'll drive your cold away for good."

"Okay, Mom."

Bev gave a double-take. If she'd ever wished Dean would be a more tranquil child, she took it all back. Docile Dean was not natural. That was not the boy she knew. She didn't like it. She'd knew she'd rather see him attempt the Evel Knievel Snake River canyon jump than lie passively on a couch. A daredevil son would be much less unnerving.

CHAPTER 2

"It's been two weeks," she said to the doctor over the phone. "I'm afraid it might be pneumonia. But whatever it is, he must need antibiotics." She made the call on Thursday, April 6, Houdini's birthday.

She hung up the receiver and hurried into the living room where Garry was gazing out the picture window, coffee cup in hand. "Garry, you're going to have to make the kids lunch for noon. The doctor's got one opening and that's at 11:45."

Garry kept looking outdoors. It was grey, damp, and mucky with melting snow.

"I don't know what they eat."

"Just ask them what they want, for goodness sake."

"I'm not running a restaurant. When are you going to get back? I can't be taking time off, you know."

"I should just be an hour. You never take time off. You're a workaholic. How often do I ask you to feed them lunch?"

She led him into the kitchen and set the ingredients out on the kitchen counter with clear instructions: open the can, heat

the soup, make the sandwiches this way for Todd and that way for Loree.

Explaining was more work than doing. Bev wished there were two of her. But the doctor's office was the more pressing place. Only she could best describe the many ways this virus—or whatever it was—was affecting Dean.

After an examination and a blood test, the doctor excused himself. She and Dean sat together in the tiny office for what seemed like way too long. She kept looking at her watch compulsively. She could just imagine Garry's complaints when she finally made it home. After fighting to keep his eyes open, Dean rose from his chair and hobbled over to the examination table, crawled on top of it like an arthritic old man and immediately began to snore lightly.

Bev gaped at her son. She never would've believed it if she hadn't seen it. "He doesn't nap," she said to the empty room.

The doctor returned. "I'm not happy. More tests, I'm afraid, Mrs. Gunnarson. Wake up, Dean."

Later in the afternoon, she leaned against the reception desk, borrowing the office phone.

"I know I what I said Garry, but what can I do? There's a slew of tests he wants to run. We'll be home by four. He promised me that. Well, probably home by four."

It was just after four when Bev and Dean came through the front door, and the phone rang. Bev saw Dean head straight for the couch and plop down as she ran to the kitchen to answer. Garry sat at the table drinking coffee. The sink was full of the kids' lunch dishes.

"You couldn't wash the dishes?"

"You asked me to feed them, I fed them."

She picked up the receiver. Right away, her irritation spiralled down the drain. The conversation was short. She placed the receiver down, standing very still.

"What's wrong?" Garry asked.

"That was the doctor's office. They want us to take Dean to the Children's Hospital right away. He has leukemia."

Husband and wife stared at each other.

Bev moved slowly to the sink and began filling it with hot, sudsy water. "I know you missed a day's work today, but you're driving in with me to the hospital tonight, and maybe...you'll have to miss work tomorrow, too."

"I know it. I'll make a call." Garry worked too much, was away from the family too much. But he this time, he knew where to be.

By the time he'd called out, she needed the phone. With a brief word, her cousin who lived nearby was on her way to watch the kids. They three hopped in Garry's truck. Bev leaned her head against the car window to feel the cool on her hot brow. She breathed onto the glass and fogged it up. She wrote out the number 15. It had been 15 years since her father had died from leukemia.

They admitted Dean to a ward right away and began testing him. Dean winced with every poke and probe. Bev pressed one hand to her heart, the other to her stomach. Her jaw was agape. Her son's pain was impossible to bear. For a moment she thought the panicked breathing she heard was her own.

"I've got to go," said Garry.

"Don't," she said. "I know you're scared."

"I've got to look after something for my work."

Bev was alone. They asked her to sit in a small room with Dean. April 6, 1976. A cold spring Thursday night. The room was dim, grim, paint worn at the edges. Beverly expected more than a place that looked like the waiting room of a small-town dental office. A box of worn toys was shoved in the corner. The magazines were all outdated. Dean plastered himself against Bev for warmth, shivering. The damp spring had seeped into Dean's marrow and he couldn't stop trembling.

"I'm freezing," he said.

"It's not *that* cold," she said, putting her arm around him and snuggling him closer. "I'm warm."

"Maybe you've got a fever," said Dean.

They were called into Dr. Bowman's office. He sat behind the desk, his hands calmly folded in his lap.

"Let's get right to it," he said. "Dean has acute lymphocytic leukemia. He's going to begin chemotherapy, radiation, and regular bone marrow punctures immediately. This is what the treatment protocol will look like."

He handed Bev a paper.

"My dad died of the same thing, cancer," Bev blurted out.

"I understand this is very overwhelming."

"I don't know even know what lymoph—whatever you said, I don't know what it is," said Bev. "My dad was big and strong and then...he was gone. My god, what will this do to a little boy? What...what are the rates of survival?"

"To be blunt, he has a twenty percent chance of survival. That's why we're not going to waste a moment. Life is going to change for you all quite a bit now."

Bev broke into a paroxysm of trembling. The control she had fought to gain in her life had vanished in an instant.

"Now you're cold, Mom," said Dean. She held him fast.

"I won't let him die," she said, but she didn't recognize that milk-and-water voice coming out of her mouth. She'd lost her strength to speak, to communicate, like back when she was a girl and her dad had died and she was lost to herself in shock and grief. Was that a look of pity on the doctor's face? She'd watched her father die and no one could help him. Why should her son be any different? The doctor thought he was dead already. She could see a hardness in his expression. He'd given up.

"Do you have any questions, Dean?" asked Dr. Bowman.

"Can I still play sports?"

The doctor smiled. "Have you been following our conversation, Dean?"

"A little bit. I'm sick. Right?"

"That's right, son. And we're going to start to try to make you well right away. There'll be lots of new things coming at you. But you're a brave boy. I hear tell you like football. It'll be like playing for the NFL. Tough, but you can win."

They sat in the office in silence for a moment, not knowing what to say.

"Well, come on. What do we do first?" asked Bev. "Let's get doing it."

The treatment began right away. When he had his first lumbar puncture, he wasn't afraid because he didn't understand the procedure. What should the words "lumbar puncture" mean to a twelve-year-old? None of it was real yet. When the nurse bundled him up to take him for treatment a package of cigarettes fell out of her pocket on to the linoleum floor. Dean knew cigarettes were bad. He'd never smoked, so he wondered why he was sick and the nurse wasn't. He picked them up and handed the pack to her.

"You shouldn't smoke," he said timidly, knowing he was being was rude. But cancer had upset everyone so much lately. "Cigarettes cause cancer, you know."

The nurse bit her lip. "You're right." She shoved the pack deep into her sweater pocket.

Bev accompanied them into the treatment room.

"I wish I could do this for him," she said to the nurse.

"All parents feel the same way," said the nurse. "Please step back and have a seat over in the corner."

Dean went where they told him to go. The doctors and nurses had all been very nice. He was always happy to oblige them. He had always been an amiable boy. He'd had scores of uncomfortable tests already. He knew the drill. Or so he imagined. But it wasn't

until the last second that the big picture came into focus. That huge needle—he'd never seen a needle that large—was coming towards *him*. Dean began to struggle, and the nurse wrapped her arms around him, trying to subdue him. Bev stood up fast to help.

"Dean!" she cried. "What are you doing to him?"

"Sit down, Mrs. Gunnarson!" the nurse panted.

Bev couldn't. She bit her hand to keep from screaming. With all her weight, the nurse forced Dean down on to his stomach. The doctor moved forward with his needle.

"Just a second," said Dean. "I need to ask you something, doctor."

"What is it?" asked Dr. Bowman.

"When does a doctor get mad?"

"Huh?"

"When he runs out of patients."

Momentarily disarmed, the doctor moved forward and pushed the needle into Dean's spine. Bev's knees weakened and she fell back into her chair. She watched her little boy, without a sound, go into convulsions and pass out. Bev sagged down, slumped over, face in lap, weeping.

With that, son and mother had crossed the border into a new land.

Shortly afterwards, the cancer doctor they'd begun with left the case. It was a dull afternoon. Dean had been poked five times and the young student doctor still couldn't find a vein to get a blood sample. He was slouching back in the chair as if he could lean back all the way and disappear into it.

"Okay, bear with me! I'm going to get it this time!" said the student doctor with a tremulous voice.

Bev stared at the scene in mute horror. If only she could offer her vein. It was unlike the boy to ever complain. But he pulled himself up and meekly said, "Please, just let someone else try."

The door clicked open. In walked Dr. Marlis Schroeder.

"Someone else try what?" she asked brusquely.

"I keep trying and trying but can't seem to find the vein," said the student, voice cracking.

"Give me that needle," said Dr. Schroeder. "You must be Dean. I'm your new doctor. Want to know something about me?"

"Yes," he said, wide-eyed and alert for the first time that day. Dr. Schroeder was different than anyone else Dean had met in this new world. She was a petite and stocky woman, not exactly athletic, but there was something about her bearing of complete assurance that he recognized from a certain something he loved a lifetime ago. Something he hadn't thought of in a while. Something he stretched for in his mind through the hospital fog. For some utterly bizarre reason, she made him think about...all-star football players. Remembering how much he loved footfall, how he ran in the Texas heat, he smiled up at her. "Yes, I'd like to know something about you, please."

"Okay, you got it. About me: I always find the vein."

With a tiny prick, the needle made purchase. Dean and Dr. Schroeder smiled at each other. She was clearly a first draft pick. And she was on his team.

"Now tell me something about you," she asked Dean.

"I was just remembering something I'd forgotten. How I want to be exactly like Evel Knieval when I grow up. Do you know who he is?"

"Yes, of course. He did that Snake River jump with a motorcycle hooked to a rocket and he crashed. Forget that. We want to focus on role models who actually make their jumps."

"But he survived! And it could've been much worse. And he got into the *Guinness Book of World Records* for the most broken bones, so it all amounted to something."

"You're a positive thinker. I'll give you that. But I'm not here to get you well so you can jump off a canyon."

Marlis Schroeder had just completed her medical training in Seattle. Walking in to the room to meet Dean was an important moment in her life. After all her study and education, she was finally in the exact place she had worked so hard to get to. How often can anyone say that? She wanted to treat young people because she liked their attitudes. Kids had spunk. She was sick of the term "victim." She wanted to change the odds for kids with cancer, which at that time was a one in five survival rate. She thrived on challenge. It was what she lived for.

"I'm your doctor now. Do you understand what I'm saying? You won't see your other doctor again. I'm taking over your case. It's you and me now," said Dr. Schroeder.

"I understand," said Dean.

"I haven't seen you around here before," said Bev.

"I'm new."

"Do you have any experience?" asked Bev. "You look very young."

"That's irrelevant."

"You're a blunt woman," said Bev, wide-eyed.

"I've heard that before. You're Mrs. Gunnarson, I presume. If you don't understand something, please ask me. All right?"

"Yes," said Bev, her throat tightening. She wanted to sob with relief. No one had said that to her yet. She'd had to fight for every inch of understanding. "Who are you? I know your name is Dr. Schroeder, I don't mean that. Why are you so...different than everyone else here?"

Dr. Schroeder didn't see herself as anything more than a doctor following well-established protocols. But she was also part of setting new protocols for children with cancer. She didn't know how to resolve these two notions. She wasn't a woman to spend her precious time thinking about her contributions to medicine. She simply liked to focus on work.

"I don't know how to answer that," she said. "Any other questions? Not about me, those are too hard. Ask away. I'm talking about the questions you think of in the middle of the night?"

"This is what goes on in my mind all night, every night. Percentages, of him making it through. He's taking these painful treatments. Doesn't that make his chances better?"

"Dean," said Dr. Schroeder, "what grade are you in?"

"Six."

"Do you know what percentages are from school, Dean? You know, your marks? Your student averages?"

He shrugged. "Yah."

"Do you know what we're talking about when we say rates of survival? Do you know we're talking about you?"

"I guess so."

"Does that scare you?"

"Not really," he said.

"I would like you to be honest with me."

"I am being honest. I'm not scared."

"Okay, then. Well frankly, I think when you're told what the percentages are for rates of survival, it's a useless concept. I hold no stock in percentages right here right now. If you have an eighty percent chance of dying, you could be in the twenty percent who live. Who knows where any single individual lands in percentages. I don't—and no one does. So to sum up, chance of survival numbers are immaterial."

Bev's eyes glazed with tears but she was too happy to cry.

"They told me Dean had a twenty percent—"

"No percentages anymore, please."

"You're not going anywhere; they're not going to send you somewhere else? You're our doctor now for sure, right?"

Beverly had been praying for something for certain. Not just a treatment plan, but a champion. Someone who was ready to stand with her and fight. She had found her ally.

The chemotherapy treatments tore Dean down to almost nothing in their efforts to smother the disease. Then he was allowed to rest to build his strength up again. Then he was hit again with chemo. Either the disease dies, or the patient. Which was going to give first? The cycle continued for three years.

After that first spinal needle, Dean never let himself cry on the cancer ward again.

"You can cry, you know," said nurses, doctors, and friends. "It's not a weakness to just let yourself cry. It's good for you to let go of your tension."

But not a tear. Not one. No one knew who they were dealing with.

"It's natural to cry," said Bev one evening as she cradled Dean in his hospital bed.

"Tell me a story," he said weakly. "Tell me about how you fell in love with Dad."

"That's kind of a complicated story," she said. Bev felt like she was going to cry. But she was a lot like her son. She wouldn't let herself cry either.

"Why talk about dad? You were always the apple of my eye."

"What does 'apple of your eye' mean?"

"It means when I met your dad, I was always hoping you'd come along. And you did. And I'll never let you go."

Bev was always there. She stuck with Dean for every step of his treatment. The doctors and nurses were used to her, and no one spoke much about it except to comment that she got a little over involved. But a lot of mothers did.

One afternoon during a spinal tap, she saw him twitch in a way that upset her, and that's the last thing she remembered. She passed out cold. Mother and son wound up side by side on stretchers when Dean was wheeled into recovery. They reached for each other's hands, and held on tight.

"Mom, you scared the crap out of me! I'm the one who should be fainting, not you."

Her resistance was down, so she asked what had been on her mind all along. "Dean, why don't you ever cry? I know you're in pain. It doesn't seem normal."

"Mom, can you do me a favour?"

"Anything. Anything!"

"Let me do my treatments by myself. I want to do them alone."

"I embarrassed you by passing out. I'm sorry, I didn't eat and…"

"I know you want to help, Mom. But there's nothing you can do for me when I'm getting treatments. I just worry about you the whole time."

"You worry about *me*?" Maybe *that* was why he wasn't crying.

"I do. It kind of makes me feel sicker to worry about you."

She sat up quickly on the stretcher, excited by the discover, discovery anxious to help. "I won't come in if that would make it easier. I'll stay outside."

"When I have to take treatments, any kind of treatment, I want to be on my own before, and when it happens, and after it happens."

"But…" she said, sitting back stiffly. "Fine. If that's what you want."

"Promise me."

"Okay…but when—"

"Promise."

"I promise."

The promise was considerable. But she saw it was necessary. She oversaw everything just out of his view. She occupied her time by filling up tiny little booklets that looked like school report cards with every single appointment met and treatment given. Her notes were meticulous. The little books multiplied like a tiny library for fairies. It was so hard not going with him for treatments, though. She felt agitated, restless, and broke her promise

by secretly hovering outside the treatment room door. Then she thought of another way to help him.

"Come here, Dean!"

"No!" he yelled, backing up across the grass, tense with a cat-like cunning.

"This is no joke. I am your mother! Come *here*!"

He scooted off like a flash, into their backyard and beyond the trees, on thin, white legs pumping fast. She could've almost been back in Texas if she imagined hard enough, watching a healthy boy tearing across the football field. He disappeared into the neighbour's trees. Once she could pick him out from any crowd by his glowing golden hair. Now her boy's beautiful hair had all fallen out. Why him? He had been the healthiest boy she knew. And none of this made sense. She tasted the unfairness like bile. Was she being punished for her inordinate pride in her boy's golden hair? Was she to be stripped of everything for her pride in her first-born, her vanity?

"Why did I take all this bother to learn how to give you injections myself if you keep running away from me?" she screamed after him. "Do you want a complete stranger to give you needles, some nurse who doesn't even love you, who has to drive all this way for nothing when I can do it myself?"

Her son gave no response. She walked further out into the yard, holding the needle. "Dean! It's for your own good! I'm your mother!"

The dim shape of her neighbour fluttered and passed at her kitchen window. *Now I'm making a spectacle of myself, and everyone in the neighbourhood will be talking.* Beverly plopped down on the picnic bench and regarded the needle she was bearing.

"You're making me look like a crazy person," she called out, but half-heartedly. Maybe I am crazy, she thought. She placed the

needle on the picnic table. Back in Texas, she'd be placing food out to feed a crew of friends. She was rocked with an involuntary sob. She breathed through it. She hated doing the injections anyway. The thought of Dean's pain made her nervous and her hand trembled. He didn't deserve that. Let go, Beverly. Leave it to the professionals.

She looked up, scanning the green space for gold.

"Okay Dean, okay. The nurse can do it. Can you hear me? I give up—we'll do it your way Dean! All the way."

"Do you promise?" asked a tiny voice from somewhere within the trees.

"I promise."

"No more at all? And no more ideas on how to help? You'll just leave me be with the doctor and nurses?"

"I promise," she said, sinking physically into defeat.

Then her little bald boy appeared, stepping out from behind a tree like magic, and walked slowly back into the house as if nothing had happened. She turned and she watched him pass by. The burst of energy from his run had cost him. He was carrying himself heavily, like a little soldier after battle. *He is fighting his fight. There is nothing I can do for him except be here,* she thought. When he'd gone inside, she put her head down on the picnic table and cried. The tears flowed freely. She let them. Even though her son still wasn't crying.

Dean's mom got to him, he had to admit. There was no one like her for penetrating his defences. But now, with her promise in place, the plan was really on. What she didn't understand was that he was using his treatments as rehearsals to hide emotion and pain. To cry would be to fail.

He'd been practising this so devotedly, and with so much success, he didn't even cry at school. School was the place he most wanted to cry, even more than the worst moments in the hospital

treatment room. He'd learned that physical pain had nothing on others kinds of hurt. You could brace yourself for physical pain, but the other kind blindsided you, could rush in to target a weak link that threatened your whole foundation. Life wasn't so bad when he was first diagnosed.

Grade 6 was the highest level at Donwood School. And the grade Dean was in when he first introduced to leukemia. He was one of the big kids then, and all the kids in the younger grades looked up to him. He was popular with everyone in his own grade too. The boys liked him because he was funny and he was the guy you wanted on your team, didn't matter what the sport. The girls liked him because he was funny and cute. The thing about Dean, he was nice to everyone. He was the kind of boy who wanted to have fun, from class to recess, lunch to after school sports, he wanted life to be a series of good times and for all you could guess, he liked everyone equally. He could pull out his Texan accent at will, which was exotic in Manitoba. That accent was in high demand. All the kids at school called him "Tex."

When their teacher announced why Dean was going to be missing so much school, there was an outpouring of affection. It had been a good gang of kids. The girls liked him; the boys liked him. His classmates made him a Get Well card on a large piece of red construction paper. Everybody signed. Some wrote messages, jealous that he got to stay home from school, imagining his life as a kind of adolescent retirement fantasy with non-stop television enjoyed from a comfy bed and a supply of potato chips, candy and pop. He was made to feel missed. That helped ease the loneliness of not playing team sports anymore. There was nothing for Dean like committing his brains and vitality to a game. Not being on a team was a terrible punishment.

Two months after his diagnosis, he graduated. Largely due to Bev, who moved so fast and worked so hard at getting Dean

to and from treatments and helped him with his studies, he had a semblance of a normal life.

But going back to school in Grade 7 was a different matter. He was starting fresh at a new school, Chief Peguis. Bev was still in there slugging it out so Dean could be a functioning student. She was doing everything a mother could do. But it was the 1970s and all the boys were wearing their hair long. Dean felt shy about being bald from chemo, especially when he just wanted to be like everyone else. What better way to disguise himself than a hat? They weren't allowed in school, so he had to get special permission to wear a baseball cap. It read "Budweiser." He liked his hat; he'd won it in Texas at a football game. Texas, where he'd had happy times and good luck. It would be his talisman.

But Dean was soon to learn the cap was not cool amongst the kids at Chief Peguis school. He stuck out in the worst way: kids used the word "Budweiser" instead of saying his name, and they said it with derision. Still, he wore the cap doggedly. It was preferable to his bare head. That felt too vulnerable. It protected him from sunburn—something he never thought about before. And he suspected if he bought another hat, any hat, it would be wrong too.

His hair had been glorious and golden. He wasn't vain, but his mother had praised it enough. He wanted to tell his new schoolmates he'd had nice hair once too, but he knew better. Because no one at Chief Peguis seemed particularly interested in knowing anything about him. The guys couldn't see his potential as a pal because he couldn't play sports. That made some sense to him. He now understood that sports were more than a physical thing, but were a way of communicating. Now he wasn't having those conversations anymore. So while he understood why the guys weren't interested, he still had plenty of friends in Grade 6 who weren't into sports, who still wanted to be his friend. So the situation didn't exactly add up.

What really confused him: girls didn't seem to like him any-more either. Did it mean so much to girls that he wasn't playing football? Surely they hadn't liked him just for his *hair*? Of course not. Girls liked him for the boy he was—he was sure of it. They laughed at his stories. They'd been glad to shoot the breeze with him. He wracked his brains trying to figure out what had gone wrong. Had his personality changed? *Am I being unfriendly in some way?* He had reached out his hand to several kids and no one grabbed hold. Maybe that was it. No one wanted to touch his hand because to them, what he had might be catching.

Dean told himself friendship was a thing of the past. He came to dread school. He avoided his schoolwork. But things can always get worse. Sensing his weakness, his schoolmates began to tease him relentlessly, boys and girls alike. From the girls he got disgust, as if by touching his arm the cancer would spread to them. From the boys, it was aggression, like they needed to eradi-cate him from the earth to protect hearth and home.

He liked to go out into the sun at recess. It felt life-giving to seep in the warm rays, he liked to breathe the sweet air into his lungs. He would close his eyes sometimes and pretend he was in Texas. But it was a risk to drop your guard. Going out for recess could be dangerous.

Certain boys circled him whenever they got out of eye range of the adults. They'd haul him up from sitting. Pushing him back and forth, trapped inside a circle of their bodies, they would hiss, "Hey, cancer boy! When are you going to die?"

He was afraid to tell them not to push him because his bones were weak. They looked hungry enough to try and see just how weak his bones were. Staggering like a sailor on deck in the storm of their shoves, Dean was mesmerized by their grotesque grins. There had been a picture he'd hated from a storybook when he was very small, a troll under a bridge with glassy eyes as big as

saucers, smiling at the prospect of luring a child down below into his slathering jaws.

"What are you looking at, freak? Don't look at me"

"Stop staring! Just die already!"

But he couldn't stop staring. He wanted to tell them they looked like monsters. As soon as he spied a gap, he sprinted from the circle and away into the school to safety.

Dizzy and hot, he went into the boys' bathroom and leaned over the sink, panting hard, wanting to vomit from the exertion. He wished he could've hit them, knocked them down like dominoes—but he had only ever really fought for his team on the sports field. The pain of needles deep to the spine was one thing, but he did not understand this cruelty. They didn't know him. They didn't know the person he'd been before his bones got soft as dough.

He was soft now, and he was running away from people, instead of running for fun. He ran from his mother, he ran from gangs of teenage monsters. He'd never run away from anything before, ever. He didn't like to look in the mirror anymore. But when he caught a glimpse of himself in the mirror in the foyer or in the panes of glass in a store window, he couldn't stop himself from staring. And now he was so white he couldn't tell his skin from the industrial white bathroom wall reflected back at him. He was disappearing into the very fabric of the school. As a little child he'd been afraid of ghosts, but now he was a ghost, or half ghost. He was becoming what he had feared. Only the bold black and red of his Budweiser cap kept him from fading away into nothingness.

"I'm disappearing," he whispered. He put one hand on to the mirror and touched his other hand to his face. The mirror was cold. He was cold. He knew he wanted to feel heat again. If only he could hang on for a little while longer. Maybe.

The bathroom door banged open. The boys from the school-yard were not done. In a flash, they had slammed him hard into the corner. Everyone heard the thud of his skull against the metal door. There was a brief pause. Dean was sure the sound had made them realize they'd gone too far. No. It had only served to excite them more and now they morphed into a huge monster with a million punching fists and kicking feet, but one single mind. Dean slid lower and lower down the wall, desperately holding onto his cap, because if his bones meant nothing, his special cap would mean less. He loved that cap and they knew it and they wanted to destroy him. The cap meant Texas and football and—They ripped it out of his grip. He kept his hands covering his face. He heard a splash and a flush, and lots of feverish laughter. In the hollow room it echoed harshly.

Then stinking, hot breath blew into his face. "You like your hat so much, follow it." Hands, who knew how many, grabbed his collar and dragged him along the dirty bathroom floor. He gagged on the stink as his head was shoved into the toilet bowl. He held his breath.

From behind there were three crashes in quick succession. Dean's head wasn't being forced down any longer. He swung his head back and saw three of the gang struggling to regain their footing. And Greg Jones standing, legs slightly spread in war-rior stance.

"Stop it!" Greg shouted. "Leave him alone! If you don't I'm going to report all of you but first I'll give you a beating you'll never forget."

"You and who's army?" someone shouted. Dean saw Greg kick something out of view that moaned.

Their classmate, Greg. A normal boy. Not a particularly tough boy. At that moment though, he exuded an ineffable some-thing that made the entire gang back up and leave the bathroom swiftly. Greg put out his hand and hauled Dean up. He saw what

they'd done. He reached into the toilet and pulled out the cap. He brought it to the sink and began to rinse it under hot running water.

"A man needs his Budweiser cap," said Greg with a smile. He'd never talked to Dean before.

"Thanks."

"Don't mention it. Those guys are utter creeps. They'll think twice next time."

Dean wanted to cry. Not from the cruelty of the beating, but from the kindness of Greg. But he fought it. Tears were one thing he could vanquish.

CHAPTER 3

Dean could vanquish tears because he had a secret weapon. He'd been doing a lot of reading because he'd been doing a lot of sitting around. He already knew about Houdini from the paperback his mother had given him in Texas when he was ten, but he had found another book in the school library: Milbourne Christopher's, *Houdini: The Untold Story*. This time, because he wasn't a boy on the run, instead of a skim he read the book carefully from cover to cover. And this book was filled with photographs that took the story off the page and into his imagination. He read a different message in Houdini's life story. The heart of the story wasn't about overcoming the odds to become famous. Dean thought it was about fighting to survive.

The day he took *The Untold Story* out of the library was the last time it ever sat on the school's shelves. Every time the book was due Dean signed it out again. He carried the volume with him everywhere he went. In treatment or at school, it was tucked in his knapsack. When the mocking of his snot-nosed classmates threatened his spirit, their voices could be tuned out because Houdini the titan, his friend, walked beside him, protecting

him—so Dean didn't cry. Occasionally in these dreams, Greg Jones was allowed to walk with him and Houdini too. Finally, the librarian asked Dean to return the book and let someone else have a chance to read it. Dean refused.

"I can't return it, I'm sorry."

"Have you lost the book, Dean?"

"No, ma'am, it's right here in my bag. I've taken very good care of it. No dog ears, like you said."

She pushed her glasses back up to the bridge of her nose. "Sorry, why can't you return it, then?"

"Because I love it. I need it with me at all times. Because it's mine. I mean, it belongs to me more than it could ever belong to the library or anyone else," he said. He leaned in closer to whisper. "I can't say any more. The less I say the better."

The librarian pulled off her left clip-on earring and gave her earlobe a rub as she tried to look into his eyes, which were shaded by his Budweiser cap. But she saw enough.

"Don't tell anyone else I did this. Bring me a dollar when you can, and I'll sell it to you on behalf of the school library. I think I get it. I used to feel that way about George Orwell's *1984*."

He was sick but not prepared to be sickly. He needed to feel the air rushing past his ears as it did when he was running. He wanted to disobey Dr. Schroeder's orders and play sports, but he was too smart to risk breaking his bones. Instead, he bought a dirt bike with his savings and rode as fast as it would go. It was the feeling of running without the fatigue in his bones. He imagined what Dr. Schroeder would say if she knew. "Dean, you're not stupid. If you crashed that bike, the damage you could do to yourself would be monumental. Lock it in a shed and leave it there."

But he wouldn't. He couldn't. He needed to feel the wind as much as he needed water.

But he couldn't ride his dirt bike in winter. What was he to do to survive this? He asked his best friend Houdini for advice. Houdini always had a lot to say to him. He never let him down.

"Learn magic like I did, start from the bottom up, and start it now," said Houdini. "You're going to need it."

So Dean fought the boredom lying down. Playing cards, rings, coins, silks all spread out over the quilt on his bed at home, or on the cold, starched sheets of the hospital beds. He honed card tricks and hand magic, and everything Houdini did when he was first starting out that wasn't too vigorous. The other things—the daredevil stunts and escapes—he read about them in his Houdini book over and over and over again. Houdini was the master of escape. If he read carefully, if he trained diligently, maybe one day Dean could escape. He started with ropes, and he started on something he thought would be small. And he learned, spreading out before himself numerous knots, knots of all kinds. He had no idea there were so many different knots. And if you knew how to tie them, you would know how to untie them. If someone, some-where, offered to bind you, how would you know what kind of knot they'd use. You couldn't. So best to learn every single one. Sometimes when Dean was feeling weak, he enlisted his dad's help. Garry had a good, firm grip and he could tie the tightest knots. But even when Dean was feeling equal to his task, Garry wanted to help. He was interested in knots, too.

But knots were just ornamental string until you were tied up by them. When Dean had a score of different knots down, he had his dad tie his hands together in every different way he could think of—in front, behind, hog-tied. In ever growing incre-ments of rope and entanglement, Dean was insatiable for bondage. He and his dad would tie up and untie while they watched the TV at night, as Bev cleaned up her house after the whirlwind of the day.

"We're kind of doing the same thing, Mom," said Dean. "Working at making something better."

"You're right," said Bev. "You put your knots together, and then take them apart. I put my house together and night, and you kids take it apart in the morning."

As their experimentation progressed, he could hardly wait for his dad to get home. "Dad!" he'd holler, hurrying to the front door bearing a length of strong rope. "Tie me up! Tie me up!"

Beverly followed swiftly behind them, arms crossed, shaking her head in disapproval.

"Guys, can we not...find a new hobby?"

Garry was the only one in the family who would tie Dean up. Last night, he'd tied him to the staircase, but he was running out of permutations.

"I've tied you up every which way I can think of," he said. "There's no new way under the sun for me to tie you up."

"No, I've thought of something," said Dean. "This time you can hog-tie me with a rope noose around my throat."

"Dean!" hollered Beverly. "Don't talk so foolishly! All this tying up is bad enough but Dad is not going to put a noose around your neck! Over my dead body!"

It was much less painless than that. Garry simply made sure Bev was well occupied in the kitchen preparing dinner before he hog-tied up his boy.

"Dinner! Dinner everybody!"

Loree and Todd came running, and Garry wasn't far behind.

"Dean, we're waiting on you! The meal is getting cold!"

The familiar sound of footsteps descended from upstairs.

"Why were you up in your room? You feeling okay, honey?"

"Yup. Just fine, thanks."

As the family passed the hot dishes around the table, Bev cocked her head at her number one son.

"Weren't you wearing your yellow T-shirt today?"

"No, Mom."

"I could've sworn you were wearing…"

"He was wearing his blue turtleneck when I came home," said Garry.

Beverly looked from one to the other.

"Can you pass the meat, Mom?" asked Dean.

"Now, please no complaining. You can have a bit of roast but you know I want you to eat this liver to boost your white blood cells," said Bev.

"No problem, Mom! I'll be happy to eat the liver!"

"Dean…what are you up to?" asked Beverly.

"Whatcha mean, Mom?"

Dean dug in. As the roast beef and liver dinner progressed, Garry was sweating through his shirt, silently praying the light red chafe marks around Dean's pale neck would fade by bedtime. If they didn't, he'd be in very big trouble.

Dean dreamily picked at his food, silently exulting over how little time it had taken him to escape the noose hog-tie. He'd been faster than he'd even hoped. Houdini was sitting beside him at the dinner table, black hair greased back, brown tweed suit, whispering in his ear, prodding him on. "Dean, push harder, push further. You can't delay. You know what you have to do next."

"Dean Gunnarson," said Beverley. "Earth to Dean. What's the matter? Don't you like your meal?"

"Don't be mad, okay?" said Dean.

"What?" asked Beverly sharply, putting down her knife and fork. "What's going on?"

"Okay, well, you know I've been saving my money up? I know what I want to buy with it."

"Go on," said Bev coolly, bracing herself.

"I know what he wants," said Loree. "He been drawing it for days."

"I want a bike!" said Todd.

"Do you guys mind?" asked Dean.

"So what is it I'm not getting mad about?" asked Bev.

"I wrote away to buy something on mail order," said Dean. "But they wouldn't send it. So then I was making some phone calls..."

"Oh really. Do you know about all this Garry?"

Steadily eating, Garry shrugged.

"But that didn't really work 'cause no one sells them to kids. They don't take us seriously! So then, I sent Dad..."

Garry flushed red as he chewed.

"You sent Dad, did you? No one told me. *Garry?*"

Garry didn't lift his eyes from his mashed potatoes.

"Go on," said Beverly with a sigh.

"Well anyway, I need my own straightjacket."

"Excuse me?" said Beverly with a tiny shake of her head.

"He's been drawing straightjackets over everything," said Loree. "This should not be a surprise to anyone."

"Weird thing to buy when you could get a bike," said Todd.

"Straightjacket escapes were a regular part of Houdini's routine," said Dean. "It's just like how a magician needs a dove and a coin and a silk. An escapist needs a straightjacket."

Bev perked up a bit. This was actually good news. "Will this stop you from bugging Dad to tie you up with ropes every night?"

"Yeah, that's the thing! I'm so good at ropes, I need to challenge myself even more. Houdini says—" He stopped himself.

"He talks to Houdini," said Loree flatly. "Is his cancer making him see things?"

"I've heard him in his room talking to Houdini," said Todd. "I bet he thinks Houdini is talking to him right now."

"There are worse people to talk to you kids," said Beverly. "Get rid of the ropes, and I'm all for the straightjacket. Maybe you can wrap me up in it eventually."

"I for sure could do that, Mom!"

"I was kidding," said Beverly.

"But no one will sell one to a kid, and when I sent Dad to the medical supply store they said they wouldn't sell a straightjacket to just anyone off the street."

"Dad should have mentioned this to me. Right, Dad?" Bev said, with one eyebrow raised. Garry continued to be passionately interested in his dinner plate. "Because I have a brilliant suggestion. Maybe Dr. Schroeder can help you get a straightjacket. She's a doctor. She's bound to have an 'in'."

Dean leapt up and began to dance around the room. "My mom's a genius!"

"Thank you," she said, with pleasure, though she was watching her husband digging into his meal again. He still hadn't met her eyes.

"Hi Dean. To what do I owe this honour?" asked Dr. Schroeder from behind her desk in her private office. "You've never booked an appointment with me before."

She wore a neat red suit jacket with a polka dot blouse. Dean was always surprised by her pretty clothes. He thought she should be dressed in something more like her manner; something tough and intimidating, like leather.

"Dr. Schroeder, you said I was to come to you if I had any kind of question."

"Go ahead."

"I need to buy a straightjacket, but no one will sell me one. I've figured it out though. If you could call and arrange it at a medical supply store for me, then my dad can pick it up. I've been trying to do it all myself but no one respects kids. I keep telling them I'm an escape artist in training, but they just laugh. My money is as good as anybody's, isn't it?"

"You want to buy a straightjacket."

"Yes ma'am," he said. "It'll be my first."

"What will you do with it, may I ask?"

"I'll be put into it by my father, and then get out of it like *that*! I'm going to be the next Houdini."

"Of course. Yes, I can arrange that. But I do not want you to tighten it to its fullest extent, do you understand me? Your bones are weak."

"I know they are," he said, looking down. He hated hearing those words. Even if he wasn't tired, the words made him *feel* tired.

"However, if you get tied up in a straightjacket, you won't get out. I'm telling you that right now. But if you want it, I'll arrange it today."

"Really? It's that easy?"

"It's that easy. And Dean," she said.

"Yes, ma'am?"

"It actually a good thing they're not handing out straightjackets to all and sundry on the street. Some things are worth fighting for. Right?"

He smiled, waved, and hurried off. And after a long, two-week wait, he had his very first, crisp, bright white straightjacket. When Garry came home with it, Dean was fit to be tied. Beverly, Loree and Todd gathered around to admire the shape of it, the strange long arms and tight stitching.

"Okay, I need Dad and just Dad, to bind me up."

"No!" the family wailed. "We want to see too!"

"If you're interested then, let's all go to the sitting room," he said.

Dean liked to be bound in that room because it had a door on it that could be closed.

"Tighten the straightjacket to its fullest, Dad."

Gaping, the family watched the long cloth arms be wrapped around his chest, and the leather belt be cinched uncomfortably under his crotch. He was already sweating.

"This is too extreme!" said Bev, chewing her nails.

"No Mom, it's totally normal for escapists."

"It's totally freaky for everyone else," said Loree.

"Now—I need everyone to leave," he said, breathing heavily in anticipation. "I require privacy."

"*He Requires Privacy*," said Todd, in an upper class accent.

"You call us when you need us," said Beverly. "We'll be right outside."

"Go," he said firmly. He needed to begin. He was ready. His family shut the door behind them as they left, as Dean had requested. Of course no one knew he was in there with Houdini, who talked him through his first straightjacket escape.

"It'll get easier," said Houdini as Dean strained. "Just a few things to fine tune. And after that, you do it hanging upside down."

"Upside down. Do you really think I can do that? My bones are soft."

"I have no doubt in my mind that you can. But it'll take a bit of time to work up to that anyway. You'll be well by then, and your bones will be perfect. And there's a trick to doing it upside down that I can tell you…"

Houdini spoke very low, just in case someone was listening.

Dean worked on his magic every single day. He gained skill. On the best days at Chief Peguis High, no one paid him an ounce of attention. That meant he wasn't getting beaten up. On that day, he was having a good day. Quietly at his desk, he practised a coin vanish trick to keep his hands steady. He was going for a painful treatment that afternoon, and he'd noticed hands shaking in anticipation. Coin tricks were good because they were such small sleights, you could practise without calling any attention to yourself. But someone did notice.

"Hey Dean, what did you just do there?"

His body tensed, waiting for a hard slap to the head or a shoulder check.

"Can you do that again?" ·

"Who, me?"

"You made that coin disappear."

"Oh—that. That's just a classic palm. It's basic." Dean made the coin disappear again. "Just doing my hand agility exercises."

"Hey guys, come over here! Look at this. Do it again, Dean, show them."

A dozen kids, some of who'd been outright cruel to him, some of whom he was amazed they even knew his name, surrounded him. He made the coin disappear flawlessly, of course—he'd been practising that trick from the start. At their urging, he did it a few more times, and for good measure, he made the coin melt through paper. Their homeroom teacher came over when he couldn't get anyone's attention, and Dean repeated everything again.

Magic. Schoolmates who despised Dean's weakness were instantly misdirected. On one side of the coin, he was the bald and dying alien. The coin had now flipped, forever. He was the boy who held the key to mystery and illusion. Dean Gunnarson could do magic tricks.

Three years after the treatment began, April again, the same month as his diagnosis, 1979, Dr. Schroeder asked Dean and his mother to step into her office.

"The chemotherapy is over. Your tests have come out all clear. You're on the road to health, Dean."

Out of the corner of his eye, he saw his mother cover her face with her hands and begin to cry. It was the oddest sensation, but he couldn't hear her. He focused solely on Dr. Schroeder.

"Excuse me, Ma'am?"

"I said it's over Dean. You'll still be monitored closely for the possibility of relapse. But at this moment, you're cancer free."

He sat there, gaping at her. He felt like he was missing something. He was so used to enduring pain he had the sensation he'd put his foot up to climb the stairs but a step was missing.

"Dean? Do you understand what I've just said to you?"

Against his wishes, against his Houdini-inspired training, against his vow—he was sucked down into the maelstrom, and tears were flowing out of him like they'd never stop.

Later, he analyzed why he cried when he had trained for three full years to beat emotion. How he felt just before could be instructive. He traced back in his mind to the minutest detail. Dr. Schroeder really had blindsided him. She just came right out with it, in the bluntest way. If he'd had just one indication this would be big news, he could have let all his feelings drain out, just concentrated on his breathing, relaxed and stayed totally dry-eyed. But this was really his fault. He well knew her bluntness by now. He should have prepared himself second he saw her. She was unlike anyone he knew. The opposite of his mother, who would say things like, "Dean, we need to talk." No, this had been an accident waiting to happen.

"Don't beat yourself up about it, Dean," said Houdini. "You cried. Okay. It's over. But you learn from your mistakes."

"Yes. I learned about being blindsided."

"If you're going to be an Escape Artist, that lesson is going to serve you well. Because that's what it's all about."

That evening, Bev announced at the dinner table to Garry, Loree and Todd that Dean was better.

"But he wasn't in the hospital," said Todd.

"He was—for four days. But I worked hard to keep him at home," said Bev.

"Hmmm. I kind of forgot he was sick," said Todd, heaping his fork with mashed potatoes and gravy.

"Yeah, Mom. Everything seemed so normal around here," said Loree.

"And what do you have to say, Garry?" asked Bev.

Garry nodded as he ate. "That's good," he mumbled.

CHAPTER 4

Dean had grown impossibly handsome at sixteen. He glowed with the kind of good health only the very fit exude. After years of baldness, he never wanted his ears to show again. His flaxen hair grew back quickly and it was soft and curly. He grew it long, every inch a '70s celebration. His mane was his peacock's tail, the opposite sex drawn to his strutting confidence. His humour and ease made him the envy of other young men. He had missed a lot of school but he was a fast learner. He couldn't catch up so fast with playing sports, though, weakened by three years of chemotherapy. His bones weren't going to become strong again overnight. But the magic was garnering so much positive attention, he surprised himself by not being too disappointed when he didn't make the cut for the East Side Eagles football team. After all, a football team is made up of twelve players, but what Dean did was unique. And at the school dances, girls wanted to dance with him again. He felt good. But he sure wasn't like all the other young Winnipeg dudes.

He had a very unusual, arcane skill at his fingertips. Man, that kid could do cool tricks. And there is nothing like magic for

making friends. He was always being called by people, kids shouting out his name from all angles, "Dean! Can you come here? Show me that trick again!" The classmates who'd abused him had selective amnesia. It was like they'd never tried to drown him in the toilet. They were like the rest of his avid audience members, begging for just one more trick and anxious to be his friend.

Dean knew a slew of jokes, too. He'd been using them on the doctors and nurses for three years. His comedic timing was perfect, vaudevillian. He left everyone happy and wanting to see him again soon. He was kind of like a movie star at school. He was *that* guy—the guy who knew the tricks. And he was really nice, too. Everyone at Chief Peguis got to know him. Where had he been hiding all this time? Dean Gunnarson was the total package.

He was getting very nimble at card and hand magic. His straightjacket escape times were ever-improving too. His name spread by word of mouth beyond school. What was said was, the kid was an entertaining, genuinely talented young magician. December of 1979 he performed at a banquet at the Marlborough Hotel. He didn't have his driver's license yet. But he already knew how to drive, being mechanically inclined, so he wasn't too bothered.

"Can I get the car keys for a couple hours?" he asked his mom.

"Excuse me?"

"Can I—?"

"You will *not* drive without a license, young man!" cried Beverly. "I don't know where your brain is sometimes. Your dad will drive you, thank you very much!"

Garry was glad to drive him. They were silent on the way there. Dean felt the nerves pulsing violently through his body. He observed his shaking hands with interest. He held them out in front of him, and steadied them by thinking them steady. He breathed deeply, slowly, getting calmer the closer they came to their destination. His father watched the whole process in his

unobtrusive way. His son's hobby was nothing he ever could have imagined for him. He once thought Dean might go into construction. Here was an alien creature beside him, dressed in a tuxedo and looking like someone off of TV. Where did he get this from? All he knew was, he admired the boy. After they unloaded the props together, they shared a silent look. Garry knew who his son was practising his magic at home. But who was Dean as a performer, a *real* performer, with an audience of mostly strangers? He was about to find out. And filled with an anticipation he hadn't felt in a long time. Garry could hardly wait to see the show.

It was a boy on a small stage in a hotel banquet room. He had a small table in front of him and props stashed behind. People had been drinking and eating well and looked up at him with lazy contentment. Dean began his patter and gave them a small sampling of his favourites, with all his best jokes. He'd hoped the lineup he'd designed was going to build in drama and spectacle. His plan seemed to be working, faces from all over the room had been leaving their conversations and turning to him, and now, yes, it was all faces forward and here came the big penultimate finish: He broke an egg into a pan, set it on fire, and a live dove materialized: the Dove Pan trick. The crowd roared with appreciation. Now they all inched forward on their seats. He pulled an unwitting fellow out of the audience to help; he'd had a few drinks and somehow that added to the fun. The audience was in stitches, but the guy sobered up fast and locked Dean in cuffs and tied him in ropes and covered his wrists with a dinner napkin and—Dean was free. No one looked more surprised than Dean. He knew he could do the tricks, and now, he'd performed a whole *show*. The crowd was wowed. Performing for a big audience had been exhilarating. Dean felt, he *knew* he'd reached them, and not just through the tricks. The unknown had been the intimate communion between performer and audience. He was crowded by admirers congratulating him afterwards.

"That was wonderful," a man from the audience told him. "The tricks were very well done but—"

"It's his personality," interrupted his date. "You can get magic tricks at any old show, but you really have a star quality that sets you apart. Good for you, kid."

Driving home, Dean felt so electrified he didn't think he'd ever sleep again. "Dad, that lady was right. You can see magic tricks anywhere. She said I could be a star. Do you think she's right?"

"Son, I work in construction. I couldn't tell you. But I will say—you were perfect up there. I've never seen anything like it."

"Do you think I should go into acting instead?"

"How much did you make tonight?"

Dean ripped open the envelope he'd been handed. "Fifty bucks!"

"Not bad, but actors make millions just for standing around."

It was his first paid gig. He photocopied the fifty-dollar cheque before he cashed it. But if someone somewhere was giving out millions...

Dean got involved in the drama club and he acted in school plays. Young people are often grimly surprised by just how often one has to rehearse for a play, but Dean showed his knowledge of the process and his professionalism right from the start. His pleasure at rehearsing and making his performance better and better distinguished him. He was well praised for his efforts by his teachers, fellow actors, and the audience. The stage was getting into his blood and bones. Acting was something he could see himself doing. He requested a private meeting with his junior high drama teacher, Mr. Fontaine, in his office.

"I want to be a professional actor. I don't want to waste time going down wrong paths on amateur stuff. I want to go to the top. So I'd like your advice, please, sir."

Mr. Fontaine was in the big time. He'd done a television commercial. But to Dean's surprise, Mr. Fontaine looked at him with a curious mixture of compassion and horror.

"Be anything else," said Mr. Fontaine with a slow shake of his head. "Anything."

"I don't understand, sir."

"Acting is no kind of *life*," said Mr. Fontaine. "Dean, you've been through a lot with the cancer. You deserve a really great life. You want to starve? Suffer? Constantly compare yourself to others? Be kept awake at night with regrets and total insecurity about your life choices? Not be able to afford basic dental work?"

"But—you've been on a commercial!"

Mr. Fontaine appeared to stifle a snort. "Yes, I sure have. How can I put this... Acting is a fine hobby, Dean. Go into business. You've got the charisma."

Dean walked away from the interview deep in thought. He had no idea it was that tough to support yourself as an actor. He reasoned with himself. Performing magic shows was acting too, but by solely focusing on magic shows, he would have a job. He could still audition on the side, but if acting didn't pan out, he could at least be assured of making $25 doing a birthday party. He made what he thought of as a prudent business decision: he would become a professional magician who was keeping an eye open for acting work on the side. Then, he could afford his dental work. But magic was a broad field, and he needed to carefully choose his territory.

He disliked doing card magic. He enjoyed watching it well enough, but to perform it himself didn't move him. He felt that with enough practice, anyone could manipulate a card. Now Doug Henning was unique: You didn't copy Henning, you *couldn't* copy Henning—you just admired him. Now a David Copperfield, for example, with the slick choreography of his

shows, left him cold. Dean knew how the tricks worked and the presentation desperately begged the viewer to believe in something supernatural, and he found that insulting to his intellect. Dean was like Houdini—he preferred escape. Escape was real. Escape was a man pitted against his fears using everything he had to get free. There was no gimmick to it. Escape took the athleticism of sport, but combined it with the skill of the illusionist—but not the supernatural fakery. Escape was pure. And maybe, just maybe...there was more to it. Dean had a pet theory. But that was for later.

He had been in preparation for a while—ever since the first knot he'd figured out with his dad. And Houdini—he was where the love of escape had begun. Dean's feelings hadn't changed since childhood. The escapist was always in his thoughts

Dean revised his life plan. He'd follow his heart. When he weighed all his interests, he knew it was escape that spoke to his soul. And when you have a line on your soul, nothing stops you.

He would never confess it to anyone, but he still always imagined Houdini with him. No one would understand. He'd look childish, or flakey. But he could see him so clearly because of the strength of his imagination and the immense willpower that had got him through his disease. Imagining Houdini gave Dean a fierce pride, and—there was no one else to talk to about magic. Regular best friends, never far from each other, walking together, sitting on a park bench, talking things out. They debated the pros and cons of Dean's career. He told Houdini about his ideas for escape. Houdini reminded him he knew the streets of Winnipeg long before Dean was born.

"Where, exactly?" asked Dean.

"I'm not going to do all the work for you."

"But why can't you tell me?"

"Figuring things out yourself usually brings unimagined rewards," said Houdini.

Cryptic of him.

If Dean could figure out exactly where Houdini had been, he could visit precisely the same places, walking in his hero's footsteps, it would bring them even closer.

And then despite himself, for Dean had never believed in ghosts, he wondered... Could he be the one to penetrate the veil, and actually connect with Houdini beyond the grave? Séances were held yearly on Halloween, on the anniversary of Houdini's death, and it had all started at Houdini's request. Because even Houdini had wondered if it were possible. Yes, all had failed, so it wasn't likely Dean would make contact. But he felt Houdini so deeply inside him. His connection was tangible. What would be the harm in trying? Dean had the idea to research Houdini at the Winnipeg Public Library.

"I need to see anything you have about when Houdini was in Winnipeg," Dean whispered to the librarian. "I want to walk exactly where he walked."

"Interesting," mused the young man. "I love unique requests. That's going to be very old stuff. Have you ever used a microfiche machine before?"

Dean was a quick study at the microfiche station. Scrolling through the film of old newspapers on the dark, silent second floor, his heart soared: There in black and white, he saw a photo of his hero in Winnipeg, January 1923. Hanging upside down in a straightjacket from the *Winnipeg Free Press* building. The *Free Press* building. Why, he'd just walked past there that morning. He stood up from his seat, shouting, "I could! I could do that! I know I could!"

"Shhhhh!" hissed the librarian running over to him. "What's the matter?"

"Sorry, I got excited," said Dean, grabbing the librarian and jumping up and down with him.

"We love to see people excited about the microfiche machine," said the librarian.

Dean's idea of coming to the library had been to follow in Houdini's footsteps. But he now realized he could do more. He could try to emulate everything Houdini did in Winnipeg. He could share their connection with the world. He would perform for all of Winnipeg and show them how he truly walked in Houdini's footsteps.

"Is this what you intended?" he asked Houdini, whom he now discerned leaning in the shadowy stacks. Houdini smiled that trickster's smile and looked meaningfully at a far row before disappearing. Dean had copies of the old newspaper pages printed up and then went to look at the section he'd seen his friend eyeball. It was "Biography." So he also signed out everything in the library that touched upon Houdini. His aim was to make history come alive, so he needed to know everything.

Soon after this eureka moment, Dean was at a house party. A very interesting girl was going to be there, and he was hoping to bump into her. Spying her across the crowd, he moved toward her. He bumped into a big, furry blue guy

"Whoa. And I haven't even been drinking," said Dean.

"I know. I'm Kerry Hogan and I'm dressed as Cookie Monster."

"Yeah, I got that. Nice costume, man."

"You like it?" asked Kerry.

"It's the best Cookie Monster costume I ever saw. Except for the real thing of course."

"Hey that's really decent of you to say that. I started a business, you know? I'm a guy with a dream. Doesn't everyone want a great costume sometimes? Am I right or am I right?"

"You're right, no question about it."

"I'm trying to promote my new business. It's called Gags Unlimited. Isn't that a good name?"

"Yeah, it's really great. You come up with it?"

"Yeah, that was all me."

"Do you sell tricks?"

"More costumes and novelties."

"That's a great idea. You'll do amazing at Halloween."

"I know it. But, people need to dress up way more than Halloween, right? School plays, Santa costumes, St. Patrick's Day top hats, Easter bunnies...the list goes on forever. And it'll all be right there at Gags Unlimited. It may take some time, but my store is going to be huge."

"You sound like a guy with a really big vision," said Dean.

"I am. Even though I'm just starting out. I also really want to promote. I just need the talent. You look like you could be an entertainer, actually. You sing or something?"

"Not quite..."

Dean quickly became more interested in the monster than the girl. The party was packed, bodies pressed around them, but Dean and Kerry found a corner in the basement rec room, and as they chomped on Old Dutch barbeque chips, they found each other.

"...and I'm going to do everything Houdini did, to the letter. You're a business man, a young entrepreneur. I'd like your honest opinion. Do you think what I'm planning is as good an idea as I do?" Dean asked the Cookie Monster. "I think it's going to be big."

"Dude, are you kidding me? You are an insane genius! That's it. I want to be your manager. Sign me up right now. I am going to make you the biggest thing ever to come out of Manitoba. You're going to be bigger than the Guess Who!"

"You haven't even seen me do a trick!"

"I don't need to. There's plenty of time for that. But I get you, bro."

"You really want to be my *manager?*'

"I can't make it more clear than crystal. You're my dude!"

"Well....*all right!*"

They shook on it. Things were starting to cook. They met the next day in Kerry's basement. They sat on orange shag carpet, and Kerry lit up. Dean passed when offered. "Smoking's bad for you, man. Cause's cancer."

"You are so right," said Kerry. "But I cannot function without."

Dean wanted him functioning. He could hardly wait for someone to help guide his path and put some power behind his Houdini moves.

"Okay, we've got a strict hundred-dollar budget," said Kerry, lounging back on one elbow. "Which I will put up *myself*. Yeah, I know, it's not a problem. I consider it an investment. I'm going to get you a crowd, brother! We'll pack the streets like an olden time tickertape parade."

"I feel really strongly it should be free, right? That's how Houdini did it. He brought people entertainment for the sheer joy of it."

"Yeah for sure, 'cause if we pack 2,000 people onto a public street, how would we get the money anyway? We get your name out there; we make you a household name. We'll figure out how to get their money later." Kerry laughed maniacally, and calmed himself. "I'm enjoying this. You just make sure you make it out of that jacket without drilling headfirst into Carlton Street. I'll do the rest. Oh, one question. When do we do it?"

"Houdini did this escape here in 1923."

"That's the same year Babe Ruth had his best season."

"But Houdini did it in February."

"Oh man, February is way too cold. Guess they had more gumption in 1923."

"Halloween is also a very special date. It's the day Houdini died."

"Damn, he didn't die doing the escape, did he?"

"No, no. He was sucker punched. It happened in Montreal, a McGill University student named J. Gordon Whitehead. Houdini claimed he could withstand any blow, but the kid went at him like a maniac before he had a chance to prepare himself. He died

of peritonitis form a ruptured appendix on Halloween, 1926, at the age of fifty-two."

"Whoa, that's a bad stain on Canada, man. Killing Houdini. No one is ever going to forgive Canada that. Spooky, though. Okay, Halloween at lunchtime it is. I love it. Then everyone goes home that night and takes their kids out trick or treating and tells them if they want to grow up to be escape artists, they'll disown them."

On Halloween, 1982, Dean was ready for his first big escape.

He would be strung upside down straightjacketed, nine metres above ground, hanging from the Queen of Carlton Street, the old *Free Press* building. It was a daredevil's tribute to the hero who had carried him through his cancer treatments. He and his idol would have experienced the exact same thing.

Kerry was working his magic. Interest was growing. The press was calling. And Dean's mother wouldn't let him out the door.

"You are not doing this," said Beverly, blocking his exit from the house. He was going off to meet Kerry for a planning session.

"Mom, it's going to be fine."

"How can you know that? You have no idea if it's going to be fine."

Dean took her hand and led her into the sitting room with the closing door, the one he used to like to practise in when he was sick and first escaping. Bev folded her arms across her chest and crossed her right leg over her left, knotting her body up like a rope.

"You know how good I am escaping my straightjacket. Admit it."

"So. What of it?"

"I'll tell you a magician's secret. Escaping from a straightjacket upside down looks dramatic, but gravity makes the whole thing come off like it's been greased. I'm doing way less work than if I were performing the trick in the living room."

"You can't break your neck and crush your skull in the living room."

"Do you think Kerry or Dad would let me fall?"

"I don't expect anything from this Kerry, but your father helping you is just an insult to me as your mother. And it's giving us serious troubles as man and wife. Look at my face. See a face that's not kidding. I am not happy."

"Dad is supporting me in my vocation. You can't blame him for that, can you? I'm an escapist, Mom. It's what I do. It just looks dangerous for the crowd. I've got a secret fail safe. There's no conceivable way I can fall. It's safer than—"

"I did not see you through cancer—you had a twenty percent shot at life, remember—to see you throw your life away in return. Do you realize how lucky you were? Don't expect to live under my roof if you're going to play fast and loose with life."

"Come on Mom, it's going to be okay."

Dean put his arm around her and sat with her until she thawed and relaxed against him.

"You'll see," he told her, "I'll show you."

Kerry Hogan's publicity had worked its charm. The event's buzz had grown immense. About 3,500 people crammed in around the *Winnipeg Free Press* building on their downtown Winnipeg lunch hour. Beverly was not one of them.

Garry Gunnarson was Dean's assistant. By doing so, he and his wife were not on speaking terms. Garry took on the role in public that he'd been auditioning for in private for years. Kerry had a handy seamstress friend who'd fashioned a homemade executioner's mask out of black silk for Garry to wear as he tied up his son. They hadn't managed to have a real fitting, and it kept slipping down, obscuring his vision. A trembling Garry finally ripped it off and shoved it in his pocket.

"Have you forgotten anything?" he whispered to his son.

"Let's find out," said Dean with his perfect, comedic cadence. He had a glow about him that was more than his golden blond

hair in the sunlight. His face was transformed with a strange euphoria as his feet were bound by rope, and he was hoisted up three hundred feet, dangling over the crowd hanging by his ankles. His father swore his son wore a look that was rapture instead of stress or fear. The whole thing was much more smooth and natural than any of the team had anticipated.

Houdini was beside him, hanging upside down, his slicked back hair remarkably in place—but back in the '20s, men had industrial strength pomade.

"We all know you're good at getting out of a straightjacket," said Houdini.

"I've never practised doing it upside down though," said Dean.

"The upside down part is merely incidental," said Houdini. "It's your form, your *form* I'm here to coach you on."

And as it turned out, Houdini was right. The jacket was basically falling off him.

"Make it look harder!" Houdini chastened him. Dean did.

"And when," said Houdini, "when you're actually free of it, spread your arms open wide, with grace, like a dancer!"

Dean spread his arms.

"Wider, Dean—in victory!"

Dean stretched out and embraced the wind to wild applause from below. He had beat Houdini's time by twenty seconds. Did he spy his friend gazing on him with a touch of the jaundiced eye? Then Houdini was gone.

Dean gave his statement to the press. "I did it to honour a great man—a tribute to Harry Houdini, who died on October 31, 1926. He was the greatest showman who ever existed."

Maybe that would put it over a little better with Houdini. Even for their friendship, he wasn't a man to generously share the spotlight.

CHAPTER 5

Healthy and vigorously pursuing his ambitions, Dean never really left the cancer ward. Even with a clean bill of health at age eighteen, he spent his spare time performing magic shows for kids stuck in the hospital. In 1983, he was hired on for $4.25 an hour. His job was to entertain and visit sick kids. Never was there a part-time job more suited to a boy practising a trade. He sought out each child in their time of discomfort and unhappiness and spoke to them with an understanding which very few visitors could match. He had been right where they were lying, literally. And he had something more to offer than a friendly visit. He had the ability to take their minds off their troubles by astonishing them to the core.

A terrifying magic reigned on the kids' cancer ward: Life as the inhabitants had known it had disappeared in a puff of smoke, without a trace. Their families, who had learned the grim reality of childhood cancer mortality rates the way Dean and his parents had, were sick with worry. Relegated to their beds, it was a ward of kids living a punishment for bad behaviour when they'd done nothing wrong. Lying there feeling bad, looking at the dull yellow paint on the walls that was supposed to look cheerful but failed.

The smell of sickness and fear. This was their new home. Their own bedrooms jam-packed with their stuff, homes, friends from the neighbourhood, these were all jumbled into a foggy memory of normal life. Worst of all, they were unable to play. The kids were desperate for distraction. And then who should appear but the magic guy with the golden blond hair.

The magic tricks amazed. A lot of kids who Dean met on the cancer ward were inspired to become magicians, just like him. Naturally, they also wanted to amaze. When we see a trick well done, who doesn't want to be able to do it flawlessly as well? Some of those kids who were laid up had probably excelled at sports in the way Dean had, or in theatre or art. They all would have had a network of pals they played with, making new worlds together from their imaginations. Now they were weak and separated from their pack. They longed to belong again. And to engage people by something other than their illness.

There was something else to it. Maybe, just maybe, magic was real. To have a mastery of the seemingly impossible begs the question, can the magician key into more? Can a magician who really digs find something below far deeper than tricks? That was exactly what Dean wondered sometimes. And who more than sick kids in the hospital would want to find that place? To exist in and rule a world of magic.

Although the desire was powerful, the kids who wanted to learn magic never really followed through. The dazzle and thrill of seeing a coin go from the palm of your hand to appear out of your friend's ear was exactly the opposite feeling of the preparation for that trick. Tricks like that didn't come out of thin air. To do a magic trick well took practise. Repetition. Intense focus. Then the ability to self-critique and improve upon your mistakes. And again, practise. Repetition. Practise. Repetition. Not many kids made it that far. It's much more fun to watch magic than to learn it. Dean understood that.

And he loved all the kids he worked with. He saw himself in every one of them. He wanted to hold their hands and comfort them and tell them to have hope. He could never forget being the running boy, and how it felt to be ripped out of that world.

Once Philip Hornan's life had felt like it had no beginning or end, that it was all about cavorting under the big, moody prairie sky. There was family, friends, animals, and sweet country air. And abruptly, all that was over. He was ten and his right leg had been bugging him. First he found it hard to run. Then walking was irritating too. He could get around with a limp in the day, but everything was way worse at night. Sometimes he'd cry in bed from the ache. His mom hurried in at the sounds. It was uncharacteristic for him to cry. Philip was not one for complaints, never mind tears. She propped his leg high on pillows, she brought it low off the side of the bed, she applied heat, she applied cold. Nothing worked.

"Okay, we're going to the doctor first thing," Marilyn Hornan said.

"That's a bit drastic, Mom. It's really not that bad. I don't know why I let myself cry like that. It'll feel better tomorrow."

But it didn't.

At the doctor in Steinbach, she watched Phil strain to simply raise his leg. It was the most bewildering thing she'd ever seen, a ten-year-old who couldn't lift his leg. She half expected them to diagnose arthritis. But the X-rays were all clear. It was a puzzle.

Could it be growing pains? Her three older boys had never experienced anything remotely similar. Dr. Monson was stymied.

"Growing pains, Mrs. Hornan?"

"You're right. It's far-fetched. I'm just at a loss, doctor."

"I want you to go straight to Children's Hospital in Winnipeg. I see absolutely nothing amiss here, but I want them to look at this X-ray, too."

And again, the X-rays were studied. No—there was absolutely nothing there.

Or was there? Maybe the tiniest blip at the top of his hip. Size of a pinprick in the picture. Scant clue, but the only clue. There was naught else to go on. They did an immediate biopsy and found carcinoma. Given the news, Marilyn had the peculiar sensation of feeling the blood pumping through her body. She confessed it to her husband during their seemingly ceaseless stints in the waiting room.

"It's panic," explained her husband Gordon, clutching her hand.

"I know it," said Marilyn. "But I can't tune out the sensation. I hate it."

One comfort was, the doctors moved fast. On his eleventh birthday, a tiny portion of Phil's hip was removed. He started straight into chemo. The big, endless prairie sky fell out of view for everyone. The Hornans' former life as a family was dead.

When Gordon Hornan wasn't with Phil at the hospital, Marilyn Hornan was. Which meant Gordon was back in Giroux minding the three other boys and running the farm. It was always one or both of them driving in and out of Winnipeg. Overwrought, they came to hate and even fear the constant driving. What if one of them made a stupid mistake on the highway when they were tired? They lay in bed at night terrified of dying. Not for their own sakes—they had no thoughts about themselves at all anymore. It was their kids and only their kids they cared about. How would the family ever survive if they were gone?

Phil was lying in his hospital bed, blurry images from a dream swirling in his drugged mind. There he was driving the tractor and his dad's truck, though he really shouldn't have at his age, pranking his older brothers mercilessly, so gratifying to hear the older boys scream, and playing with his neighbours like Donna.

He chuckled to himself, what a fine time he had every single day out in Giroux. So what was that so incongruous agony swirling through him? He struggled to reign in his thoughts and come back to life in this new, strange place of pain. And why was he horizontal? He wasn't the kind of a boy to stay in bed. He liked to make plans and accomplish them. He struggled to sit up intermittently, but then he'd lie down again fast and almost like a faint, he'd fall straight to sleep. But Philip Hornan wasn't a boy to stay down for the count for long. His body was weakened but his spirit was strong.

One day early on in the chemo when Marilyn arrived at his hospital room, Phil had propped himself upright so he wouldn't drift off. He was waiting to speak to her on a pressing matter. Before she could even take her coat off, he launched in.

"Mom, I asked the doctors how much all the medications I'm taking cost. Do you have any idea how much money I'm taking up by being sick?"

"Honey, we're Canadian. We don't have to worry about that the way a lot of other people in the world do. We're very fortunate here."

"No, Mom, no, I am costing every single taxpayer their hard-earned money! I just feel sick about all the people going off to work at hard jobs, or jobs they don't like, and having to pay for my medicine when they could be buying stuff for themselves that *they* need."

"Phil, it doesn't work that way."

"Then how does it work?"

"I guess it *kind of* works that way," said Marilyn. She had to think about it. She hadn't deeply considered her medical benefits before. "But it's just like a half a penny per person if it's even that, and all those people *want* you to have the medicine. I promise you no one minds."

"I don't want to take anyone's money away from them."

Marilyn felt her eyes glazing with tears to see him sitting up covered by his hospital sheets, so thin, so anxious about inconveniencing the taxpayers. She moved to the window to gaze outside at the street until it passed. Phil didn't like to see her upset.

"I admit I've never thought too much about money," said the eleven-year-old Phil. "But I'm going to look into fundraising the cost of my medication. This is why they throw telethons and stuff."

"Okay, honey," she said, hoping to change the subject.

When she returned the next day, she'd forgotten his mission, but he hadn't. He had made his way slowly around the ward, asking the hospital staff about what people sold to fundraise. A few people told him they'd seen people sell pincushions.

"Mom, I have a job for you," he announced as she entered his room. Marilyn was enlisted to help him make the pincushions to sell. In theory, she was pleased. He'd been up and around, really pushing himself on this. She could see some of that old fire in Phil again. She hurried out to pick up the supplies, for he was ready to work. Fighting his lethargy, he'd wind yarn around sealers for hours on end while Marilyn made the centres. A good pincushion takes time. Marilyn's hands would be numb from the work.

"Mom, what's the best yarn colour for *this* pincushion?"

"Phil, I don't think I can make another centre for you. I'm pincushioned out."

"Red and green? Do you think Christmas colours work for a pincushion? Yes! People could buy it and save it as a Christmas present!"

"I've got to be honest—"

"Orange and blue is nice. Like a Giroux sunset. Would you buy an orange and blue pincushion?"

"Phil, in all honesty, I shudder at the thought of another pincushion coming into the world!"

"Mom," he said in a pointed whisper, and she looked up from her centre, leaning in. "The boy in the next bed? He has muscular dystrophy. I have more of a chance than he does. I'm lucky,

you know? I can still fight. It's going to be so worth it when we donate that money to the Cancer Society. Maybe for this one I'll pick red and blue yarn…"

Phil kept busy. He sold pincushions and hand-delivered the money to the Cancer Society as a donation. But not having any other crafts at his disposal, he became dispirited at the low projected financial return of the pincushion business. He began to feel tired again.

One day, a magic show was advertised. Phil had always loved magic and he had a friend from Giroux who did too. He hadn't thought about magic in what seemed like years. His heart beat rapidly with the joy of remembering. Fighting the strong desire to stay in bed and melt into unconsciousness, he shuffled down the hallway in his plaid slippers and plonked down in a chair near the nurses' station and asked to cross the street to the Manitoba Cancer Foundation. They got him there early, as he'd asked, so he could get a good place well in advance of showtime. A young guy who looked like a rock star came in with a suitcase of props and began setting up. Phil saw Dean Gunnarson for the first time.

The next time Phil met Dean, he wasn't performing a show. He was on the kids' cancer ward, and he'd been given a list of kids to visit by his direct boss. Dean tended to follow his own path though, and get caught up here and there with people he met. So he was late when he walked into the room he'd been assigned to, and now the doctors were in there, busy. So he backed up and out, and straight into twelve-year-old Philip Hornan's room. There was Phil tucked quietly into his bed, his dad Gordon sitting close by. Then he heard the bustle of the doctors across the hall leaving. Dean didn't want to get into trouble. For $4.25 an hour visiting sick kids, what could go wrong? A lot. His boss was new and she didn't seem to like him very much.

"Excuse me, I'm supposed to go over there," said Dean, backing out. "I'm really sorry to disturb you guys,"

"No, wait," said the man, wide-eyed. "Don't go! Please come back. I'm Gordon Hornan and this is Philip, my son."

The Hornan gentlemen couldn't have been more congenial. Though Phil was tired.

"I was nauseated a few minutes ago," said the boy. "They gave me something and I'm feeling better but I'm weak. But stay a minute if you can, please."

"Sure," said Dean. "Sorry you're feeling sick, Phil."

"You're the magician," said Gordon with reverence. "Now settle a matter for us, will you? Philip told me that you escaped from a straightjacket hanging upside down off the *Free Press* building last year. I told him he must be dreaming."

"No, that was me," said Dean. "I get into trouble like that sometimes."

"I told you, Dad," said the boy softly but excitedly. "It's him."

"So are you more of a magician or more of an escapist?" asked Gordon.

Dean had never been asked that before and he was glad to answer. He was thrilled to spend some time with a family that was interested in the difference.

"It's been great chatting with you, but I'd better go before my boss comes and gives me the hairy eyeball. See you," said Dean. "Hope you feel better really soon, Phil."

Phil, very pale, waved sadly.

But Gordon hurried after him and caught Dean in the hallway.

"Listen, my boy Phil has seen you perform and it's all he ever talks about. He's probably devastated, he feels so bad right now. Could you please visit him again? Maybe teach him a trick? I'm not kidding—all the boy talks about is your magic show."

Something about Gordon's polite, quiet manners made Dean suspect the Hornans weren't from around here. "Are you Winnipeggers, sir?"

"No, we're from Giroux. It's a lot of driving, and..." Gordon trailed off. Dean recognized the weariness and strain in Gordon's face, and the sympathy was instant. And Dean liked any kid who liked magic.

"I'd be happy to come back and talk to Phil about magic, teach him a few tricks, Mr. Hornan."

"When?" asked Gordon, like it really mattered. "Phil will want to know."

"Tomorrow."

"For sure?"

"I won't fail."

Dean came back the next day with a bag packed full of tricks to amuse the boy. Phil was lying flat out. His breathing was strained.

"Can I ask you for some help?" asked Phil.

"Sure, pal, anything," said Dean. "What do you need?"

"I'm weak, can you move closer?"

Dean sat down gently on the edge of the bed. "Sure, I'm right here."

"I just had surgery on my neck," said Phil, grasping weakly at a bandage around his throat, "and this bandage feels like it's cutting in to me."

"You want me to get the nurse?" asked Dean.

"No, watch."

Phil took the ends of the bandage, grabbed them firmly and then he pulled the bandage hard, *whoosh*, cutting straight through his neck. Well, *looking* as if it were cutting straight through his neck.

Dean jumped back. *"What the—!"*

"I know magic too," said Phil, sitting up, and spinning the bandage around in the air. "Hey, I really gotcha, didn't I?!"

"The old pulling-the-string-through-the-neck-trick," said Dean with a husky laugh. "That's ancient."

"Yeah, but I gotcha, I really gotcha," said Phil with near rapture.

"I just wasn't expecting it," said Dean combing his fingers through his feathered blond hair.

"I have a few tricks up my sleeve. Don't think we really introduced ourselves yesterday. I'm Philip Hornan. You're Dean Gunnarson, the magic guy. Thanks for coming back. I really wanted to talk to you about magic."

A couple years earlier at school, Philip had bought *The Great Houdini* published by Scholastic with the same yellow cover that Dean had. He'd read it over and over. He became entranced by Houdini. Even though the population of Giroux was so small its phone book was one page, it was home to more than one magic fan. There were two. Dan Borgman, an elderly gentleman, was a particular friend of Phil's. Dan would drive over to the Hornan home with his wife Gladys every few weeks for coffee and a visit. Inevitably Dan and Phil would disappear to Phil's room and the two would practise magic. Dan Borgman had taught Phil the pull-the-string-through-the-neck-trick, how to roll a coin across his knuckles and spin a mean pencil.

"It's all close-up magic," said Phil, going through his repertoire for Dean. "The way Houdini started."

"You have quite good technique," said Dean, who was now lying on Phil's bed, his head propped up by several pillows beside Phil's feet. He hadn't been expecting to be given a show. And he'd been up late the night before with a young lady, so was grateful for the rest.

"Yes, Mr. Borgman is a really good teacher," said Phil. "He says technique is everything."

When Phil had finished performing, he lay back against his pillows and looked at Dean.

"You look tired," said Phil.

"Late night," said Dean. "You know girls."

"I've only got a bunch of brothers," said Phil. "Well, my mom's a girl. And there's my next door neighbour Donna. But she's more like a friend than a girl."

"Take your time with them. They'll still be there when you're ready," said Dean with a wink. "I notice you didn't show me any card tricks. Let's start there. I'm going to teach you a simple I-know-your-card trick, so you can pretend to be psychic. The psychic act is so important if you want to do magic. Ready?"

Dean taught Phil how to make it seem like he was reading minds. Then he helped him finesse his make-a-coin-appear-from-anywhere. They discussed the principles of how-to-draw-a-silk-out-of-your-mouth-for-miles. All the kids on the ward loved magic. But to Dean, Phil was different somehow. A deadly serious scholarly attitude like guys Dean knew at school who wanted to always get A-plus.

The boys naturally stopped working after a while and relaxed back on Phil's bed talking about Houdini.

"That's one thing I miss about regular life. I could talk about Houdini with Mr. Borgman. But people aren't really interested in talking about Houdini around here."

"I could talk about Houdini all day," said Dean.

"I could talk about Houdini all week," said Phil.

"I don't think I'll ever be tired of talking about Houdini," said Dean. "In my whole lifetime."

They didn't know it then, but a lifelong friendship was born.

"I better get back to work before my supervisor walks by," said Dean. "That'd be bad. Getting fired from the kids' cancer ward."

"That *would* be embarrassing," said Phil. "Come back as soon as you can."

CHAPTER 6

"You came back," said Phil.

"Didn't I say I would?" asked Dean.

"Yeah...you did."

"So why are you surprised I'm here?" Dean sat down on the edge of the hospital bed, slinging his bag beside Phil's feet.

"I've had a few friends come and visit and they never came back. Some kids who I expected to see never came at all." Phil surprised himself, saying these things he'd only kept on the fringes of his heart.

"Yeah, same thing happened to me when I had cancer."

"*You had cancer too?*"

"Didn't you know? I thought they would've told everybody. But I've been hanging around here so long they're probably sick of me. I wasn't in this room, but I was in a few different rooms for sure, right down this hallway. It's much brighter here now. It was pretty depressing back then."

"What happened to your friends when you were sick?"

"My school friends? I lost them," said Dean. "I was alone."

Dean pulled a silver dollar out of his bag and rolled it smoothly over his knuckles. Phil watched it roll back and forth along his hand like it was alive.

"You do that way smoother than I do," said Phil.

"It just takes practice. Here, you do it now."

Dean handed Phil a silver dollar, and he began to roll it over his knuckles as well.

"Tell me about your friends," said Phil.

"Every single friend of mine I lost. It's hard to understand now, but you should feel sorry for *them*. They have no idea what you're going through. They see you look way different than you did before. They don't recognize you. They get scared."

Phil stopped rolling his coin, and tossed it onto the bed sheet. "That's a stupid way to think," said Phil with an anger that surprised him. "Obviously it's still me."

"No it's not," said Dean. "Watch."

Dean let his coin drop into his palm and he squeezed it so hard his hand trembled. He opened his hand fully, and the coin was gone.

"I didn't see you transfer that," said Phil. "But I know how you did it."

"I know you do. And you've disappeared to everyone the same way. They don't know where Phil is. But you and I know the secret, don't we?" Dean continued, pulling the coin slowly from Phil's ear. "You've been right here in front of them, all along."

Phil picked up his coin again and looked at it.

"Don't be mad at them for not getting the trick, Phil. Not everyone can be a magician. Keep this coin—and practise the art of re-appearance."

Phil began talking about Dean non-stop, the way he used to talk about Houdini back home with Mr. Borgman. Phil came to life again. And with that, everything in life related to Dean. Dean

became the sun to Phil. There was some parental worry, naturally. Phil's parents were used to Phil's friendships with older people. He always got along with people, all people. But Dean looked like he lived in the fast lane, and Phil was only twelve. Dean was kind, but at eighteen, did he really feel the friendship as strongly as Phil?

How happy Phil was, though. Gordon and Marilyn decided that perhaps they should let the relationship play out and hope for the best. They liked watching Phil practise magic. He was getting really good. And it was a great relief for Marilyn, who tried never to think about pincushions again.

Magic suited Phil's attention to detail, which was intense. It wasn't a well-known Hornan trait, especially in his brothers. He liked things to go smoothly, and be well ordered. He enjoyed the rigour and repetition of rehearsal. Most of all, he loved to astonish people. Before Dean, his performances were devious tricks played on his older brothers. Phil would plan a prank down to the move. He could lie patiently in wait for hours for the perfect moment to grab a brother's ankle from under their bed and make him scream. He would do anything for the big payoff. But magic gave more back.

Phil performed his tricks with pure joy. He and Dean delved into magic history together, and Phil spoke with ever-deepening respect for the art. He was steeped in magic. Sometimes he needed some special item for the trick he was practising. Toad Hall Toys had opened in 1977, taking its name from *The Wind in the Willows* by Kenneth Grahame. The place was styled after an old country dry goods store, with dark polished wood and fine glass display cases. Treasures waited in every nook and cranny. This magical place had a dedicated area for magicians. At the magic counter, people of all ages would go and discuss tricks.

Toad Hall was also one of the groundbreakers, moving in to what was then a rough area of the city rampant with drugs and

prostitution. So when Phil needed something from Toad Hall and asked his mom to pick it up, Marilyn would steel herself. The walk wasn't a long one from the Health Science Centre down to Toad Hall. But for a woman used to the simplicity of Giroux, she was half-holding her breath and looking over her shoulder. The doctors told Marilyn and Gordon privately, "He's sick, but as much as you want to, you must not spoil him. You're going to want to hand him everything he asks for. Don't. Treat him like the rest of your sons. If Phil makes it through this and you've given him everything, you'll have ruined him. Treat him normally, all the way." And so they followed instruction. They did not treat him like he was different than before.

Going down to Toad Hall to buy a ball or a silk couldn't be called spoiling the boy. But the chance of getting mugged or accosted was real back then. So to do something that Marilyn felt was dangerous was like secretly giving Phil more than she was. How she wanted to spoil her boy and shower him with every gift she could to make him feel better. But she didn't want to do wrong by Phil. Holding the faith that he would survive this ordeal was paramount. She needed to believe the day when Phil was just as healthy as her boys Michael, Robert and Darrell was on the horizon. She wouldn't spoil Phil, but she could give him magic. So much had been taken from him already.

It was a Monday and Dean arrived to Phil's room, full of stories to share about his weekend escapades. He looked '80s chic in a tight jean tuxedo. He was feeling so good he felt his health pulse through his veins. He never took that for granted, ever. His smile disappeared. Phil didn't sit up.

"What's wrong?" asked Dean, instantly sweating. In that moment he felt how much he relied on Phil to be there waiting for him.

"Dean, I appreciate all the tricks you've taught me," he said horizontally. "But now can you tell me about escape? I want to know everything."

Dean kept sweating but now for another reason. He'd hoped his misdirection—emphasizing Phil's success with hand magic—would simply eliminate escape from the menu. Some days, Phil's hand magic presented beautifully. Other times, Phil was so weak and puffy from the chemo, his movements weren't always so precise. Dean desperately didn't want Phil to do something he'd fail at. He found the nerve to say the words he'd been rehearsing in his head just in case.

"Escape is hard, Phil."

"I know."

"You have to be strong. Really strong sometimes."

"Sometimes I don't feel weak at all."

"Today you do. I can tell."

"Of course I do," he said, still lying flat out looking at the ceiling instead of Dean. "The cancer is spreading again and they have to do another surgery. Most of the rest of my hip is going to have to go, and my shoulder near the lungs. So I guess I'll limp pretty bad."

"I'm sorry," said Dean.

"It's okay. It'll just take me a few hours or so to get used to the idea. But I need to say to you, the tricks you've been showing me are great." Phil raised himself to his elbow and stared at Dean. "Don't get me wrong. But I had an idea that maybe... Forget it." Phil slumped back down and folded his arms over his chest like a mummy.

Dean was still reeling with the news of the surgery and all that implied. His throat was thick and sore with fear. But he knew he had to be brave for his friend. "Go on, say what's on your mind."

Still not looking at Dean, Phil said, "I thought if someone believed enough, believed for real, they could find true magic.

You know, not card tricks. But *real* magic. Maybe you think I've gone crazy..."

But the crazy thing was, this sick twelve-year-old kid had said the very thing Dean had felt ever since he'd started practising magic. That maybe if he worked hard enough, and believed in magic with all of his pure heart, he too could find real magic.

Dean lay down on Phil's hospital bed, his feet beside Phil's head. Phil raised his head for a moment.

"Now you look weak," said Phil.

"Well, of course I am," said Dean.

"Why do you say 'of course I am'? No! I don't want you feeling sorry for me. I still have a fighting chance."

"It's not that. It's because I never had a friend like you before. We think the same. I think real magic may actually exist. Somewhere, somehow."

"But how do we find it?" asked Phil.

"I'm not certain. But I think maybe the key is...to believe with a pure heart."

"Sounds like Linus in the pumpkin patch waiting for the Great Pumpkin. But you know what? I'm always on Linus's side."

"Me too," said Dean.

"Does that mean you'll teach me escape?" asked Phil.

"I'll tell you what. I'm preparing to do a big, big escape. If you aren't scared off by what I do, and what happens, then I'll teach you about escape. Fair?"

"You're on! Is it anything like the straightjacket escape at the *Free Press* building?"

"I'm serious, Phil. There'll be nothing like it ever seen. Houdini didn't even try this."

"Can I help you plan it? Assist you?"

"I've got a safety advisor and assistant already. Better known as my dad and my cousin. You just concentrate on resting up and

doing what the doctors tell you. After you see the escape, we'll see what you say about escape then."

"I already know what I'll say," said Phil. "But I'll wait."

Dean's dad, Garry Gunnarson, had been promoted to Dean's sole voluntary safety advisor and assistant. They sat together in Garry's garage workshop, feet up on a crate, on a warm June afternoon. Dean had a hot cup of green tea, Garry sipped on a cold beer.

"This Halloween..." said Dean. "I've been thinking."

"You want me to build you something," said Garry. "Could tell by the look in your eyes. Scribbling in your little notebook. Whenever you draw in your notebook, Loree says, 'Look out, here comes trouble'."

"We've got to top last year's escape, Dad."

"Yup, knew that was coming."

"People are going to expect something bigger, more thrilling, more life threatening." said Dean, his voice climbing the summit.

"There's just one thing."

"What?" asked Dean.

"Your mother isn't going to like it."

With a groan, Dean stood up and peered at their house through the garage window. The family home was looking smaller and smaller to him.

"When I plan something, I'm thinking of thousands of people—not just one. I want to be the Everyman. People *need* to see me escape so they know that when disaster strikes in their life, they can escape, too. Mom may not like it, but she's got to face the fact that I'm an entertainer."

"Good luck with that," said Garry. "So, you want to hang from something higher than the *Free Press* building? The Richardson Building, maybe? The Trizec?"

"Would *you* have a problem with that?"

"Nope," said Garry, taking a sip of beer. "I like this escape stuff."

"Why can't Mom be more like you?"

Garry shrugged. "Everybody's different."

Dean turned his back on the window, and his eyes narrowed. He wasn't looking at his dad. He was seeing an escape being played out before his eyes.

"I'm thinking the opposite of high this year. Not up in the sky, but under the water."

"That'd be pretty cold on October 31st," said Garry with an involuntary shiver.

"That's why you're my safety advisor, Dad! But I've thought of that already."

"Okay."

Dean began to pace the cement floor of the garage. He kicked at the scattered oil stains with his shoes, as if he could eliminate them.

"The cold is going to figure into my training. Here's what I want to do: Go off the end of the Alexander Docks. Me: chained, locked, nailed into a coffin; the coffin wrapped in chains and locked. Then submerged in the Red River."

"If Houdini did it, I guess you'll do it too."

"But Houdini never dared this."

"Whoa, there, son…"

Dean felt a shiver himself and turned quickly toward the garage window. He could just discern a man in a dark suit walking past. He ran his hands through his hair restlessly. He hadn't seen Houdini in a month. It made him nervous.

"I can't always be copying. I have to break away and be unique to make my own mark. Maybe this one can get me worldwide notice."

"I guess that makes sense," said Garry, taking a few gulps in a row.

"You're okay with this?" Dean was surprised by his prickly tone. But he was more surprised by the way his dad paused lingeringly before answering.

"As long as you know what you're doing," said Garry slowly. "Swear."

"I do Dad, I really do."

Garry finished his beer, crushed the can, and tossed it across the room into the metal garbage can.

"Where do you want me to start?"

"Here," said Dean, passing his black notebook to Garry. "Check out these eight drawings. My design for the coffin. Can you make it for me?"

Garry slowly turned the pages, examining the sketches. Dean hovered over his shoulder, pointing excitedly. "It'll be hard—but I'll find a way," said Garry.

The men went directly to the periphery of the double garage, where Garry stored extra lumber and other extra bits that he figured might come in handy some day—with a son like Dean.

"Here, help me hoist these pieces," said Garry.

When Dean left the barn, his dad had begun work on his son's coffin. He called back from the door, "Can I take the truck, Dad?"

"Help yourself. It's out front."

"Thanks, Dad. Thanks for believing in me."

Approaching the truck, Dean's spine went cold. He knew exactly what was going to happen next, just by the sound of the car in the distance. He decided not to run.

Beverly pulled up behind the truck in her little red beater.

"Hey, what a surprise, Mom," said Dean with a sweet smile.

"Is that why you held your little planning session, you didn't think I'd be around?" she said, slipping off her seat belt and standing to face Dean. "Where are you off to? Work, girl or magic?"

"A little bit of all of them, I guess," he smiled. She wasn't swayed by his charm.

"Got your driver's license yet?"

"No, but it doesn't make me drive any better." People always laughed at that line. She really wasn't swayed.

"I heard through the family grapevine you and your dad were having a 'meeting'. I don't get to see you much, so I figured an ambush was the best way to speak with you."

"Who told you? Loree or Todd?"

She lifted her chin a little higher. "I have ears. What are you discussing with your father? We may be divorcing, but you're my son so this *is* my business."

He sighed. Might as well get it over with. The hot prairie wind ruffled their hair and shirts.

"We're just planning our second Halloween escape."

"I was really, really hoping you'd do something different this year. What about my idea of a big magic show for the neighbourhood kids at the community centre?"

"We've got to do an escape, Mom, you know that."

"What kind of escape, then?" she asked, putting her hands on her hips.

Of all the mother-son moments of conflict over the years, Dean registered these words were the most fearsome to say to her: "It'll be underwater, escape-from-a-coffin escape."

She turned her face straight into the wind, away from him for a moment. He was afraid she was going to cry. She didn't let herself.

"No...no..." she said softly. Her eyes wide, Bev turned to him. "*What did your dad say about all this?*"

"Calm down, Mom, he's got no objections. He thinks I should follow my dreams. He's building the coffin right now. There are a few rigs to it. It's a failsafe. There's no way on earth it can fail. It's going to be okay."

"Right," she said, breaking into a run across the lawn toward the back. The wind blew her blond hair straight up like she'd had an electrical shock. She swung back as she ran, "I don't know what to say to you anymore. But I know what I'm going to say to your father."

"Mom, I know what I'm doing!"

"No. You don't. If you do this escape, I'm done."

She disappeared into the back and out of sight.

CHAPTER 7

Later that day, Dean was told he had to vacate the family home. He packed his khaki duffle bag full of clothes and magic books and moved in with his grandmother, Dorothy Chivers, who had once taken in Bev, Garry and baby Dean before their big Texas move. Her support for Dean's chosen vocation had made sparks fly between mother and daughter too many times. He was sorry for feeding their conflict, but when you are fighting to fulfill your calling you have to surround yourself with support. Plus, he was a broke, like his folks had been many years before.

Dean persuaded his girlfriend Lori's dad to let him prepare for the underwater escape in her family's icy-cold, leaf-filled backyard pool. It really should have been drained by October—but they held off to assist Dean. The women he liked usually had finely chiselled features and blond hair, much like his mom when she was young. And the similarity didn't really end there.

"Ugh! That is way too cold! You'll go into cardiac arrest!" Lori said, shaking the water from her hand and shoving it under her arm for instant warmth.

"If escape were easy, everybody would be doing it," said Dean.

"I have a hard time believing that," she said. "Even if it were easy, I'd still be watching you thinking you're nuts."

Unlike his usual practice spot—the bathtub—her family pool was chilly and murky.

"This couldn't be more perfect. It's just like the Red is going to be!" said Dean.

"First time I've heard a pool full of slimy leaves is perfect."

"First time you've dated an escapist," he said with all his charm. It didn't work.

"Dean, don't. It's too cold!"

"This is what escapists do," he said. He lowered himself into the pool and, taking a huge breath, submerged. His long blond hair floated tremulously with the leaves. She was timing him. After one minute he shot upwards, his fair skin blue. "Arrrrgh!"

"Now I'm really worried," she said. "I was holding my breath along with you, and I was fine! If that's the best you've got, you're in trouble."

"It's way harder to hold your breath when it's cold," he hollered from the pool. "Give me a hand!"

She helped pull him out, and he hugged her to him, the lovers falling back onto the cement in what might look like an embrace.

"You're getting me all wet!" cried Lori.

"Warm me!" he hollered. "I'm freezing to death!"

"What did I tell you? And it's only going to get more brutal by Halloween. Are you supposed to escape, or freeze into an ice cube? 'Cause if you do that, everybody's going to be wanting to do it."

"Okay, okay," he panted, holding her tighter. "Point taken."

Dean convinced Bryant Stevens, his new manager, to rent a royal blue wetsuit from 3 Fathoms Scuba.

"Whoa, dude. That blows our hundred-dollar budget right there," said Bryant grudgingly, pushing his credit card across the

counter to the clerk. It had been difficult to leave Kerry, but Dean thought his new manager would be an upgrade in professionalism and vision. But Bryant sounded more and more like Kerry all the time. And Bryant didn't have a Cookie Monster costume.

"Poor you, Bryant," said Lori. "Why don't you just consider it a good investment if Dean lives?"

"Your girlfriend is pretty funny," said Bryant with a thinly disguised sneer.

"I could be Dean's manager too," she said. "Look how this beautiful blue colour sets off his hair. All the girls' hearts will go pitter patter when he leaps out of the coffin. This wetsuit is good for business in every way."

"Hey, you think I don't know that? Why do you think I'm paying the piper?"

Dean and Lori returned to the pool that day. Her dad accompanied them, putting his arm around his daughter's waist and pulling her close. The two shivered in unison.

"Helluva odd hobby, Dean," he said.

"He'll have handcuffs and locks and chains, too, on the day," Lori said. Although her tone was trying to impress her dad, her scowl betrayed her true feelings.

"Good lord, that's not a day at the beach," he said.

They stood together watching the telltale patch of floating blond hair until Dean popped up again, gasping for air.

"How did it feel this time?" she asked.

"Like being wrapped in a flannel blanket."

"Really?" asked Lori's father. "It's that effective?"

"No, not really," said Dean. "But it's way better, and a bit of extra warmth buys me more time down there."

The father cleared his throat. "Uh, novice question?"

"Yes, sir?"

"If the escape involves handcuffs and chains and all, shouldn't you be practising with them now?"

"Oh, no, that's the easy part. I'm a genius at getting out of all kinds of binds."

Dean went under again. Lori's father pulled her close. The chill that day was brutal. He wasn't pleased about this current escapist boyfriend.

"You wouldn't ever try anything like this yourself, would you?" he asked her.

"No way, Dad. I know it's strange. But he's really different, you know?"

"I know, honey," said her dad, remembering what it was like to be very young.

Dean was tired of the skeptical looks he kept getting from older people, though he was far too wise a youth to let them know it. He didn't remember this many naysayers for the escape of last year. Why? Perhaps he had told fewer people. That must be it. What really bugged him was Houdini's absence. Where was he when he was needed? The hell with it, Dean would tick off the boxes on his own. As always, he could rely on his strength, skill, and overflowing teen testosterone to make the escape. He made the escape last year, and he'd do it again this year. Who would need more prep than that for an underwater coffin escape? He didn't need to hang upside down to get out of a straightjacket, did he? He was set.

It was three weeks before the escape, and Dorothy Chivers's phone rang.

"Dean! Glad I caught you. It's your uncle Brian. Thought it was time we did some catching up. You're a growing young man. Buy you lunch?"

Beverly's brother, Brian Chivers, suggested lunch at the Paddock restaurant on Portage Avenue. The Paddock was a family favourite. Dorothy was the bartender, a job she'd keep until she was sixty-five, and all of the servers in the restaurant were older

women. It was a Winnipeg landmark. Kids got to pick a treasure out of the treasure chest at the cash register when they were leaving. But Dean had grown out of childish treasures. He was going to take what he wanted. He was noticing that his attitude didn't have many fans. He had a suspicion about what was coming.

They both ordered the beef dip.

"Okay Dean," said Brian, the same high, handsome cheekbones as Beverley. "This isn't exactly an innocent lunch. I'm here on behalf of everyone in the family."

"Except Dad," said Dean.

"Yes, except your dad."

"And Grandma," said Dean.

Both men turned and waved to Dorothy, her little grey-blond head bobbing behind the bar.

"Don't do this escape, Dean." Brian leaned in, his big hands folding together over his napkin and cutlery. His shining black hair was the exact opposite of the fair Dorothy and Dean's. He spoke with a persuasive, smooth voice. "You were lucky with the straightjacket last year. I'm happy you did so well with it, but it was pure fluke you survived, and you did not make things easy in this family. Okay, you did it, it's done. But this coffin-in-the-water thing is just plain scary, and you're not properly prepared for something like this."

Now it was Dean's turn to lean forward, and he was luminous with his enthusiasm. "Uncle Brian, I've been training for this for years. I'm not a kid! I can hold my breath as long as Houdini could. Do you understand what that means? Dad is building me a coffin with a custom designed-by-me fail-safe—though I'm telling you that on your honour, never breathe a word of that to a soul. I'm going to have that patented sometime soon. As well, I've got a wetsuit to protect me from the cold. I'm going to do this and it's going to be bigger than Houdini!"

At the mention of Houdini's name, Dean scanned the restaurant patrons for his friend. It would be just like him to be off in a dark corner, smirking at him, or giving him a nod. No such luck.

"I can't help but think of the Titanic when you say 'fail-safe'," said Brian. "Everybody called the Titanic 'unsinkable'."

"My coffin *will* sink—that's the point!"

"You're not listening to me."

"You're not listening to me either. I know everybody cares, and I appreciate it, but I'll be fine. Don't worry. I've planned everything right down to the moment."

"You can't plan something like this! There's so much that could go wrong," Brian said, slamming his hand on the table for emphasis. "You're being reckless and you're destroying your mother in the process."

"I love Mom, but she's got to understand I'm an escape artist. I can't be anything other than what I am."

"Dean, you just can't do this. I won't be there if you do it. None of us will. I won't watch you die."

"I've already looked death in the face, Uncle Brian. I survived cancer. Death and I eyed each other up. I got away once. What death doesn't know now—my specialty is escape."

"Just a lot of words, Dean."

Grandmother Dorothy left the bar for a moment to visit their table.

"So lovely to see you two here," she said with her characteristic warmth.

"Our conversation did not have the desired effect," said Brian, pushing his plate away, unable to finish his lunch. "You've always been such an outspoken lady, Dorothy. You can guess what we're talking about. Care to weigh in?"

"On my little housemate?" Dorothy smiled and stroked Dean's fair, silky hair. "He was the most beautiful baby I've ever seen.

Look at that smile. I love to see him happy. Everybody should follow their dreams."

"Okay," said Brian. "I've got one more thing to say. Dean, you're nineteen, you think you've got all the answers and nobody can tell you anything. But you're about to learn the lesson of your life. I hope you survive it."

Dorothy walked away before he was done. Dean was wolfing down his uncle's remaining sandwich. Brian felt like he was shouting into the wind.

Dean slept off and on the night of the 30th. For all that, he woke up feeling well. He swung out the front door to grab the newspaper from the mailbox for Dorothy and got blasted with wet sleet. Halloween 1983, in Winnipeg: Pity the trick-or-treaters. They would be shivering, for certain. But would they cover their costumes with parkas or raincoats? One never knew from year to year. You couldn't tell anything about how the day would go yet, except the water would be cold enough to turn your skin blue.

Father, son, and promoter had rented a crane with a cherry picker bucket to lower the coffin down into the water.

"My budget!" moaned Bryant, tearing his long hair with his hands. "It's shooting into the stratosphere."

Bryant's publicity savvy and word of mouth had more than doubled the previous year's attendance. Again, the men weren't charging a dime for the entertainment. The way they'd planned it, this was the last big investment in Dean's reputation. Over ten thousand people gathered along the banks of the Red River at the Alexander docks. Other than Garry, Dean's family—mother Bev, sister Loree, brother Todd—were not among the crowd. There was only a smattering of cousins. Dorothy smiled and kissed him when he left her house, but there was no way she could watch this escape. In fact, she'd requested to be put on shift that day.

She needed to keep her mind off things. Dean's girlfriend didn't show either.

The wind blowing off the water howled words into Dean's ears. He didn't understand their meaning, but they felt ominous. He waved to the crowd. One last chance to see if his most special friend had shown up. Dark suit, dark hair, dark eyes. Houdini. He should be there. But there was no sign of him. Odd he couldn't imagine Houdini anymore. Why?

"Lie down," Garry said nervously.

"Not quite yet, Dad," said Dean.

Four assistants chained him around his wrists and ankles. He looked so dashing, it was a shame to box him up. But down he went. Dean settled back in his narrow homemade coffin. Had Houdini been there and he'd just missed him? Garry Gunnarson pounded the nails into the coffin lid with a hammer, wrapped the whole box in chains and locked them. He was working double-time. Garry then heaved himself up into the cherry picker, turned the ignition on, and it roared with a pitiless power. The crane began to lift. Dean had already escaped the handcuffs before the coffin was off the ground. The coffin lifted and was up and out over the Red River. Cinder blocks hanging from the four corners of the coffin (so it would sink and sink levelly) dangled insubstantially in the raw October wind, like fruit on a branch in the breeze. If Dean had practised the complete escape even once, he would have known the cinder blocks weren't nearly enough.

It was showtime.

His father let the coffin drop. Dean had a good idea of how long it would take to for the coffin to make contact with the Red, and his instincts were right. At the correct moment, Dean emptied his lungs with all his force, and then filled them to capacity as Houdini always did in water escapes. The coffin hit the water with an earthquake jolt. The back of Dean's head cracked against

the wood. Water rushed in from all angles from the pre-drilled holes, from unseeable inky corners. Disorientation was immediate. Dean didn't know if he was up or down, but then he perceived the coffin wasn't sinking as planned. It lay stubbornly on an angle, ¾ submerged with an air pocket all around his head like a halo. This was unexpected, but could afford him another huge breath. It would buy him extra time. He decided to steal some air.

Again Dean pushed out his air with brute force so he could get the big breath in.

That's when the coffin went down like it had taken a knockout punch. Submerged. No air to take in. All that breath-holding practise in vain.

His thought was—now I've done it.

For an escape artist, there's only one way to die.

Regular folk, if they're inclined to worry about death, might consider all the dangers waiting to claim them: car accident, plane crash, heart attack. There's something waiting at every corner. But a good escapist doesn't think like that. He knows if he miscalculates the timing of that last crucial breath in an underwater coffin escape, the way to die is not drowning.

The way to die is calmly.

Relax. Slow your pounding heart rate down, and let the fear go—like bathwater swirling down the drain. Welcome the water into your lungs to fill you like a vessel. And go into the light without hesitation—the light that sucks you in and shoots you out of the world like riding the Mega Drop at the Ex on a Saturday afternoon—the big drop. Without end.

Dean Gunnarson understood how to die.

He pushed his consciousness away and went into a meditative state.

He knew he would be pulled up in two minutes. That was the agreement. If he hadn't surfaced by the two-minute mark, his father would raise the coffin. Only two minutes. He could hold

his breath for over twice that in the warmth. In the cold, he could make two minutes for sure.

He waited and counted to himself. One minute. One-thirty. One forty-five. Two minutes. No one was pulling him up. Two-fifteen. Two-thirty. His lungs were bursting. Okay, something had gone wrong above ground. Slightly wrong. But nothing could go too wrong. There'd be no conceivable reason not to pull him up. Yes, he was going to drown, he knew that, but his rescue was imminent. He was back in the cancer ward taking a shot to the spine. Take the pain. Don't show fear. He knew how to do that. Time to let go. When it's time, it's time.

So Dean let everything go. Water filled him up. There was the corridor, and there was the light at the end and he fairly flew toward it, little legs pumping. A little blond boy, running through the tall grass, cold wind ruffling his fair hair. He checked back over his shoulder. He hoped a friend was coming to run with him. But no, he was alone under an immeasurable, blue sky, so alone his heart hurt for the lack of people. The wind grew stronger. His feet lifted off the ground, he felt his soul fly. He opened his arms wide, with a flourish like an old friend had once taught him, and his soul was sucked into a vacuum stream. It was glorious, but he missed the feel of the ground under his feet. Maybe only another minute of flight, maybe... Or maybe more. Maybe he'd fly forever. His last thought before everything went black was *I'm flying—God help me.*

Above, on dry land, twelve-year-old Philip Hornan had elbowed his way to the very front of the crowd with his father, Gordon. Philip always wore his beloved Casio digital watch. Big digital watches were very cool in 1983. Philip used that watch regularly for a very important reason—to know when he needed to take his meds. But this time he was checking the seconds for his new

friend. Few people in the thrill-seeking crowd would imagine that the man in the coffin and the little ill-looking pale boy had met in the cancer ward, and that they practised magic together.

Philip had a gut feeling Dean had been down there way too long.

By his calculations, from what he knew about Houdini, Dean should have broken the surface already. He told his dad, "Something's wrong."

"He must know what he's doing," said Mr. Hornan. "You wouldn't try something like that and not know what you're doing." But Gordon Hornan was feeling short of breath and panicky. And helpless.

There was nothing to be done but watch and wait. Dean would be hauled up soon.

Bryant was on the stopwatch. He called it to Garry. "Two minutes! Pull it up—*now!*"

Garry Gunnarson tugged the ropes and heaved the coffin up, water spewing from the gaps in the oblong box.

But then he quickly lowered the coffin back underwater again. The crowd collectively gasped.

It was a confusing move. Since when do escapists go back in?

What the crowd didn't know was that Garry Gunnarson had seen Dean gesture to him from the coffin, saw him point down as if to say, *Put me back under—I want the chance to do the trick right. Give me more time.*

And Garry had complied.

But the coffin was made completely of wood. He could not have seen Dean. Garry had had a vision.

It's hard to resist holding your breath along with an escapist who goes underwater. I'd guess the whole audience there tried, for a time. But at three minutes and forty-seven seconds, everyone above ground would be breathing again. And agitated. This escape? It wasn't fun.

"Hey," someone shouted out. "I bet he was never even in the coffin in the first place!"

The crowd lost its focus and began looking left and right in anticipation of Dean's big re-appearance.

"I don't get it," another shouted out. This was nothing like last year's straightjacket performance.

Philip tugged at his father's sleeve in a panic, insisting he do something. Phil's Casio watch began beeping incessantly. Time for meds. Your time is up.

"Dad! Dad! He must be dying!"

"I know, Phil!" cried Gordon. "I'm scared too."

They clenched one another's hands.

That's when Garry Gunnarson hauled Dean up for the second time. By then, his son was dead.

CHAPTER 8

Bryant had had a last minute thought that Halloween morning of the escape.

"A team of paramedics," he'd said, snapping his fingers. "That's what we should line up! You just never know, eh?"

And a team of Winnipeg paramedics was standing by. Dean's assistants rushed in and unlocked the chains that wrapped the coffin even as it was being lowered onto the dock. The lid was pried off in a heartbeat. Dean's eyes were open. He had been looking fully on the light before he'd left his body. The paramedics hoisted Dean's limp body out and onto a stretcher. His face was the only flesh not covered by the wetsuit. It was blue with purple patches. An oxygen mask was pressed hard onto his face. The paramedics wheeled him swiftly down the centre of a parted sea of thousands of onlookers.

But Dean was not there. He had no name. He was running up a beam of cold light. How he could run so fast without feeling any traction he did not understand, but he'd never moved faster. It was almost like flight and so eerily cold, bright and beautiful Then with a jolt he dropped down a few inches, and his feet made

brief purchase with something solid. Now this felt normal, right. It felt like home. He almost remembered his name. Give a boy a small foothold. He pumped his legs backwards and reversed into darkness. His legs became instantly weary—how far had he run? He needed to lie down for an immediate rest. He took form again in his body in the damp. He felt slimed and helpless as a baby with a sticky, wet afterbirth. He had a name. Dean.

He dimly became aware of quick forward motion, and the ambulance siren. He was in the heaviest fog of waking sleep, when you can't even open your eyelids but you are all the time becoming aware. He knew something had gone wrong. He'd bungled the escape...somehow. Uncle Brian would be so pissed off. His mom was going to kill him. His overwhelming worry was the present destination. He'd heard the Concordia Hospital wasn't so good. He wanted to go to the place that was familiar—the Health Sciences Centre, where he'd had his cancer treatment. It was his second home.

"Where're you taking me?" he said softly, the first words of his second life.

No one answered. Was he really there?

He repeated, finding a stronger voice. "Where are you taking me?"

"To the Health Science Centre," said the paramedic.

Relieved, Dean passed out.

His life made a jump cut to the emergency room, lying flat out on a table and shivering with icy cold. Noises and voices from every angle.

"Nurse."

"Yes, doctor?"

"Cut off the wetsuit."

She moved in, and a glint of light from shears blinded him. Unseeing, he heaved himself up and took a lazy swing to ward her off.

Dean thought he was saying, "We'll never be able to afford to replace this wetsuit if you cut it off me! Do you realize how low our budget is?" but what the health care workers heard was urgent but indistinct mumbling. He knew his best bet was to assist. Struggling to pull down the top part of the suit, he passed out again. Escapists know the secret: It's harder to get out of a soaking wet wetsuit than a straightjacket.

The health professionals worked their magic while the day turned to Halloween night and little children dressed as phantoms walked through the street, howling for tricks.

Dean's dad and his sister visited him in hospital. He was bundled up in blankets and looking absolutely normal, except a robust red to his cheeks. Garry and Loree, however, were both pale and shaken.

"Hey, you guys! Smile! It's all okay now. Come on, lighten up."

Loree leaned against the wall and cried with ragged abandon, and Garry sat heavily and hung his head. Dean was sure Garry was hiding his tears.

"Hey, you'd think this was a funeral. I lived, remember?"

Their throats thick and aching with emotion, they couldn't respond.

"Dad, I want you to know that you were only doing what I asked you to. You were supporting me in my dream. This is not your fault. I brought it all on, and I take responsibility. Loree, make sure everyone knows that, please. Now come on you guys! Aren't you supposed to be cheering *me* up?"

Grief hung on Garry and his sister Loree and weighed them down. They didn't snap out of it during that visit, and Dean couldn't quite grasp why.

"Can someone at least smile?" he asked, as they grimly filed out.

"Someday you'll see the video footage," said Loree turning back. "Sorry. I love you. I'm glad you're alive. But I just don't feel like smiling."

When they left, Dean got up for a wander down the hospital corridor. And fell down.

"Mr. Gunnarson! Haven't you had enough excitement for the day? Back to bed please!"

Dean looked left and right. "Oh, when you said *Mr.* I thought you meant my dad."

The orderlies helped him into a wheelchair and lifted him back into bed.

"Hey, could you do me a favour? I really, really need to make a call, but I don't have any change."

"You'll be wanting your mother, I'm sure," said the matronly looking nurse, and with a wink she added. "And maybe a girlfriend. We can roll a phone in for you. But then I insist you sleep."

"Yes, ma'am. Uh, it's long distance."

"Yes, it's fine."

The person Dean chose to call was Philip Hornan in Giroux.

"Dad! Mom! It's Dean!" A kerfuffle of screams and hoots thundered in the background at the Hornans'. "You're alive! You're made it!"

"Now that's just the kind of reaction I've been wanting to hear today!" he laughed, relaxing and feeling warm again. "Phil, it was insane! I don't remember much, but I've still got so much to tell you!"

"You looked dead when they pulled you out of the coffin. We heard on the news you were dead! But then later, we heard you were alive. We weren't sure what to think, but I just *knew* you were okay. I sensed it."

"I've scared you off from escapes now, haven't I?"

"Are you crazy? This proves to me we should work together. If you'd let me help you plan, I bet I could've helped."

"I can't believe you said that!" said Dean, surprised, impressed. "You're not scared off?"

"No," said Phil. "Has it scared you off escape?"

"That's the weird part. What happened to me down there...I discovered something. I was born to be an escape artist. I know this is my real calling."

"I'm glad you're alive, Dean."

"Thanks. Hey, me too. But I want us both to learn from this, Phil. If we're going to train together, we have to train hard and well...this is why you have to be careful when you do escapes."

"Do you know what you could've done better?" asked Phil.

"Yeah...a bit. I want to see the video footage. But some stuff now for sure. I can hardly wait to see you. We've got so much to discuss."

After Dean hung up he was slammed by exhaustion, and he diligently did as he'd been told and slept like the dead till dawn.

The police had confiscated everything used in the escape, because if events had gone the other way, it would have been a crime scene. Later, when word spread that Dean had survived, a reporter asked a police officer who'd investigated the scene if they thought Dean had suffered any brain damage during the escape. The officer replied, "He's got no more than he had before."

His mother Bev had begun her own ritual at the moment she knew Dean was beginning his escape. She and Dean were barely speaking, but she had a network of friends who kept her abreast of what her first son was doing. Whenever he did something dangerous, she began meditating. It was a state that some might call prayer. She had rented a small house in Winnipeg and lived alone. She'd leave her place and take a long, slow walk to her best friend's house. That Halloween day when she arrived, her friend had been listening to proceedings on the radio. She said, "Bev—they've just taken him out of the river. It's not good." The women held each other while waiting for updates on the radio.

Dean was anxiously awaiting discharge November 1, as early as allowed. He had got a call from his girlfriend and Bryant, and

the press were all lining up for interviews. He could hardly wait to share what he'd learned.

As Bev entered his room, he was fidgeting on the edge of the bed. The doctor had said he'd be right back a half hour ago, and Dean was expecting him.

He looked up, startled. "Mom!" Then he couldn't speak.

"Hello, Dean."

"Hi."

"I just wanted to look into your eyes. I love you."

"I love you, too."

"Are you going to keep doing escapes?"

"Yes. I was born for this, Mom."

Beverly looked stricken. She walked out.

Dean remembered Houdini hadn't made an appearance. He sagged on the edge of the bed. What was the matter with his mind, that he couldn't summon the creatures of his own imagination? Was he losing touch with himself? But then the doctor came in to discharge him, and Dean got revved up. He had places to be.

Dean hurried home to his grandmother's house, showered, donned the white tux he'd rented from Malabar's which flattered his blond hair. Within twenty-four hours of his death, he was down at the Alexander Docks making statements to the press.

Dean's father never helped him with an escape again.

CHAPTER 9

In the months after the underwater coffin debacle, Dean pulled back on his public performances. Took a hiatus from escape. Instead, he turned to Philip Hornan for understanding. And for an appreciation of magic, the safer cousin of escape. Together, the two boys essentially disappeared. They spent most of 1984 immersed in magic, talking and practising tricks and sleights of hand. That's all they did. Even though Dean was taking first year studies at the University of Winnipeg, he wasn't the most ardent student. Dean did have his girlfriends. Being in their company was wonderful, but compared to magic they were minor distractions. Phil was in and out of hospital, his parents working hard to keep him at home in Giroux whenever possible. But oftentimes, he had to stay on the ward. He had a few favourite nurses.

Sylvana was the one he chose to ask to cut his hair when he relapsed. His hair had a nasty habit of falling out when he least expected. Phil was an easy-going guy, but the thing he couldn't abide was clumps of hair falling into his food. "Nothing can put a guy off his dinner faster," said Phil to his mother Marilyn.

Sylvana, the nurse, was in the room and overheard. "You know," she said shyly, realizing she was listening in on a private conversation. "I've cut the hair of a couple friends of mine."

Sylvana asked Marilyn's permission, and when it was granted, she got a little artistic, and gave Phil an Iroquois cut. She was reliable with the scissors and enjoyed the job. She kept his hair trimmed for months. It was something he could rely on. And then one day he realized he hadn't seen her in awhile. Phil heard her name spoken from the hallway. He asked other nurses, and yes, she was not sick, she was on the ward. His hair was growing in unruly spurts. He asked that people please give her the message that he'd like to see her again. It was time for his haircut. Yet she didn't come. Maybe, he figured, he'd taken her help for granted. Maybe she hadn't enjoyed the ritual as he though she had. So he asked people to please give her the message she didn't have to cut his hair if she didn't want to. He just wanted to see her and say hello. But Sylvana didn't come back. Couldn't come back. Everyone knew Phil wasn't doing well. And she liked Phil too much. Why did good things have to come to an end?

Phil liked one of Dean's girlfriends quite a lot. He deemed her to be far superior to the other young women he'd meet with Dean.

"She's okay," Phil would say about anyone other than the one. "But she's not the best one. You know who I mean. If I were you, I would never break up with her." Despite their seven-year age difference, Phil was quick with his reviews of Dean's girlfriends. And his opinions were always mature and well thought out. Sometimes Dean thought Phil was the same age as he was, sometimes older.

Dean shrugged and smiled. "It's called dating, Phil. I'm not ready for marriage."

"Why not?" asked Phil. "My mom and dad have a good time."

Phil and Dean were as close as a couple could be, though. The magic circle the boys had created around themselves was sacred and impenetrable. And the Hornans didn't lose a son, they gained one. Dean would hang out in Phil's hospital room when he was there having chemo. Marilyn would occasionally allow herself to go and have a coffee and cigarette outside, knowing Phil was completely engrossed in magic.

"Mom, if you're going out to smoke a cigarette, I wish you wouldn't," Phil would call out when Marilyn didn't even think he'd seen her pick up her handbag.

"I'm giving them up. Tomorrow. You guys carry on making your magic."

Dean and Phil were a team. Dean would follow the family back to Giroux when Phil could be home. Gordon was a skilled woodworker, and for the first time in his life, he began making strange, non-functional contraptions. Creations custom-made for the boys, boxes with tricks to them, whose only reason for existence was to amaze. Gordon had to admit, he was having fun hanging out with his magic twins, as he called them. Gordon started to have magic on the brain, too. He'd dream of strange transformations and miracles. He made to order whatever the boys needed and started to get some of his own funny ideas that he puttered away on. It was a good distraction from disease. Gordon thought about magic even when he was exhausted by driving and worry. And then the family caught a break.

In May of 1984, Ronald McDonald House opened up just down from Children's Hospital. It was built for people exactly like Marilyn and Gordon. Families who were commuting from out of town for their child to get cancer treatment now had a homey place to go to at the end of the day to cook their supper, rest, or sleep.

"Man, my mom and dad would have loved this place," said Dean, beaming. "It's getting better for kids, now, Phil. It's another reason to hope."

Free respite rather than making a dangerous drive back home while you were tired, or spending ever-dwindling funds on food and a hotel. Maybe the best part was, you could talk to other families who knew exactly what you were going through. You'd make friends. Someone would bring you a cup of tea when you just couldn't do it for yourself. You could hold a person's hand when they needed it. Sometimes you'd just listen. Sometimes you'd go to each other's children's funerals.

When Phil was staying on the cancer ward, he too was reaching out to others to make life away from home more bearable. He'd put on mini-magic shows for kids, and visit them one-on-one as if he were the healthy one. He'd go to other wards and introduce himself. He loved to feed babies their bottles.

More often than not, 1984 was the year of Dean appearing at the Hornan dining table.

"Can we squeeze one more in?" shouted Gordon from the living room.

"Dean Gunnarson, in like a dirty shirt," Marilyn hollered back.

One more setting was prepared as the aroma proved too irresistible and everyone found their seats. Big, delicious home-made meals served in Corningware, tinkling sounds of serving spoons against glass. Food made with love and thought, food to nurture and heal. The loud voices of all the men and boys chattering, broken up by the lone female voice. Roars of laughter around their meal table. Gordon could always be counted on for jokes.

"The patient says, doctor, I have a ringing in my ears. The doctor says, don't answer!"

Dean had started breeding pigeons and doves for their tricks out at his dad's place, who now lived alone near Riding Mountain. Occasionally one would fly through the lively chaos of the Hornan home looking for a bite to eat as well. Not even a bird would go hungry. After they wolfed down their food, Dean

and Phil couldn't wait to get back to their work. And Phil was fighting the disease. Every moment of practice was an investment in his future, every discussion about escape was proof that one could thwart a captor. Just as Dean had when he was taking treatment, they started small. Handcuffs, locks and chains, and ropes. They went meticulously discussed the rest of Houdini's repertoire: straightjackets, the sealed milk can, the Chinese water torture.

"Would you really do the Chinese water torture?" asked Phil.

"Absolutely. It's foolproof. Kind of. Just the underwater coffin escape...I guess I'll give that one a rest for awhile."

They weren't the only people in Manitoba who were breathing magic. There was a man who the boys didn't know yet, but needed to know. This man most emphatically did not want to know Dean Gunnarson.

In 1941, Bill Brace joined the RCMP. He was eighteen and the job was a family legacy. His father had been a Chief of Police before him. At that time, married men would not be hired. And if you wished to tie the knot after you were on the force, you were required to give ten years of service first before you were allowed. By the time Bill was ready to wed, the rules had relaxed somewhat. Unlike his dad, he only had to have worked for five years to be allowed to marry Margaret.

Back then, cultural diversity in the workplace was not a priority. RCMP officers were male, caucasian, and of a certain age, height, and weight. Looking big and rugged was a boon. You also had to come equipped with an amorphous thing they termed "fine moral character." What that meant precisely was largely unspoken. But Bill Brace had just what they were looking for.

He was a big man with a straightforward manner. On the job, intimidation was sometimes half the battle, and Bill could look as tough as he needed to be. In those days, officers might deal out their own, unofficial justice. In a small town, the RCMP

was deeply woven in the fabric of the community. They knew a lot about what was going on behind closed doors. If you were a resident thought of as trouble and you stepped over the unseen line, you'd likely find yourself walking that long, cold, "starlight tour" home, a non-sanctioned police practice of driving an undesirable person outside of town, beating them up, and letting them walk home in the cold. These were outlaw times. Officers followed their instincts and did what they felt to be right. Bill's outlaw sense was mainly channeled into his profound empathy for kids. He was known for sizing up people very fast, and he had good instincts. It was those instincts that drew him to the force. On the job, he used his innate sense to keep the peace. With all young people, even troubled ones, ones who *were* trouble, his instinct screamed *potential*. He was born with an affinity for youth. He'd do anything he could to reach kids and communicate with them.

Bill worked as a Dog Master for the force. That mostly entailed sniffing out lost kids and illegal moonshine. Because he even towered over most adults he was glad of the dog. Big Bill ceased to be imposing to kids with a furry friend between them. And after awhile, when the kids got to know Bill better, he didn't need the dog to break down barriers.

Bill thought a lot about that, how situations were softened by having a good dog at his side. The dog was so important to his main objective: getting kids on the path to being good citizens. The life of an RCMP officer would be improved tremendously by heading off crime before it happened. How else could he reach kids, he wondered? If dogs could break down barriers, there was another sure thing. He was a sucker for magic tricks, always had been. His friend and fellow RCMP man "Tiny" Cavell knew some tricks, and when Bill watched him perform at the station he felt pure childish joy. Bill asked Tiny to teach him what he knew, and the big bruiser of an officer gave it a shot.

Bill did youth outreach in schools for the RCMP with his dog, and that's where he gave his first official little show. His instincts were right yet again. He was a hit. So this red coat-clad RCMP man began to sell his official message of good behaviour by grabbing kids' attention with magic. Between the dog and the magic, Bill became immensely popular wherever he went. That reinforcement served to redouble his resolve. He practised over and over, learning new tricks and perfecting his moves with coins, cards and silks in the small detachment office. At times his audience was only a lone prisoner locked up in the single cell. Bill Brace could always be counted upon to give a good show for guilty and innocent alike. After all, to Bill Brace, the guilty were only people who hadn't yet found redemption.

Magic spread joy. The more joy he saw in his audiences, the more his love for magic grew. Sometimes he dreamed of being a professional magician, though he knew it wasn't in the cards for him. He was a rural family man with a growing household. And the actual performing part wasn't what moved him exactly. He knew the element that brought the magic to him was the communion with kids.

He worked harder. Bill taught himself everything possible from the few library books he could get his hands on. He ordered tricks via mail order. He worked at them diligently. Some tricks were easier than others to figure out.

"If I could just get someone to tell me what to do with my fingers!" he'd cry out, his huge, mitt-sized hands fumbling to make a rose appear out of nothing.

It was so much easier when Tiny was around and worked things through with him, watching and giving feedback. It was instantaneously clear that mentoring was the way to learn. He wished there was a place he could meet other magicians and learn.

Bill and Margaret Brace had four children of their own, and they fostered and adopted as well. They were a couple who had

an unending well of love and energy. Margaret Brace was no less a force than Bill. Reaching a career pinnacle of head nurse at the Grace Hospital, she was still the kind of grandmother who kids remembered always being there, who they could hardly wait to visit. She baked the cinnamon buns that ruin any other cinnamon buns for a lifetime. Margaret Brace brought her own brand of magic. Bill's magic was more literal. And he needed to find his path.

He retired from the RCMP when he was stationed in Winnipeg in 1964, so they decided to put down their anchor and stay. The idle life was not for him. He facilitated horseback riding for disabled children, and performed hundreds of free magic shows at schools, youth centres and seniors' homes. Though he was no longer an officer, he was always ruled by his moral sense and outspoken about right and wrong. Bill was never afraid to make someone angry with his opinion. He argued vehemently in defense of the first RCMP officer who fought to wear a turban on duty. He didn't care if his stance was unpopular as long as he thought it right. Baltej Singh Dhillon observed his religion and wore a beard and turban on duty. He was a hero to Bill Brace, a man who spoke up for his beliefs. Because that had been his question. How could he reach young people, help them to have a voice, so when the day came that they too needed to speak out they could do it? It was the early '80s when Bill finally asked himself the question that had been just on the edge of his consciousness his whole life: How can I reach the greatest number of kids and somehow impart to them the confidence to speak out?

Performing magic was a trick within a trick: Because it was fun, magic could make a shy child stand up boldly front of people and talk. The answer had been right there hiding in plain view all along. Magic, of course.

With that understanding, Bill's life finally found its greatest purpose. In 1982, he founded the Society of Young Magicians.

He was its first director in Canada, appointed by the Society of American Magicians. He held the position for fifteen years. SAM was a mighty force for magicians, the organization of which Houdini was the first and longest running president up until his death. The very first meeting of SYM took place in Bill and Margaret's St. James apartment. It consisted of Bill, his grandson Cary, and a single little girl. Fueled by Kool-Aid, cookies and magic, the group was small but mighty. The three couldn't wait to meet again. Word spread and the group swiftly swelled to fifteen at the next meeting. Bill Brace excelled at recruiting young members. What he was giving away was simple and free: Under the leadership of an adult magician, the kids shared new magic tricks they'd learned on their own. They did so up on their feet, practising in front of the whole group. And they talked about magic. The news was, they were developing their public speaking skills. Of course, the kids didn't know that part. They just thought they were having the time of their lives.

Bill was also good at getting adult magicians to run their own clubs too. At one time, there were more registered members and chapters of the Society of Young Magicians in Manitoba than any other place in the world because of Bill. He also started a magic festival at the Unicity Mall called "International Magic Week," which at the time was the largest of its kind in the world. There were competitions, free stage shows, info booths, roaming magicians and workshops. Bill Brace created a culture of magic for youth in Winnipeg.

In 1983, the ranks of young magicians were growing steadily under his directorship. What they could accomplish for magic in Winnipeg was an undiscovered country. So it was a special, much anticipated Halloween day when Bill and his young grandson Cary got together in Bill's living room to watch the television. They were geared to catch the hot young magician

Dean Gunnarson perform his Houdini-inspired underwater coffin escape. Bill was curious about this young Houdini wanna-be. He was press savvy. He could bring province-wide attention to his club and build their profile instantly. Dean could be a guest speaker at multiple clubs and attract a lot of new members. Escape had only been touched upon in SYM meetings because of Houdini, naturally. Dean had a real insight into this offshoot of magic.

But when they saw the lifeless Dean lifted out soaking wet from the coffin and rushed away by ambulance, Bill had to turn off the television. Then he grabbed his grandson's hand and crouched his towering frame low so he could look in the boy's eyes. He said to Cary sharply, "This is exactly what you must never do. That kid is a hot dog. A showboat. And if he lives—and I pray he lives—he will live to be a flash in the pan. Never, never be a hot dog. Don't be a fool like Dean Gunnarson. Keep away from escape, stick to hand magic."

Ideas for a magical union dispersed like confetti blowing down a deserted street after a parade. Dean Gunnarson was the last person Bill wanted influencing kids.

Bill Brace's SYM groups sprung up all over Winnipeg, and Dean and Phil were performing at small rec room parties, honing their skills and gaining performance experience. Word was spreading that they were great magicians. They were so young, and so impressive. The magic scene was flourishing. Young people were approaching them to talk about magic. Sometimes their names came up at meetings.

"Can we bring Dean Gunnarson to speak? The escapist?"

When Bill didn't respond, they went on.

"He's our age, and he works with another kid, too, named Phil. My cousin saw them perform at a party. He said they were amazing."

Bill Brace shook his head, "No." He didn't know much about this Phil kid, but Dean Gunnarson, no, he would not be a guest speaker. Not on his watch. He didn't want Dean to inspire any kid to be foolhardy.

But Bill couldn't stop the kids talking. They wanted to be just like Dean.

One of those young people happened to be Donna, Phil's next-door neighbour. She'd always been a fixture in Phil's life, flying across the prairies playing with Phil and his brothers, her long blond hair the colour of the sun. She liked to watch them do tricks and chat. Phil and Dean always had time to share encouragement, teach Donna a trick, but they were an established team. No one could join. Once, when Donna had headed home after learning a new trick, Phil asked, "Do you like her?"

"Me? Whaddya mean? *Like* like? What makes you ask that?" asked Dean.

"I've seen you notice her."

"I haven't noticed her. Not that way."

"I'm not sure I believe you," said Phil.

"Look, Phil, she's cute but trust me—if you want to be cool, you won't ever be seen with a fourteen-year-old."

"Whatever you say, Dean," said Phil.

But Phil knew the art of misdirection by now.

CHAPTER 10

Phil roared his brother Rob's motorcycle down the gravel road from the Hornan house to visit his brother Michael at his farm whenever he could. It was a short trip, but the ride was like a powerful daydream. He was speeding away from everything bad. Mike was now starting his own family, but he kept near. Even though Phil was too young to get his license, that had never stopped him driving. He was just like every other country kid. And as Phil always joked, you don't need a license to drive. He got that from Dean. That was, until he got caught.

"I can take this bike away from you, young man," said the RCMP officer. "You know that, don't you?"

"I'm sorry, officer. I would've driven it down in the ravine to keep out of the way of traffic, but it's full of boulders."

"You still don't have a license. That counts in the ravine, too."

"I get your point, but I was driving nice and slow, and only on the edge of the road. You have to admit that."

"Son, you need a license to drive this motorcycle. Do you need me to spell it out?"

Phil didn't tell the officer what was really on his mind. That driving the motorcycle to visit his brother was one of the most powerful ways he still had to cheer his spirits. But his mother Marilyn knew.

"No, no, no! What'll we do about this?" she asked. "You need to drive that motorcycle."

"I don't know," said Phil, pondering. "If it were my motorcycle, I might even risk the chance that they wouldn't catch me twice. But it's not mine. They could impound it, and then Rob would kill me. But... They wouldn't be prepared for a kid as young as me to give them a run for their money."

A horrible scenario flashed across Marilyn's mind, of Phil in a high speed chase with the RCMP to protect Rob's bike. "Phil! I know you're sick, but we still obey the law for goodness sake! Let's see what we can figure out—within the law."

She drove down to the Steinbach RCMP detachment the next day and took a private meeting with the staff sergeant at his desk. Behind him, there was locked wooden gun cabinet that Marilyn would never have imagined her son would have anything to do with. But in the near future, he would.

"My fourteen-year-old boy got a warning from one of your officers yesterday about riding without a license," she said. Her voice was strong, confident. Her request was eminently reasonable. "But I want my boy Phil to be given permission to drive a mile down our road by motorcycle to visit his brother's place, please and thank you."

"He's too young for a license, Mrs. Hornan. And too young to drive that motorcycle," said the sergeant, leaning back in his chair with a slight smile. "Tell the boy to relax. Only two more years."

"You don't understand Sergeant, he may not have one year left. Phil's got cancer and visiting his brother by motorcycle just makes his day. It's too far for him to walk. Riding a pedal bike would be way too hard on him on gravel. He just loves that motorcycle."

The sergeant straightened up. "I'm very sorry to hear he's sick, ma'am."

"Thank you. Now could you okay him riding a motorcycle?"

"Thing is, I don't have the authority to do that. I wish I did, but it's all about the insurance."

"Officer, it's one of the few things he's..." Frustration surged through her. She stopped and took a deep breath, trying to focus her thoughts so she wouldn't lose the strength of her position.

"Officer, I'm his mother, and I want this to happen. This is not a rocket to Mars. This is not brain surgery. Why should riding a motorcycle one mile down a gravel road be difficult?"

"If I were to make a suggestion," said the sergeant gently, "maybe if you let him drive it nice and slow and you followed him in your vehicle with the blinkers on, that might appease the officers."

Marilyn sputtered. "What—*every time?!*"

"I thought you meant he wanted to drive there once!"

"No," said Marilyn shaking her head. "He could drive over there twice a day on that motorcycle. It makes him feel like a normal boy. Can't he get a special early license or *something*?"

Would it make her weak or unkind, in his eyes, to tell him she desperately needed Phil to get away from the house, too? His small moments of autonomy gave her a break to pretend she had her old life again. A regular mother, with healthy kids away at school, coming home at 3:30 for a snack while she prepared supper.

"I *have* heard something of early licenses in Alberta. I recommend you bring your case to the insurance people. There may be a special dispensation. I wish I had to power to help you myself, Mrs. Hornan. It's just out of our scope."

Marilyn left the detachment office and stood on the stairs looking out at the prairie. The hot, dusty wind choked her and made her eyes run. Once, a long time ago, her days had a variety

of ups and downs. But everything now was so hard. She found a tissue in her purse and wiped her eyes. If that was the way it was going to be, fine. She'd fight back just as hard. All the way. Because Phil needed her more than ever.

She made an appointment at the Steinbach branch of Manitoba Public Insurance. She met the manager in his office and sitting across from his wide wooden desk, and spoke her piece.

"The answer is no," he said, after he'd paused in a way that made Marilyn hope he'd say yes. "I have no power to grant him a license. He simply cannot get coverage. He's too young."

Speaking of too young, Marilyn thought he was an awfully young fellow for an office and a big MPI desk. He was probably as old as her eldest. She had a fleeting sense by the look in his eyes he might have a younger brother. But still, the rules were the rules.

"Well, I guess that's it, then." She stood up and slung her handbag over her shoulder. "Thank you for your time."

"Wait," he said, standing too. He was tall and his suit, though decent, looked ill-suited to him.

"Yes?"

"I'd really like to meet this young man. He sounds like the kind of person I'd like to know. Could you set up a lunch meeting for us, say Friday? I could explain the situation to him myself."

"I could do that," said Marilyn, her heart soaring. "But...why would you do that?"

"I don't know...but he might appreciate it," said the MPI man with a slight blush.

"I know he would," said Marilyn. "And I'd appreciate it, too."

If you can count on anything at all in small-town Manitoba, it's the choice between Chicken Chef and a Chinese food restaurant. So if you know the area around Giroux, you'd probably guess that the lunch meeting took place at the Chicken Chef because with two hungry young men, there's a better chance of getting fries. Marilyn dropped Phil off and the two were

on their own. Afterwards, Phil reported an excellent lunch and conversation.

"What did he say?" asked Marilyn.

"Oh, some stuff."

"Can you be any more...specific?"

"About what, Mom?"

"Did he have any insider insight into your problem?"

"Could do...could do..."

"Could do? What does that mean?"

"A magician never tells his secrets, Mom," said Phil.

Phil went right on with visiting his brother down the road by motorcycle. And no one ever bothered him about it again. That was his life, thundering around on two wheels under the big prairie sky, practising magic, and taking chemo. He was happy, in a way. While not full of hope, he still hoped.

In 1985, the Rainbow Society approached the Hornans to make a wish. The Rainbow Society was founded in 1983 to fund once-in-a-lifetime dreams for Manitoba children with life-threatening illnesses. The child and family could take a brief moment in time to forget the hard stuff and simply be together and enjoy watching the child's greatest wish come true. This was difficult for the Hornan family. In a way it was an acknowledgement that this could be Phil's last request. The Hornans pushed that part out of their consciousness. They were not quitters. They would never give up the fight for Phil.

Phil puzzled for a few days to himself. What would he choose, of all things? He honed it down. The boys had got Gordon to hog-tie them to practise escaping from bindings, and they were straining and sweating at their ropes.

"If you could pick, who would you go see? Doug Henning or David Copperfield?" Phil asked Dean, rolling on the living room carpet, panting.

"Doug Henning without a doubt," said Dean with a grunt. "He's one of us. A Winnipegger! And Copperfield is about making magic sexy. Snooze. But Henning is a true original. He's all about the magic."

The boys beat their best time slipping out of their bindings. They had been escaping very well indeed. Philip, Marilyn and Gordon packed their bags and said goodbye to Giroux for L.A.

They were off to see the hottest magician on the earth.

Doug Henning was a glittering, spandex-clad hippy, with a massive fuzzy moustache. Slight and buoyant, he leapt about the stage like a kid. Despite the elfish appearance and the childlike wonderment he brought to his shows, Philip and Dean, whose style was more muscular and direct, had a lot in common with Doug Henning. They were all three Manitoba boys who began practising magic young, honing their craft at birthday parties. They were all galvanized by the audience reaction to their performances, and driven to obsessively advance their craft. And all three of them believed that beyond the tricks, beyond the flash, real magic actually existed. Doug Henning had a lot of backup for this theory that magic was real. His life was charmed by magical success. Despite his hippy persona, Doug Henning's drive and ambition were immense.

Henning the teenager taught himself as much magic as he could. He performed his first show at fourteen. He would do magic in any space, at any party. Moving from small-town Manitoba to small-town Ontario, some young magicians might have been happy enough to practise in the basement and getting small gigs. But not Henning. He was a small-town boy with a world view.

Magic was his religion, and magic history was his bible. Reading from it daily gave him the perspective to see his place in the continuum of magicians. He learned from history; advanced

study was paramount for him to improve his skills. He needed a mentor. Although still a teen, his will was indomitable. He got a small Canada Council grant and used it to further his experimentation in a dramatic way. He blasted out of his town and went to the source. His mentor was in Los Angeles, a Canadian named Dai Vernon.

Vernon was one of the world's best. He had performed his first trick at age seven and told the *Yale Herald* that he'd "wasted the first six years" of his life. He had extensive technique and knowledge which had garnered him the nickname "The Professor." In fact, he'd shown Houdini a card trick that had left him befuddled. Vernon then promoted himself as "The Man Who Fooled Houdini." Houdini would have hated that.

Vernon is credited for changing the "pick a card" trick to "think of a card," making the effect specifically about mind reading. He was a game changer, like Henning was to be. His love wasn't performing, though, it was magic as an art form. Dai Vernon had mentored many, many magicians. His calling was to teach young people. He took young Doug Henning under his estimable wing.

Henning learned fast. After months working closely with Vernon, his first impulse was to go to Vegas and try to break in to the big time. He was itching to put it all together, but the fact was, he was still a teen. Dai Vernon knew how truly unique this Canadian kid was. Too unique to do what was already being done in Vegas. With Vernon's encouragement to stay true to himself and not follow the well-worn path, Henning returned to Canada and began working on a play. It's wasn't a modest piece. There wasn't a name for what he was doing because he was making it all up as he went along. It was nothing less than Doug Henning's imagination brought to life.

He designed his show to bring magic out of the realm of birthday parties and to take Vegas into high theatrical art. It was also

a vehicle for him to act in the lead role. Called *Spellbound*, the play featured magic illusions, all devised by Henning, woven into the narrative. Being welcomed by, and working with Dai Vernon, had taught him many arcane sleight-of-hand illusions with cards, coins and rings, and deep magic theory. It also taught him to aim high and aim to work with the best. He turned to his equally driven young college pal Ivan Reitman, now known for his big Hollywood blockbusters like *Ghostbusters*, to produce it. The script was written by a young filmmaker, with whom Reitman and Iain Ewing had founded the Toronto Film Co-op—David Cronenberg. The music was by Howard Shore, who went on to score *The Lord of the Rings* and *The Hobbit* trilogies.

The play debuted in Toronto in 1973 starring Henning and Jennifer Dale. It was such a smash success, breaking box office records, Reitman took the show to its next stop—Broadway. The book, score, and cast were replaced, but Doug and his magic effects stayed the same. It opened as *The Magic Show* in 1974, when Doug Henning was only twenty-six. The show was one of Broadway's longest running musicals, selling out for four and a half years. Doug Henning is credited for transforming the Broadway musical by infusing it with Las Vegas spectacle. He revolutionized not only the magic show, but Broadway itself. Magicians like David Copperfield laud Henning for paving the way for the blockbuster magic show, which they in turn emulated. Many brilliant careers arose because of Doug Henning's ingenious conception of a magic show.

After Broadway came prime-time television. Henning was also heavily influenced by Houdini, and he proposed to NBC that he reproduce Houdini's original water torture escape. Doug too was following in Houdini's footsteps, just like Dean. Doug Henning had over fifty million television viewers for the first broadcast of NBC's *World of Magic*. Six more NBC specials followed, jam-packed with appearances by celebrities of the day.

At the end of the program, Doug would always say, "Anything the mind can conceive is possible. Nothing is impossible. All you have to do is look within, and you can realize your fondest dreams. I would like to wish each one of you all of life's wonders and a joyful age of enlightenment." This notion of making what the mind conceives real was just what Dean and Philip felt to be true. And Doug's success was the proof. Not bad for a boy from Winnipeg.

As happy as Dean was for Philip to go to meet Henning, it was hard to be the partner in crime left behind. How Dean wanted to meet Doug, too! Doug, the man who followed in Houdini's footsteps and became a great success. Dean wondered if Doug had ever *really* walked with Houdini, the way he had. He wondered if Doug still saw Houdini. He'd like him to pass on a message.

But Philip was instructed to call daily and tell Dean every detail. Marilyn, Gordon, and Phil took their very first trip out of Canada. They went straight to Los Angeles. In 1985, Henning was at the top of his field. He was a household name, everyone knew Henning and his satin rainbow style. And no one could put on a bigger magic show. Henning *was* magic in '85. The Rainbow Society arranged with Doug Henning for a rare and exclusive tour of Henning's Santa Monica warehouse where he stored every prop and trick for his massive shows and rare pieces from his private magic collection.

The Hornans' fascination outweighed their nerves. Shown into Doug's luxurious office by an assistant, they sat to wait. Marilyn absentmindedly stroked the soft, rich upholstery.

"I don't want to blink. This office is so beautiful," she said. "It's like an art gallery."

"We sure aren't in Giroux anymore," said Gordon.

And in he bounced—for gravity didn't seem to have a hold of Doug Henning the way it did everybody else. He was a diminutive

man, but he radiated vitality. His long hair was lustrous, his two-piece satin sweatsuit a cascading rainbow of shades of red.

"Welcome, Hornans all! So happy you could make it down to my place. It's a long trip for you. Where is that place you come from again? Giroux. Sounds very exotic! How was your trip?"

He sat crossed-legged on a chair, a very odd thing Marilyn had never seen someone do before, and they all exchanged pleasantries until Doug hopped up and declared, "Let's begin the tour."

Everyone stood, and Doug instantly clasped his hands and gave another, different little hop, which planted him firmly on earth. There he stood, rocking back and forth from toes to heels. "I'm so sorry for the confusion, Gordon and Marilyn. This tour is private, *magicians only*," said Doug. "My assistant here is going to serve you some healthy refreshments and tell you all about what we do here. Most importantly, settle back and relax together. I'm certain you don't get much time to do that at home. Philip and I have a lot to discuss."

Without a look back, Phil and Doug were disappeared.

Marilyn and Gordon sank back down into the massive couch. Marilyn stretched her legs out, looked at Gordon and shrugged. "I know," she said. "You wanted the tour, too."

"I'm Phil the magician's builder, after all," said Gordon. "I'm kind of semi-professional."

"But this couch is awfully comfortable."

"You're right." Gordon put his arm around Marilyn and the two snuggled up together. "Doug's right. We don't get the time to just sit together anymore."

Doug and Phil, two Winnipeg magicians, entered the warehouse. Everything about the magic show Philip had read and imagined was right there. He could touch his dream. Henning explained the provenance of the pieces and their workings as he would to

a respected fellow professional. Phil noted that he wasn't getting the kids' tour. But Henning too was amazed by Philip.

He had not expected such an informed young man. Their discussion was lively and Henning was fairly shaken by the depth of Philip's love of magic. At the end of the tour, Henning gave Philip a priceless gift: a coin that had been owned by Houdini which Henning always used to practise his finger agility exercises. "This coin is special to me, and it's special in and of itself. It's imprinted with Hecate, the goddess of magic."

"Are you *sure* you want *me* to have it?" asked Phil.

"I'm very sensitive, Phil, and I feel that Houdini wants you to have this."

"Really?"

"Yes. I feel this very strongly. Hecate helped Demeter find her daughter, carrying twin torches through the underworld. Perhaps you too will be a guide for someone who needs your light."

Phil didn't trust putting it in his pocket. He could lose track of it there. He pressed it into his palm to feel the coolness. He pressed the impression of the goddess into his flesh.

After the tour, they all said their goodbyes. But there was another gift: Doug sent them off to the Magic Castle for lunch.

"What in the world is the Magic Castle?" asked Marilyn.

"If Phil lived in L.A., it would be his home away from home," said Doug.

"Mom—it's just—the most incredible place. I've read all about it. I can't believe we're going there."

"Believe it, Phil," said Doug. "You know a lot about magic. Now it's time to start living it. Oh. And there's one more thing…"

He handed Marilyn a card with his personal phone number on it. "Anything you need," said Doug.

"I'd never inconvenience you," said Marilyn. "You're a very nice man, though, and I thank you for the thought."

"No, Marilyn, I *want* you to call. I don't do this for everyone I meet. Promise me you will."

Billed as "the most unusual private club in the world," the Magic Castle is a cornerstone of the magic world. The turreted chateau-style mansion in downtown Hollywood is the home of the Academy of Magical arts, an organization devoted to the promotion and development of the art of magic. It's also an exclusive clubhouse for magicians. Only members, or those invited by members can get in, and you must adhere to a strict dress code. There are no visible doors. You must say a secret phrase to an owl sculpture which is perched upon a bookcase to gain entry. If the password is correct, the bookcase slides open and you have gained access to a magic world.

They were registered under Phil's name. When he spoke his name to a bookcase in the lobby, magic-land opened up to them.

The mansion holds too many rooms to count. But how could you count them, so darkly lit, maybe shifting, maybe disappearing? Each one holds its own secrets. There are also performance theatres and bars, with shows of all kinds going on at all times. The unofficial shows that you just happened upon were the most sought-after, though, the most memorable. Back then, you had a good chance of meeting Dai Vernon sitting at the bar just fiddling around doing card tricks. Anything magical was possible within those magic walls. But the Magic Castle is a secret place and should remain so. However secret, it may be told that a player piano named Emma utterly beguiled Phil. As Emma pounded out "St. James Infirmary," Phil asked, "Dad, can we get an Emma some day?" The Houdini Room could not have been more perfectly suited to a person, and Philip could have stayed there forever. "Escape," he murmured, wandering the room as if hypnotized. "Escape."

The Magic Castle is also the home of the Magic Castle Junior Group, skilled young people cutting their chops among the best. Dean and Phil would have been members there if they'd lived in L.A. Within those magic walls, it's possible to imagine a young Phil and Dean there right now, wandering in and out of their favourite rooms, forever young.

The Hornans were suddenly starving. Doug had made them a reservation in the exclusive restaurant, where the top magicians dined.

As they feasted, Gordon said, "Well?"

"Well what?" asked Phil.

"*Well what?* What was it like in the magic warehouse with Doug? The tour!"

"Incredible. Beyond everything I'd ever dreamed."

"Go on! Give us some details, please."

"Details?" Phil asked.

"Of course!" cried Gordon.

"Oh, Dad, there's seems to be some confusion. That was just for magicians. I was sworn to secrecy."

"Come on," said Marilyn. "You don't have to tell us your magician secrets. Just tell us something!"

"It's *us*," said Gordon. "Your mom and dad!"

"Well...can you keep a secret?" asked Phil.

"Yes!" said Marilyn and Gordon in unison.

"Good," said Phil with a bright smile. "So can I."

CHAPTER 11

Doug Henning did stay in touch with the Hornans. He called to check in on a regular basis, and Marilyn called him to update him on Phil's health. She came to count him as a real friend, like family. Someone who was interested, who cared about their welfare. In 1985, Doug came to Winnipeg to perform his big solo show, *Doug Henning and his World of Magic* at the Centennial Concert Hall. The Hornans, this time with Dean in tow, were his special guests. The show had been sold out. Afterwards there was a swirl of fans wanting to meet him. You could barely press forward. Henning emerged from his dressing room in his post-show outfit of white suit with massive padded shoulders and lemon yellow button-up shirt, calling, "Philip! Philip Hornan! Where is Philip Hornan?"

"Doug!" shouted Phil.

They fought their way through the crowd and embraced. Doug maneuvered the unwieldy group backstage.

"This is Dean!" cried Phil. "The one I told you about!"

Dean finally got to shake hands with one of his heroes. Because they were all magicians, Doug gave them a quick, confederates

tour of the set and props and introduced them to the stage hands. Dean's awe of the tour didn't stop him from examining the "Lighter than Air" illusion with an expert's eye.

"You understand this?" Doug asked Dean.

"Yes—and I knew how you were doing it from the audience, too. But I still believed you were floating anyway. It makes no sense, I know."

"You believe in real magic, then?"

"I believe...it *can* exist."

"Me too. Dean, you really are following in Houdini's footsteps, aren't you? The escapes you've done, Phil told me all about them," said Doug. "You've chosen very dangerous and demanding tricks to do."

"You've done them too."

"Yes. When I was much younger."

"I wanted to ask you something about Houdini," said Dean, the one single moment he was able to get Doug to himself.

"Of course. I love to talk about Houdini to true fans."

"Have you ever seen him, and talked to him?"

"*Talked* to Houdini? How old do I look to you?" laughed Doug.

"That's not what I mean exactly," said Dean. "I know you're way too young to have met him while he was alive."

"You mean have I talk to his spirit? His ghost?"

"Something like a ghost. But more solid."

"No," said Doug. He answered Dean soberly, respectfully. "No ghost. I do sense his presence, though."

Dean gazed out over the bustling, brightly lit backstage, curtains pulled back and T-shirt clad roadies packing equipment away with clean efficiency. The vast bank of seats was now empty. How easy it would be for someone to sit there quiet and still and go unnoticed.

"Have *you* seen his ghost?" asked Doug with a tilt of his head.

Dean opened his mouth to answer, but just then Doug got pulled back into the fray. Amazing, after all this time, that he couldn't imagine Houdini.

Dean and Doug didn't get a chance to speak one-on-one again. Henning wanted the Hornans to himself. In the middle of the backstage party, he pulled them into a far corner of the green room altogether.

"I've been thinking of Phil a lot since we met," he said, his voice raising above the din. "I want to share something with you all. I have known several people who have survived cancer."

"I like to hear those stories," said Marilyn.

"They're very encouraging," said Gordon.

Doug's eyes fixed on Phil, who straightened up, sensing a moment of import. "That brings me to what I want to discuss with you."

Doug had long had a fascination with Transcendental Meditation, and his interest had grown and deepened over the years. He was now a devotee. A method of deep meditation through the use of mantras, it was believed one could achieve a state of pure consciousness and transcend mental and physical boundaries. Doug believed humans were actually capable of flight if they reached a high state of meditation. Even from his youth he'd been of the mind that possibilities were limitless. That conviction was what led him to create his magic shows. Though Doug had not flown—that he ever admitted—he heard magic knocking on reality's door. Now that door was slowly opening. He didn't know what was behind the door, but it was his life's work to find out. He was on the cusp of transcendence.

His magic shows were done for one reason: To inspire the human race. The magic tricks he performed could be considered mechanical inspiration to people as to what might be achieved with the belief.

"Phil, I feel so strongly that you can control your destiny and your disease," said Doug, sitting down slowly, looking in his eyes.

Doug felt Philip would be an idea candidate to attend a wellness clinic in Boston he knew of. There, Philip could receive Transcendental Meditation sessions with his own personal faith healer. That, combined with a series of cleanses and detoxes, could be the cure for Philip's cancer. Doug proposed this to the Hornans, adding, "And I know this may sound like a lot of money. You're not to worry about that. Leave it to me. Let's just keep it all discreet."

No one answered immediately. His generosity of spirit simply washed over them all.

"I don't know anything about this Transcendental Meditation..." said Gordon slowly.

"That stuff is like a foreign country to us," said Marilyn. "But if you recommend it, we're willing to try anything."

"And it's okay with you, Phil?" asked Doug.

"I feel the same way as my mom and dad. If you think it's worth trying, let's give it a try."

It was that easy. Shortly afterwards, the family went on to the Boston Clinic for a month of treatments. Doug had an infectious optimism. As he often said, "Magic is something that happens that appears to be impossible." With Philip worsening all the time, the Hornans were ready for a manifestation of real magic.

Philip called Dean several times during treatment. By the end of the month he was tired out.

"It's really cool, what he's doing for me. I've never met anybody so kind and caring. His generosity—I mean; I didn't know people like him existed. And I don't know what I've done to deserve it. He's given us so much. But..."

"What?" asked Dean.

"I just know the treatment's not doing anything. I want to sleep in my own bed. Do you think they'll all be disappointed in me if I say I want to go?"

"No one's going to be mad if you you're honest," said Dean. "I promise."

"Are you disappointed in me?" asked Phil.

"Me? Why would I be disappointed in you?"

"Everybody wants me to get better so much. Will I let you down if I don't?"

"You're going to get better, Phil. And no one is going to be mad."

No one was mad. Though the doctors at the clinic wanted to continue, the family decided they wanted to go home. Soon they were back under the big Manitoba sky in Giroux.

"Mom, now we've been to L.A. and now Boston and I go and miss Giroux. I must be a real weirdo."

"Takes one to know one," said Marilyn, gazing at the bright pink and yellow sunset.

Everyone slept better back in their own beds. The failure of the clinic treatments hadn't entirely crushed their hopes. What moved them the most was Doug, and his unfailing belief that the mind could positively effect the body. The clinic may not have been the right place. Philip back on the farm where he could be comfortable was positive in and of itself. And the quest had just begun.

Philip and Dean rattled and slid along the icy back roads toward Steinbach in Dean's dad's old pickup truck. It was December 18 and brutally cold. They could see their breath even though they'd been driving for almost an hour. The truck heater wasn't in prime condition.

"I never knew it could take this long to get from Giroux to Steinbach," said Phil. "That's quite a feat."

"Funny, didn't think you liked getting pulled over by the police," said Dean.

"Here's a suggestion," said Philip. "Why don't you just get your driver's license?"

"You should talk."

"Ha ha. You know very well I'm too young."

"Doesn't stop you from driving your motorcycle every chance you get."

"But you *can* get your license. So why don't you?"

"Because I can drive as well without a license as with one."

"Funny joke. But we wouldn't have to drive down so many back roads if you weren't avoiding the police."

"You can hardly say I'm avoiding the police if I'm driving to the RCMP detachment, can you?"

"Good point," said Phil. "About that... If they let us...do what we want to do...what do we do if—"

"I've told you already. Don't worry about it. It's all a learning experience. In fact, it doesn't really matter what happens. This is how we learn. We've got to push our art to truly become artists, Phil."

"Yeah, I get that. Just thinking of that time you died underwater in a coffin while you were pushing your art."

"Your point is?" asked Dean. "Even in failure we learn. Got it?"

"Got it," said Phil, tapping his fingers nervously on the armrest.

They were headed to the Steinbach Detachment Office. It was time to put months of escape practice to the test. Escaping from cuffs out of Dean's collection in the safety of the Hornan home was like a beginner reading *Dick and Jane*. Sure, it was the perfect way to begin learning. But they'd never grow into true escapists without meeting the unknown head on. It was time to throw themselves into the void and be forced to improvise.

"It'll be so embarrassing if they lock us up and we can't get out," said Phil. "We'll never live it down. Word will spread like a prairie fire from Steinbach to Giroux to Winnipeg to—"

"We're are doing exactly what Houdini would tell us to do at this point in our training. Do you want to escape for real or don't you?"

"I do," said Phil. "For real. I want to escape."

"We've been preparing for months. Trust that. The thing I'm worried about is if they play by the books. If the cops are being hard-nosed today, they'll show us the door and we won't be locked up."

"Yeah, that *would* be worse actually, not to be locked up."

"You're a true escapist," said Dean.

"We'll see," said Phil.

They pushed open the heavy door of the Steinbach Detachment office, and Constable J.L. O'Ray stood up and shook their hands. He knew the boys. Everyone around there did. Plus both boys were infamous for their driving habits.

"Dean, Philip. Good to see you. How'd you get here today, boys? Dean, you got your license yet?"

"My dad dropped us off, sir," said Dean.

"Heard your dad was in Winnipeg. I must've been mistaken. Sure you wouldn't keep driving without a license and risk more trouble. How can I help you?"

Despite his steely advice to Philip in the car, Dean felt a tremble of anticipation. "I know you're aware Phil and I have been walking in Houdini's footsteps by practising escapes, sir."

"Your little coffin trick didn't go so great, did it? Never heard of Houdini flubbing up like that. You got pretty wet, I understand."

"I sure did, sir." Dean restrained his sigh. He'd taken a lot of ribbing since the coffin escape. But he knew it wouldn't pay to broadcast his frustration. Always, always be positive. That was his mantra. "We're working on dry escapes. Since it's December and all."

"Good thing. And Phil is escaping, too? I didn't know that. Okay, what about it, boys?"

"We'd like you to lock us up, sir," said Dean.

"Please, sir," added Phil.

"Huh?"

"However you want, using cuffs or whatever you have here," said Dean. "We're going to try to escape."

Constable O'Ray sputtered with surprise. "I've never had anyone *ask* to be cuffed before, I'll tell you that for free!"

"It'd mean a lot to our training," said Philip. "We want to be just like Houdini and David Copperfield and Doug Henning."

"Doug Henning was from Manitoba, sir," said Dean, playing earnest. "He's a Manitoba boy, just like us."

"I don't know… Not sure the staff sergeant would approve of using equipment for non-police work," said Constable O'Ray. "In fact I'm fairly sure he wouldn't be impressed."

"Is he here?" asked Dean, a touch of insouciance slipping through.

"Are you suggesting I'd do anything behind the staff sergeant's back?"

"No, sir!" said Dean. "But look at it this way. If we escape, we're doing you a favour."

"Oh really?" said the constable. "And how do you see that?"

"It's like this," said Philip. "Say you have a really dangerous guy handcuffed. A killer. But he's also an escapist. He's an escapist gone bad. You turn around for one second to make a call for back up. *Suddenly his hands are around your neck.* He bust out of his cuffs in that very moment you weren't looking! The killer has you."

"No one has ever escaped from these handcuffs before, son."

"Then you have nothing to worry about," said Dean.

"Of course, we probably won't be able to escape from them, anyway," said Phil. "It'll be way to hard."

"No, we're probably about the embarrass ourselves totally," said Dean.

The constable looked from one boy to the other. "You kids," he said, reaching for his cuffs. "This is quite a hobby you have."

"Thank you, sir!" said Dean.

"You've got your choice: the interview room or the broom closet."

"We'll take the interview room," said Phil.

"You guys are going to regret this. But if you want to give it a shot, knock yourselves out," he said.

The Steinbach Detachment office was very small, as most of them were. The constable walked them down the short hallway to the interview room. He would have preferred to lock them in the holding cell and let them try that lock too, but it was right out there in the open. The interview room housed the detachment gun cabinet and the staff sergeant's desk, where Marilyn Hornan once sat, arguing for her son to be allowed to ride a motorcycle down a dirt road.

"Okay, let's keep this snappy, boys. Meet the issue Flexcuffs. They're disposable, single use cuffs. But you won't soon forget them." The ratchet zipped along a hundred little plastic teeth, and the nasty little cuffs bit the skin in a sharp, sturdy hold. One set for each of the boys. "The skeleton key you've hidden where the sun don't shine isn't going to be any use to you with these," he said. "Do me one favour, guys?"

"Yes, sir?" they both asked.

"Don't let's draw this out. When you realize you're sunk, don't be proud. Get it over with and call me to unlock you. I don't want you struggling in there for three hours. An RCMP detachment office is a place of serious business."

"Yes, sir!" they both answered.

The constable looked at his watch and shut the door. He brewed a pot of coffee. Halfway through his second cup, he heard the them calling for him. He looked at his watch and blinked.

Dean and Phil made a production out of their difficulty in escaping their bonds, moaning about how hard it had been.

"You guys are in an awful hurry to leave," said the constable. "Just a second here, boys!"

"Could you type us up a letter, stating what happened? The way you locked us up and how long it took us to escape?" asked Dean, walking down the hallway toward the exit.

"What for?" asked the officer.

"For our scrapbook," added Phil, just behind Dean.

"Yes, I can do that," said the constable hurrying after both boys.

"What was our time by you, sir?" asked Phil over his shoulder.

"Eighteen minutes."

Dean and Phil shared a glance at the front door. "We've kept you long enough," said Phil. "Can we come back for the letter next week?"

"Okay," said the constable, "but—"

Truth be told, he wanted the boys to stay now and tell him every detail about how they escaped. But the boys were already putting on their parkas. Dean looked back.

"Sir—what's in the cabinet in there, anyway?" asked Dean.

"Well, it's a—"

And the door swung shut behind them.

"Guess he didn't want to know that bad," the constable mumbled to himself. "Or..."

He grabbed his key ring and moved hurriedly to the gun cabinet, heart racing. The cabinet's security was vital and oft discussed amongst the crew. If something were wrong with the gun cabinet, there would be a world of trouble. He unlocked the cabinet door, eyes darting to all angles. The rifles were all there and looked as they should. But there, taped in the very centre, was a piece of paper from a yellow legal pad, folded like a note from his school days. Scrawled with pen, it read, "Thanks, John!"

The constable ripped it down. He knew the staff sergeant had a yellow legal pad in the left-hand drawer of his desk. Which was also locked. The boys had got free from their cuffs, broken into a locked desk drawer and a secure gun cabinet *and* made out like a couple of wiseacres in eighteen minutes.

Rattling down the back roads to Giroux after the laughter died down, Dean asked, "What was it like for you? Were you scared?"

"I was scared and nervous, and before I actually thought I'd be too jittery to make it. That is, until the cuffs went on," said Phil. "Then everything changed."

"Pure focus on escape, right?"

"Right," said Phil.

"Everything drops away," said Dean.

"Your whole world shrinks—"

"—in an instant to the task at hand."

"Everything gone, except the escape. I want to do more," said Phil.

"I knew it," said Dean. "I knew you'd say that. That's exactly how I felt after the coffin, though I know it's hard for people to understand."

"I understand," said Phil.

"Then you were also born for escape."

They went back to the Hornans' and went straight into the basement to work.

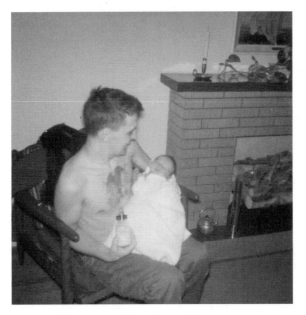

The young father Garry Gunnarson

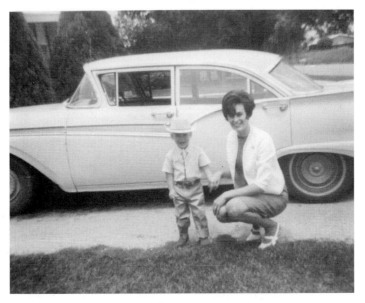

Dean and his mother Beverly

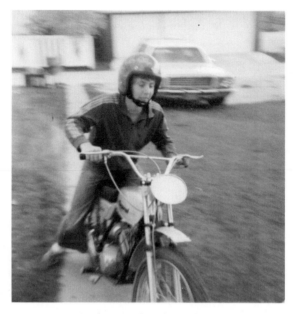

Evel Knievel in the making

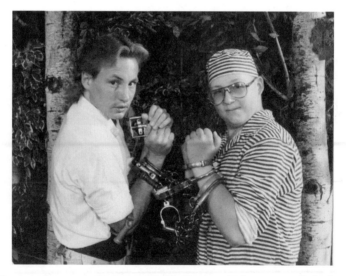

Partners in escape. Dean and Philip Hornan. Taken 3 months before
Phil died. "To Dean: My real friend in life and magic & escape"
–Magically Yours, Philip Hornan, Sept 24/86

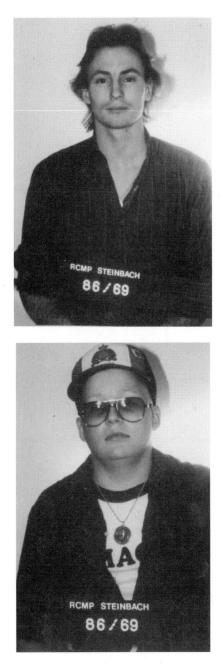

Fake mug shots on the big escape tour

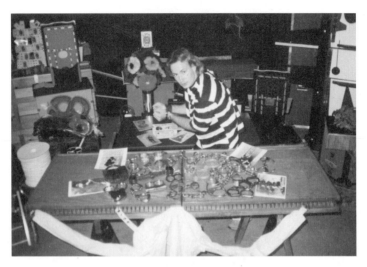

Practising with some of his collection

Dean with Bill Brace and Len Vintus at one of their
favourite restaurants, The Marigold

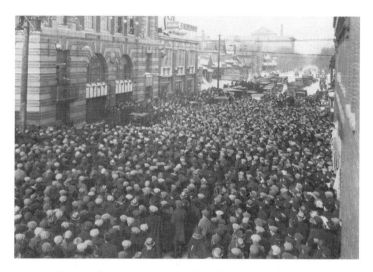

Harry Houdini wowed a crowd of 5,000 by squirming out
of a straightjacket while suspended outside the *Winnipeg Free Press*
building on Carlton on October 31,1923. L.B. FOOTE

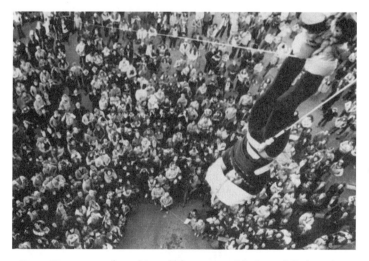

Dean Gunnarson frees himself from a straitjacket while hanging
by his feet from the side of the old *Winnipeg Free Press* building
in his first public escape performance in October 1982.
KEN GIGLIOTTI/WINNIPEG FREE PRESS

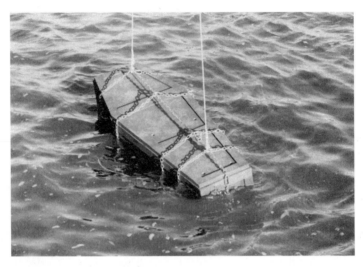

The fatal second escape. Phil Hornan was watching from the crowd.

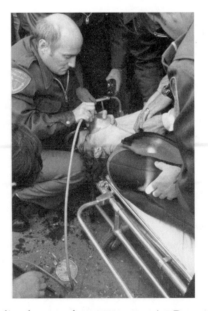

Paramedics desperately attempt to revive Dean after the
escape went wrong. GLENN OLSEN/WINNIPEG FREE PRESS

With The Amazing Randi and the Milk Can Escape
that was the unlocking of Dean's career

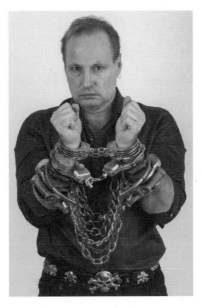

Dean Gunnarson, always escaping

Gordon Hornan and his masterpiece: Philip's Magical Paradise

The girls who revealed the magic to the magician:
Kali May (left) and Shayla (right)

CHAPTER 12

Phil always laid out his clothes right down to the matching socks before bed. Living with cancer, he never knew what the new day would bring. He didn't want to chance not feeling well and have to struggle to get dressed. His homework was always done and packed neatly in his knapsack as well. You just never knew when a moment, never mind a morning, was going to be rough. He did his chores neatly and methodically at every opportunity. He was always paving his paths for smooth travel. Because he didn't want to miss a thing.

Over the years, mornings were Marilyn and Gordon chasing after their other boys to get them ready for school. They never had to pay much mind to Phil. He was different.

"Where's your homework? What do you mean you didn't have any?! I've never heard of not getting homework on a Wednesday night! Get dressed! Brush that mop for mercy's sake!" could be heard throughout the Hornan home on a typical weekday morning.

Neatly turned out for the day no matter what it might hold for him—school, chemo, practising his art with Dean—Phil would

inevitably be at the breakfast table as his brother Robert—the last remaining brother at home—straggled miserably in.

"You know, a little prep at night goes a long way," Phil would say. "Think about your future! How're you going to function as an adult if you can't get yourself out of bed now?"

Robert shook his head. "Dude, you are an alien creature landed down in the middle of a normal household."

"It's normal for *me* to be prepared in the morning."

"Ergh," moaned Robert. "Why am I too young to be allowed to drink coffee?"

His parents' eyes locked across the room. They'd said it many times before in the privacy of their bedroom: "If Phil survives this, he is going to be somebody, no question."

Marilyn shooed everyone off to school and got to work. She had been doing a lot of research and found an article about a clinic in Minneapolis that was doing wonders with terminal cancer cases. After numerous conversations with a doctor by phone, she'd been tasked with compiling a copy of every single X-ray and report ever written about Phil, every scrap of paper associated with his case. It had taken weeks to get the papers together, but she'd done it and booked the flight. She felt the passage of time like a bubbling of panic in her chest. Days were not spent cheaply for Phil. And now as she packed every word written about Phil's cancer all together for their next day's flight, she felt a rare wave of defeat pass through her. The package was almost too heavy to lift. She could carry it, but her hands ached under the strain and her arms shook with the exertion. She never calculated that part.

"No," she cried out to the empty house.

She let the package fall and plopped down on the couch, putting her head in her hands. How to manage the suitcases, the passports, tickets, American money, Phil, who may not be feeling well, and this unholy package? She and Gordon had decided

Marilyn should make the trip alone with Phil. Someone had to stay home with Robert and mind the farm, and they didn't have unlimited money anyway. All her worries bore down on her and the panic began to bubble over again. Her cozy living room looked strange and foreign, it offered no comfort, and she knew if she sat there a moment longer, she would be in the iron grip of anguish. She leaped up and rushed to the front door, throwing it open. She took great gulps of the fresh country air and looked out over the horizon of blue sky and yellow fields and cried raggedly. Later, she was calm again.

Looking at the big sky helped. As she took in the colours—the prairie blue never, ever did anything less than amaze her—she thought yes, the travel would be difficult, but if something on this trip gave them cause to hope, then the effort would be worth everything and more. She went inside and shut the door. There was more to pack.

"I feel like a pack mule!" she hollered a few times on travel day. But somehow, with the help of some kind people here and there, a flight attendant, the cabbie, a stranger, they made it with all their bags intact to their hotel. They had no time to relax but went straight back out and hailed a cab to the clinic. She handed off the heavy package to the clinic receptionist, and it was whisked away. Marilyn silently said goodbye to it. At last unburdened, she sagged down beside Phil in the waiting room.

It was over an hour before the doctor came out and greeted them.

"Face to face finally, Mrs. Hornan," he said shaking her hand. "Hello, young man."

"The receptionist gave you the package?" asked Marilyn.

"Yes, and I've been going over it," he said. "Phil can come with me now."

"I'm coming too," said Marilyn, perplexed. "Aren't I?"

"No, this is a consultation between patient and doctor only," he said. "Relax, Mrs. Hornan. My receptionist will bring you some coffee."

Another hour passed before Phil came out. "Let's go," Phil said in a blunt way so unlike him that Marilyn jumped up and followed him straight out without saying goodbye to anyone. They rode the elevator down in silence. Only when there were walking down the busy metropolitan street did Marilyn say, "Well? What happened?"

"Nothing really."

"What do you mean nothing? You were in there for an hour. What did you talk about?"

"He just asked me questions."

"Well, what kind of questions?"

"It was basically one question, in different ways."

"What?"

"He wanted to know how I felt about dying."

Marilyn's mind spun out. She stopped walking. Despair of the cruelty, wasted time, effort, expense, *injustice* flooded her body. The injustice of losing Phil. She wanted to sit right down on the sidewalk and weep forever. But Phil was still walking on.

She studied him, as if seeing him for the first time. He walked slowly and evenly along the foreign city street, looking down. It wasn't like him not to look around at all the new sights. How was he walking ahead, so placidly? She wanted to ask him how he got to be so brave.

It didn't seem like the time to talk, though. She ran to catch up, bit her tongue and held her boy's hand gently as they walked.

CHAPTER 13

Dean took a small apartment on Kennedy Street and he began attending first year classes at the University of Winnipeg. He liked the bustle of campus, and the students and his professors. He loved meeting new people. His heart wasn't really in his studies, though. He dreamed of escape. His attendance wasn't perfect.

He bought most of his tricks by mail order. More and more pieces accumulated, and his one-bedroom crib began to resemble a small magic warehouse. Dean also began collecting coffins. He had nine packed into the place. Three were lying down, but the rest were stored upright so he could make it across the room. He'd vowed not to do the underwater coffin escape again. But still, he was compelled to buy coffins. He couldn't exactly explain why. It was something to do with his love of Halloween, Houdini, and that Halloween was the anniversary of Houdini's death. But there was more to the coffins as well. Dean knew the explanation was beyond his words.

Dean was rarely in his apartment, though. He would date girls casually. He liked them all a lot. But magic was his true love,

and she was the one he pursued with his heart. If he wasn't at his place or the Hornans', which was where he was mostly, he'd be out with his dad at his small cabin near Clear Lake. That was where his dad had built him a pigeon coop. Garry cared for them on a daily basis, and when Dean came out, he trained the doves to do tricks. Dean loved the birds and they cooed back their love to him. It was a quiet comfort being out there in the wilderness with his dad. He felt pure acceptance there. Not many words needed to be spoken.

A letter had arrived for Phil, and he'd been waiting for Dean to show up to Giroux. Dean listened with a dove sitting on his shoulder.

"We've been invited to speak at a magic club meeting. They want to hear first-hand about how we met Doug Henning and what he's like. Isn't that cool?"

"It's pretty cool," said Dean. "Why do they just want to know about Doug Henning? We're practising escapes, doing shows. I've done the *Free Press* straightjacket performance and the coffin one..."

"I don't know," shrugged Phil. "It says we get to speak for a half hour. Can we speak that long?

"Geez...I guess we can tell them all about what we do to hone our skills."

"That'll take five minutes," cried Phil. "We'll never fill a half hour! And these aren't kids. This is a group of adult magicians."

"You can't fool magicians," said Dean, beginning to pace. "This is making me more nervous than escaping."

They arrived at the Health Science Centre University Building to a crowd of over thirty men. The chatter was intense, and Bill Brace greeted them and took the boys' coats. No one heard him say, "We're very interested in hearing about Doug Henning. But

I am not impressed by your escapes, Dean Gunnarson. You're a hot dog. A lot of people here are interested in escape. I don't want you encouraging anybody. Plus, my young nephew is here. Watch what you say. You understand?"

"Sir, I would never encourage anyone to do anything unsafe!" said Dean.

"Good to hear. But I don't know you yet. All I know is what I've seen, and from what I've seen, I'm not impressed. Nice to meet you, Phil."

Bill walked away and sat beside a young boy.

"Wow. No pressure," said Phil.

The boys were introduced, and Phil and Dean, sweating with nerves, took their place at the front of the room. They began by speaking haltingly about Doug Henning, but the crowd was most curious about Phil and Dean. They were amongst their own people, magicians. They quickly found their footing. Questions flew and enthusiasm glowed on every face.

"We practise constantly," said Phil. "We perform basically anywhere people want to see a show. We just did an escape at the Steinbach RCMP detachment that was kind of scary."

"How did you arrange that?" a voice called out from the crowd.

"We just...went in and challenged them, I guess," shrugged Phil.

The crowd rumbled with excitement.

"It was bold," said Dean. "We went in there and said to the officer, 'Lock us up however you want. Do your worst'."

"But what was the trick?" another crowd member asked.

"Yeah, did you 'suggest' somehow what you actually wanted them to lock you up with? To get them to do what you wanted?"

"Huh?" asked Phil.

"No, no, we were prepared for anything," said Dean. "The point was to challenge ourselves with the unexpected."

"To be true escapists, you must be ready for anything," said Phil.

More rumblings and exclamations from the audience. The audience was captivated by these two young men who'd gone from hobby to vocation to obsession.

Their thirty minutes easily turned into a full hour, and the boys demonstrated some handcuff and rope escapes to the rapt crowd. Dean surprised everyone by producing a dove right at the end. Bill wished he'd booked two hours for these guests, but he was forced to draw the meeting to a close. In the flurry of people leaving, Bill pulled his presenters aside and shook hands firmly.

"I want to thank you for that sincerely, boys. It was an excellent presentation. I know I can be brusque. You'll get to know me."

"I hope I didn't do anything wrong by introducing the cuffs and ropes at the end," said Dean.

"No, I think you really spoke to a need the group had. What you demonstrated was classic early Houdini. That's appreciated by all of us."

Phil and Dean smiled at each other. Bill couldn't have given them a better compliment.

"Phil, you didn't say much about it, but if the Rainbow Society gave you a wish, that would mean you're sick."

"I have terminal cancer, sir."

Bill didn't seem surprised, as if he'd diagnosed the condition in his mind already, just by observing Phil. Dean, on the other hand, didn't hear Phil say the word "terminal" often, and he felt it like a punch to the gut.

"I've met people who were diagnosed terminal and went into remission," said Bill. "I've seen that more than once in my life."

"Thanks for mentioning that, sir. I'm fighting it. With everything I've got."

"I've been a boxer and a wrestler, so I know a little bit about fighting. Let's do lunch, you guys."

Dean and Phil nodded eagerly.

"Good. And I'd like to come out and visit you and your folks in Giroux sometime, if you could stand a visit from an old fellow like me."

"You don't seem very old to me," said Phil.

"And you, Mr. Gunnarson. I owe you an apology. By your reputation, I admit I took you for a flash-in-the-pan fool who had no true appreciation of the Art of Magic and Escape."

"You don't mince words," said Dean.

"Truer words were never spoken. I'd like to get to know both of you better. And introduce you to some people. You are two young men worth knowing, I'd say."

They put on the jackets and picked up their bags of props.

"The Westminster Hotel Banquet room, 685 Sherbrook," said Bill to Dean as they shook hands goodbye. "That's where the magicians meet. They have a helluva Sunday smorg. But we mostly go there in the late afternoon for a beverage or two, if you know what I mean. I'd like to see you there sometime soon. And you too, Phil, when you're a little older."

The room cleared out fast, and Bill said goodbye to the last attendee. He turned back to get his own jacket, when his grandson Cary bounded into view. Cary had somehow procured a length of rope and he was doing a mad dance about the room in his stocking feet, swinging the rope over his head.

"Where did you get that rope, boy? Did Dean Gunnarson give it to you?" hollered Bill. But Cary was not prepared to give away his secrets.

"Grandpa! Grandpa! Hog-tie me for real! Don't do it easy. do it tough. I want to play Dean Gunnarson! *I'm Dean Gunnarson!*" he howled. "I'm gonna escape some day, just like him!"

"What have I done?" Bill said to himself as he lit a cigar and sat down to watch his grandson. Cary rolled around the meeting

room floor pretending his grandpa had had the heart to tie him up, and he was fighting for his life.

"Escape! Escape! Escape!" cried Cary.

Driving Garry Gunnarson's truck back to Giroux, without a driver's license as usual, Dean said, "Telling people your theories out in public like that makes you need to live up to them."

"What can we do to prepare for the unknown even more?" asked Phil. "We can't ever think we know it all."

"You know what we should do? Go to the RCMP museum in Regina and examine their collection of old handcuffs. We need to be familiar with all the cuffs out there."

"Do you think they'd let us try them?" asked Phil.

"Yes, we'll charm them. You know what else we could do?"

"What?" asked Phil.

"We should escape from every RCMP detachment in Manitoba."

Phil held Dean's performing dove tenderly in his hand, stroking its head. "Every single one? Now that would be the ultimate challenge, wouldn't it?"

"It absolutely would be," said Dean. "It would be the final test of our skill."

Phil pressed his cheek against the cool window to quell his sudden nausea. This was happening more and more lately. The setting sun was purple and blue tonight. Never the same.

"We can't develop our art too much further if we just practise on the farm day in, day out," said Phil, but his voice was weak. Dean didn't notice in his enthusiasm.

"We need to push our limits," said Dean.

"Do you think we actually could...break out of each and every jail in Manitoba?"

"There's only one way to find out. But I think it's possible," said Dean. "Steinbach jail was easy. I've had a harder time getting out of bed in the morning than breaking that jail."

"I've had a harder time making pincushions," said Phil. "Maybe we *could* do it."

"Let's try. When?" asked Dean. "Whenever you say, I'm good to go."

"What about university?" asked Phil. "If I said, 'Let's do it tomorrow,' you'd miss weeks of class. You could flunk out."

"University doesn't really do it for me, you know?"

"But it sounds so cool," said Phil. "You pick the subject. Not like school where they pick for you."

"Oh, yeah, university is cool. It's just not escape. And all I want to do is escape."

"Me too," said Phil. "There's just one thing. Maybe my body won't keep up with what I want."

"It will," said Dean. "I can't do it without you. Just tell me when."

CHAPTER 14

"If I've said it once, I've said it constantly," mused Marilyn. "Thank god for Ronald McDonald House. I am certain it's saved my sanity, if not my life, more times than a cat has lives."

Phil was wheeled around by a nurse as he and Marilyn were given a tour of the expansions at Ronald McDonald House before they left. They'd been in town for another aggressive round of chemo.

"It's going to be beautiful. And all this new space! It's going to really come in handy for a lot of people," said Marilyn. "But I pray not us."

"We've seen Ronald McDonald House grow from a brand-new place to an old place needing expansion," said Phil. He wore a black baseball cap, black T-shirt and jeans. His face was pudgy and pale from the treatments, giving him a youthful quality. But he was growing up. "Makes you really notice time pass."

The nurse hugged Phil as she helped him into the car.

"We're so fond of you, Phil," she said crouching down by the passenger-side door and taking his hand for a brief moment. "We don't want you back, but we always want you back, if you understand me."

Phil smiled at her. He felt too tired to speak for the moment.

"What in the world does Dean live on?" asked Marilyn, pulling out into traffic and setting her sights toward the Manitoba Legislative building, which was basically Dean's front yard.

"The cash he makes at birthday parties, mostly, I think," said Phil.

"He can't have a dime to his name!" said Marilyn.

"He's happy, though."

Phil had been missing Dean of late. With the chemo for Phil's lungs, the world had faded to grey for the Hornans. Dean had been away, out at his dad's in Riding Mountain for a spell, and then doing some birthday party performances. He'd invited Phil and Marilyn to dinner at his apartment before they headed back to Giroux. Mother and son were both exhausted and wanted the comfort of home, but at the same time, they desperately needed Dean. When he wasn't around, life was a bit less colourful.

"I don't know how he can afford to host a dinner. If he serves us any kind of little fowl, I don't know about you but I'm not eating it."

"Mom! He'd never kill one of his doves to eat, no matter how hungry he was!"

"If you say so," said Marilyn with an unconvinced shrug. "We could've taken him out and treated him."

"I think he wants to thank you for all the nice meals you've given him."

"Your friends are always welcome at our table."

Phil said nothing, but he felt the word "friend" didn't quite cover his definition of Dean.

"Very snazzy location," said Marilyn as she parked on Kennedy Street, looking at the massive stone legislative building and grounds. "Maybe he's doing better than I thought."

"Well... the apartment is maybe a bit small," said Phil. "You'll see. But it's definitely Dean."

"That's the important thing."

Dean was waiting. There were a few doves at home as well, all gloriously alive and flying from perch to perch: the coat rack, a barrel escape in the corner, a crumbling vintage female mannequin, the back of the stove to see what their master was cooking up, and mainly, on Dean's shoulder.

There wasn't far to travel on the tour of the place. "It's a bit tiny, but it's a decent apartment," said Dean. "The only part I really don't like is the landlord doesn't want me keeping the doves, so I have to smuggle them in. He's a real downer." Marilyn looked at the bird droppings scattered about and as an honoured guest, bit her tongue.

The young host served up a simple but tasty spaghetti bolognese dinner off a coffin that doubled as a table. It was adorned with a red checkered tablecloth and a red candle burning in the centre. The three sat around it on folding lawn chairs.

"Reminds me of camping," said Marilyn. "I mean, in the best way."

Marilyn ate heartily, enjoying the rare occasion of being cooked for. Phil picked slowly at his food. He'd been through the wringer at the hospital. As the evening eased on, Marilyn couldn't help but talk to Dean like he was her other son.

"Dean, you might want to think about renting a house sometime soon. All this could be regarded as a fire hazard," said Marilyn, unable to stop gaping at the jam-packed apartment. "I thought you boys kept everything out at our place. You've accumulated a lot more magic stuff than I'd even dreamed."

"Everything you see here, plus everything at your place, is the making of a big, big show, Mrs. Hornan," said Dean. "It's everything we're working towards."

"A really big show, Mom. If we can keep building our reputation, the sky's the limit," said Phil.

"What we want is to get noticed by the magicians in the us," said Dean. "That will lead to television."

"And television is key to fame," said Phil.

She looked from one to the next and back again, their faces transformed by hope. Once upon a time, she'd feared the age difference between the boys was too great. She gave her head a quick shake at the memory. They were two of a kind. The hope in their eyes hurt her. How could they think ahead to a television show? Her question was, would Phil make it through the night tonight, after all he'd been through with the chemo? Would he sleep heavily, or would he be kept up by the pain? How would the next week fare? Would he live through the next month? And there they were, looking at her with eyes alight with dreams for the future. They must be mad. God, but it was infectious.

"Doug Henning could certainly help with that," said Marilyn, leaning in to the low oblong table to get a forkful of noodles. "He said he'd help with anything." She shook her head again sharply this time, amazed by how she could just jump on their train of optimism and ride.

"What is it, mom?" asked Phil. "You gave your head a shake."

"Nothing. How're you liking university, Dean?"

Dean smiled his dazzling white smile. He had charm to spare. "Let's just say it's not escape."

Philip snorted.

"You boys," said Marilyn, shaking her head.

"Admit it, Mom," said Phil. "You love our magic."

"I never said I didn't," said Marilyn. "But you've got to get your education to fall back on in case you don't make a big hit on TV. Not a lot of people do."

"We will hit it big, Mom, don't worry," said Phil.

"Don't worry, Mrs. Hornan," said Dean. "It's in the pocket."

"You two are unbelievable," said Marilyn, laughing in wonderment at her two dreamers. A thought occurred to her and she looked quickly back and forth around the space. "Do you even have a desk to do your homework on?"

"My desk is my dining room table," said Dean.

"You mean this coffin we're eating on?" asked Marilyn. "I'll hazard a guess homework is not your biggest concern in life."

Dean smiled that smile again.

"Dare I ask where you sleep?"

"It's all about saving space, Mrs. Hornan," he said, knocking his fist on the coffin.

"You two had better make it big, at this rate," she said. "You won't be good for anything else."

"About that," said Dean. "We have this great idea."

"Oh-oh," said Marilyn. "Here it comes."

"You know how we escaped from cuffs in Steinbach?" asked Phil.

"How can I forget?" asked Marilyn folding her arms tightly across her chest. "No one for miles around will let me. Out with it. What are you two up to now?"

"We just figured we could further ourselves as escapists if we escaped from say, every jail cell in Manitoba," said Dean. "This will be our university class. We'll have perfect attendance, I promise you that."

"And we've been doing our homework," said Phil. "I guess it's class with a pop quiz at every jail."

"At least one escape will be the big exam," Dean continued on, enjoying the metaphor. "But we won't know that until it's happening."

The boys stopped when they noticed Marilyn's hang-jawed expression.

"I'm glad you broke that to me while I was sitting down," she said. "*Every single jail in Manitoba?*"

"What do you think, Mom?"

She looked back and forth between them. It was official. These boys had gone off the deep end. But yet...

"Do you think you could do it?" she asked.

"Maybe," said Phil. "I think maybe."

"Probably," said Dean. "I think we've got a pretty good chance."

"So you propose to drive, just the two of you, to every police station and RCMP detachment in Manitoba and ask them to lock you up?"

"Yes," said Phil and Dean in unison.

"I have one question for you, Dean Gunnarson."

Despite his cool calm, he started to sweat under her piercing mother's gaze. "Yes, ma'am?"

"I know you've been driving in and out of Riding Mountain, Giroux, and all over town to perform, not to mention go on all the dates I imagine you go on."

"Aw, c'mon, Mrs. Hornan, I don't go on that many dates."

"Answer my question: Did you get your driver's license yet, for real? *No jokes now!*"

Dean lowered his head. "No, I didn't, ma'am. See, I don't have tons of money, and though I could've got my license any-time—I'm a really good driver Mrs. Hornan, even the cops who have pulled me over will tell you that—I recently spent my cash on an old set of handcuffs to practise on, so no, I admit I don't officially have my license yet. Not officially."

"Good for you for being honest. You guys set on doing this?"

"Yes," they answered as one.

Phil cleared his throat, and Marilyn and Dean looked his way. They both could tell he had something to say that he was nervous about. It took him a moment.

"I don't feel up to it right now. I'm going to need to rest up a bit after all the chemo. Sorry, Dean. Maybe you want to go without me and do it now."

"Don't be sorry," he said. "I don't care when we go. I'm waiting for you. I can't do it without you, Phil."

"If you succeed, you know that this will be the most embarrassing thing to ever happen to the police and RCMP? Right?" asked Marilyn.

"We kind of look at it as a public service. We're showing the cops the loopholes in their system," said Dean.

She exhaled hard. "A public service. Now I've heard it all. Okay," said Marilyn, "I agree to this. Mostly because I admit I'm curious to see if you can do it. But I have one proviso: When you're ready, I do the driving. I'm not having you do this with no license. If you get in an accident, there'll be hell to pay."

"Okay, thanks Mrs. Hornan," said Dean.

"Thanks, Mom," said Phil. Dean and Marilyn both looked to Phil again. His voice had dropped away to a sliver of what it had been, and he'd sagged back alarmingly into his lawn chair.

"Phil, you feeling okay?" asked Marilyn.

"I think maybe we could go home now," he said. "I feel like I could sleep for a week."

"You'll bounce back in a couple days," said Dean. "You always do."

Phil smiled. Dean jumped up and they clasped hands, and he pulled him out of his chair.

The first Sunday afternoon he got, Dean went to the Westminster Hotel. He stood there on the sidelines, watching. Magicians old and young were drinking and smoking together in the banquet room in a cloud of blue smoke. This magic club called itself The Linking Ring. Dean wondered why. He wanted to know everything about them.

Seeing all these people, for the first time since he'd begun magic, he was flooded with the feeling of his place in a larger community. He'd fought like a lone warrior to learn magic and escape and to eke out a place for himself in the world. True, he had Phil now, but Phil was like his right arm: part of him. Today he was in a troop of compatriots. Each person in the room was searching for their own avenue to magic. Dean had no idea there

were this many people in Winnipeg who identified with magic so strongly. He longed to know their stories. The older men especially intrigued him. He was greedy to understand everything about the history of magic in Winnipeg, and Bill Brace was the one who held the treasure. Dean heard loud, animal-like grunts echo through the room. He looked left and right.

Like an illusion in a fog of smoke, Bill Brace came into view tussling with another man who was surely in his twenties, half Bill's age. Bill fighting was the last thing Dean expected to see in the bar. He'd seemed so proper in his apartment, a man for rules and proper behaviour. Bill was the larger man, but the younger one was well muscled. It was a toss-up who would prevail. Bill pulled the kid into a cross-face chickenwing wrestling hold, and red-faced and sweating, both men grimaced with their exertion. The younger was stuck. Members of The Linking Ring were watching with calm interest from their seats. Dean didn't understand why no one was intervening, but he couldn't pretend a fight wasn't happening. He got within range.

"Uh, Bill, you okay?" he asked, ready to help out his new friend should he need him.

"Perfect," said Bill, with a grunt. "Good to see you, Dean. Something about me you're learning today—love the art of wrestling. Just proving a point. Be with you in five."

Sure enough the fight, which actually now seemed more of a demonstration, was resolved and the two men were shaking hands in no time. "Join me, Dean," said Bill whetting his throat with a short glass of whisky that had been waiting faithfully on the sidelines. "What'll you have?"

"Just a Dr. Pepper, thanks."

Bill gave him a double take. "I think they're pretty basic in their soda pops, here. Sure you won't have anything stronger? You are of age, aren't you?"

"Pepsi then—I don't drink alcohol," said Dean. He saw the other opponent join his friends happily enough, but with a slight stagger. "That fight...I'd hate to get on your bad side."

"I never throw the first punch, Dean, but I always throw the last." Bill took a puff of a fresh cigar. "Smoke?"

"I don't smoke. Thanks."

"You're a real purist, aren't you? It's all about escape for you. I can tell. That's good," said Bill.

Dean followed Bill to a table where a small man was twisted around, deep in conversation with someone at the next table. "Len, this is the fellow I was telling you about. Dean Gunnarson, meet Len Vintus."

Len Vintus snapped his head around and with his small, dark eyes, gave Dean a thorough appraisal.

"You should know each other," said Bill.

Len was immaculately dressed in a suit and tie, and had sharp, youthful movements that belied his grey hair. After a pause, Len reached out his hand and the men shook cordially enough. Dean sensed a deep reserve, though.

"May we join you?" asked Bill.

"At your pleasure," said Len. There was an edge, suggesting their pleasure might not be his.

The men sat, but Len appeared hypnotized by his cigarette smoke rings as big as bagels floating through the air. Bill was ignoring the cool reception. He was going to make up for it with enthusiasm.

"Len Vintus, stage name of Melvin Justus Given McMullen. Primarily a ventriloquist. Fabulous act, Dean. Jerry the Talking Doll is his kneepal."

"Kneepal?" asked Dean.

"Do you like to be called dummy?" asked Vintus harshly.

"No, sir," said Dean.

"Ventriloquists call them kneepals. You learned something else today, kid. But Len is a Winnipeg magic legend," said Bill. "Go on, Len, tell him about yourself. You'll want to hear this, Dean. It's big stuff."

Dean leaned in. "I'd love to hear it, Mr. Vintus."

"No, no. You go ahead and tell him, if you must," said Len to Bill. "I want to enjoy my drink while it's still hot."

Vintus took his steaming mug and sipped tea with relish. Dean's heart fluttered at his rudeness. But he was so fascinated by these men, he knew he would have weathered worse.

"Another teetotaller," said Bill with a sigh.

"I'd love to hear about you from *you*, sir," said Dean, but Len didn't answer.

"Don't mind him," said Bill. "Len has seen a lot of magicians over the years and he doesn't like to waste his time on wannabes. Dean's the real thing, Len. I'm telling you something for free."

"Harrumph," said Len.

"Have it your way! Allow me to tell you about my charming friend Len here," began Bill.

On February 10, 1922, Len Vintus founded the International Brotherhood of Magicians (IBM) along with Gene Gordon of Buffalo, New York, and Don Rogers. Len was so young he was sometimes called "boy" by the other members. But he was sharp, energetic and driven. The IBM was borne from one man's longing for the support and society of other magicians. The primary magic clubs of the world at the time were The Society of American Magicians (SAM) in New York and The Magic Circle in England. As a small-town Canadian, Len felt alienated from other practitioners. How could a kid from Transcona, Manitoba, Canada become a player on the world scene? As it stood, the chances were zero. But Len had a big, broad vision: A worldwide brotherhood

of magicians. And by that, Len imagined not just more big cities other than London and New York, but a way to encompass all the towns, villages, avenues and dead-end streets of the world. He was a travelling man—his work in the lumber industry brought him regularly to rural Manitoba. Len knew there were magicians, or people who wished to learn magic, even in the tiniest, most unlikely Manitoba towns. He was a civic-minded man. He wanted to reach all magicians. A true brotherhood.

Len, affectionately known to his friends as Mr. Transcona, lived in that famous Manitoba community his whole life. First Transcona was a town, then a city, and only now is it considered a part of Winnipeg. Len knew about feeling cut off. And he knew his brainchild, the IBM, filled a gaping hole and could unite a vast number of magicians, even if only by mail. Never was there a more rurally-minded magician.

And so a plan began. Down in Len's basement with a small typesetting machine, he wrote and hand-printed the first newsletter for members, *The Linking Ring*. It was four pages. With the birth of the IBM, local clubs called rings began to spring up. It was slow to start. Ring 1 was begun by Gene Gordon in Rochester, NY. Other rings followed. It was clear: many, many magicians felt the need for the IBM as keenly as Vintus. Len's vision was bolstered, and his dream was becoming manifest all over North America. But they needed something to really boost their profile. A big-time headliner, for example. Someone with scores of fans, notoriety. A voice that would be heard around the world. To have the backing of a person like this would propel them to the kind of standing Len had dreamed of. And he had every reason to hope.

Houdini had started SAM and he was its president. SAM was large and powerful but only available to Americans able to travel to New York. Houdini was the man to partner with. In 1923, Harry Houdini was coming to town. He was to perform at Winnipeg's Orpheum Theatre at Main and Fort Street. And

do a little side show, escaping from a straightjacket while hanging from the *Free Press* building. Len was twenty years old and this was his big chance.

He wanted a meeting of like minds. If the IBM and SAM could amalgamate forces, it would be a huge international force for the development of magic. And to work with Houdini, his idol, would be the summit of his dreams. Transcona was about to meet New York City.

Len saw Houdini's show. The show's poster was Houdini's smiling face, with the caption, "The Genius of Escape." Len was trembling with excitement. He made his way backstage. He stood before the great one. He pitched the concept.

"And?" asked Dean leaning forward even further.

"Houdini didn't like Len too much," said Bill.

"Like? He cussed me out!" barked Len. Vintus had joined the conversation.

Dean jumped slightly. Len's energy, when he chose to use it, packed a wallop. "He actually swore at you, Mr. Vintus?"

"You heard me."

"Let's just say their meeting was short," said Bill.

"Houdini was the kind of fellow who got threatened very easily," said Len.

"I would've thought joining together and having more members would give him more power and prestige," said Dean.

"A sane man would think that. Not Houdini," said Len, and his bitterness of the long ago meeting vibrated in the timber of his voice. "He was one king who could never for a moment relax on his throne. One hand was always holding fast to his crown. And litigious! Hoooo! He threatened to sue me! For starting the IBM. As if he held the copyright on magic clubs!"

"Houdini could've done it," said Bill. "He could have joined the two groups with a snap of his fingers, established a worldwide brotherhood, and kept the credit all for himself."

"I told him I didn't care about the credit," said Len. "I wanted to the reach the small-town magicians. But he hated how young I was. Bear in mind I was just out of my teens! Threatened by my youth and vitality. 'I don't need no kids to tell me what to do or how to do it,' Houdini sneered at me. Eyes black as the devil, he had."

"I can't believe it," said Dean, sitting back shaking his head.

"Believe it," said Bill. "I know Houdini is your idol. Hell, he's *all* of our idols. But he was a man with deep failings. We've all got them. We have to separate the good from the not so good in people."

"*Why would I ever join you? You're no one, and I'm Houdini,*" said Len, still back in 1923 and hearing Houdini's voice. "*I don't need you. I don't want you. Go back to your little hick town in Canada.*"

The magicians of The Linking Ring had pulled their chairs closer. They'd heard it a million times before. But Len Vintus re-telling the tale would always be like prime-time television. Dean felt enveloped by the closeness of all the bodies, the acrid smells of smoke, booze, and sweat. Eliminate all the vices, and it reminded him of playing sports when he was young, before he got sick. The sports he loved that he was suddenly shut out of. Dean was too good at hiding his feelings for anyone to notice, but his throat tightened with emotion. *The Linking Ring.* He was a link in this legacy of magic. He had a place in this crowd, and he belonged. These were his people. And he was not going lose this place, ever. No sickness, no weakness, no one, was going to strip him of his place. He felt for Houdini, in a way, wanting to hold on to what he had with a vice grip.

"Boy did Houdini misfire, though," said Bill.

"Blackstone!" said one of the men from the burgeoning crowd. "Tell the part about Blackstone."

The group murmured assent. Everybody loved that part.

"Harry Blackstone was the opposite of Houdini. Tall, elegant, classy—and you'd never hear him cuss!" added Len, still stinging. "We got Blackstone to join us. He became the official number ten. And the IBM snowballed from there. Blackstone and Houdini were intense rivals. It was very gratifying to see that play out. Houdini *hated* that Blackstone backed us."

"And the IBM is thriving," said Bill, relaxing back, finishing the tale with a satisfied stretch of his muscles. "Still. Over two hundred rings and growing all the time."

"There was a trick..." said Len, lighting up a cigarette. Then he quickly butted it out in the ashtray. "I quit smoking thirty years ago, but old habits die hard."

"He always forgets and lights up when he tells the story," said Bill.

"There was a trick," Len began again. "It was an 'Escape from a Crate in the Ocean' deal. Both Houdini and Blackstone claimed they'd invented it. Houdini possessed the crate, though. Blackstone said he'd sold the crate to him, Houdini denied it— said it was all his, his originally designed crate. After Houdini died? The crate was examined. 'Property of Harry Blackstone Sr.' it said. The words don't lie. Houdini was the most powerful, highest grossing magician the world has known. And still he was an insecure little man."

"I'm really impressed, Mr. Vintus. Houdini hurt you a lot. But you never gave up," said Dean.

"I *don't* give up," said Vintus, and he relaxed back, draining his cup of English breakfast tea. "Ever."

Vintus became distant again, uninterested in Dean. But the rest of The Linking Ring was very interested.

"Gentlemen, this is Dean Gunnarson, the young fellow I've been telling you about," said Bill. "Some of you saw him speak with his colleague Phil Hornan recently..."

"He's underage for a bar, or he'd be here," said Dean. It was true, but not the full truth. Phil wasn't up to much lately. Dean

pictured him home in Giroux, in bed. Phil would probably be working on his finger dexterity with his coin that belonged to Houdini. That was the thing he did when he was too weak to do anything else.

Dean was welcomed and became linked to the rings in just the way Len Vintus had dreamed the club would work back in 1922. Though the joy of belonging was tinged by the absence of Phil. *Phil should be here; he would get so much out of this.* He had to force his mind away from his picture of Phil at home. When he'd heard Phil use the word "terminal" recently, it had bruised his spirits more than he'd imagined. His hope for Phil felt dark and heavy and desperate.

CHAPTER 15

Two weeks later, Phil came downstairs for breakfast later than usual. He wasn't dressed and groomed as was his habit. Still in his sleeping gear of pyjama pants and lucky Doug Henning T-shirt, he moved lethargically, saying, "My head feels as big as a —pardon me, Mom—as big as an effen Halloween pumpkin."

He sat down at the table, for once joining his brother instead of preceding him. The family looked at Phil in wonderment. But Phil was looking down at his empty cereal bowl.

"Honey? Would you like some cereal?" asked Marilyn.

"Mom, the road trip? Let's do it now. If I don't do it now, I'm never going to do it."

Marilyn put down her last bite of toast and cup of coffee, and walked straight to the telephone to call Dean. "That's fine, Phil. We've got our cousins in Regina I suddenly have a hankering to visit. We'll head toward Regina, what do you think?"

Within days, the three were off in the Hornans' car, Marilyn in the back seat. Dean had in fact gotten his license. He wanted —needed—to be in the driver's seat. This was theirs—the two magicians'—big trip. Dean needed to turn that steering wheel.

Phil needed to be in the navigator's seat. It was the natural order of things. Which was even better for Marilyn. She'd brought three pillows and three paperbacks. She propped herself up in the back seat, grabbed the book she was most yearning to begin, and waited.

Gordon Hornan leaned in at Phil's window as Dean started the engine. He was just about to head out to his beloved fields. "I kinda wish I could go on this one."

"Why can't you, Dad?" asked Phil. "You've worked on all our escapes with us. You're one of us."

"There's always work to do here, too, though" he said.

"Any words of advice, Mr. Hornan?" asked Dean.

"Yeah...I think so. Though you guys are the pros, I only hang around with my saw and drill and do what you tell me." He shifted from one foot to the other, and looked out on to the horizon, looking for the right words. "It's this: if the going gets tough, don't forget all our brain work. It's like Yogi Berra says: 'You don't have to swing hard at a home run. If you've got the timing, it'll go'."

He gave them all a nod, and walked away to the field and his waiting tractor.

They sat there for a moment in the Hornans' yard, motor idling, watching Gordon get smaller and smaller.

"Are we going, or what?" Marilyn asked.

"This is it," said Dean. "And I know it's strange but..."

"What?" asked Phil.

"I don't know how to start. What do we do first?"

Phil didn't hesitate.

"I think we should we drop in on the officers at the Steinbach detachment and say goodbye. Don't you?"

"You're the ideas man," said Dean, nodding his head, throwing the car into reverse. "Perfect. That's exactly what we should do. I'm sure they'll want to give us their blessing."

"Wouldn't it be bad if theirs was the only jail we could escape from," said Phil, bracing his hands against the dashboard with the sudden thought.

"It would be bad," said Dean, turning onto the highway going from first to fourth in a breath. "But I can tell you right now, that's not how it's going to happen. I can feel it. We're going to do this!"

They left Giroux behind.

First to Steinbach to say goodbye to their locals. The RCMP officers wished them well, hoping silently to themselves that it wouldn't solely be their detachment office that would see teen boys escape from their top-of-the-line equipment. Then to Mitchell, Blumenort, Landmark... Marilyn did not want to go inside once.

"Come and watch? No thanks. I stay away from the police as much as I can."

She sank back down into the feather pillows and drank in the heat of the sun. Never the type to laze about, it was just as well because in her life, she had never had the chance. But on this trip the back seat was hers and she relished it. It was her warm and comfy cocoon. She didn't want to see Dean and Phil struggle. She couldn't bear the possibility of Phil not escaping. She couldn't watch that.

As they drove the miles, the boys upfront chattered non-stop. Escape, escape, escape, the word that bounced back to Marilyn over the din of the motor and whisk of the wind. Escape penetrated the sentences of her murder mystery novels. Everyone, guilty and innocent, was now looking for escape. Hearing Phil's voice flitting happily in and out of her thoughts infused her with a glow of well-being. *Her youngest boy.* She soon realized she'd need a score more books. This was going to be a long, epic road trip.

"You sure you don't want to come in this time, Mom?" asked Phil in front of the latest detachment. "We're doing pretty good."

"Yup! Off you go, boys. Have a good escape."

If the officers were too busy to accommodate their request, Dean and Phil made a note of the place to get them on the way back. If the officers had time, though, they did not go easy on the boys.

"Good day, officers, my name is Dean Gunnarson and this is my colleague Philip Hornan," he would always begin as the two presented themselves at the front desk. If the receiving officer thought the boys were there to report a crime, they swiftly heard something they'd never heard in the line of duty before. Wearing T-shirts, jeans, and grave expressions, Dean went on, "We are magicians and escapists developing and perfecting our art by surrendering ourselves to the challenge of the unknown. Our request is a simple one: That you lock us up by any means you see fit and next, lock us in a jail cell. At that point, we would like privacy. Don't go easy on us. We want to be locked up as you would your most dangerous criminal. Our aim is simple: To escape any shackles you bind us with. We do this in the spirit of Houdini—a guy I'm sure you've heard of."

Most often, at that point the officers would laugh uncontrollably. Then they'd get serious, and rise to the challenge. They would break out all the manacles they could fit on the boys

"Breakfast is served early," they'd joke as they turned the key in the iron jail cell. "Sweet dreams, boys. Hope you don't get too chilly." Dean and Phil heard all the variations of the lines during their circuit. Sometimes they even laughed. The boys appreciated a good line.

The officers were so ardent with their restraints because Dean urged them at every turn not to hold back. Dean didn't want anyone to go easy. He knew this was the only way to learn. These teens were so audacious the officers couldn't help but feel the boys

should remember the day they challenged the RCMP. As it turned out, everyone had cause to remember.

In one dusty little prairie town, population 600, the boys met their nemesis. The strutting officer saw the boys into cell, and rubbed his hands together like he was about to dig into a Thanksgiving dinner. "One of you is going to get double-manacled through the bars so your hands are outside of it, and one of you is going to get double manacled behind his back. Now how's that going to work for getting that skeleton key, wherever you've hidden it, eh? I know Houdini, too," he said. "I got a book from Scholastic when I was a kid. I can see it now. Yellow cover. I must've read it about a hundred times. I know your tricks. I know exactly what you *thought* you were going try, smart guys." He'd given them a vigorous frisking and was a bit irritated hadn't found the pick he knew was there.

Dean backed away from him a few steps, and his breath came in a panicked pant. "Don't lock my hands through the bars!" he said quickly, and then put his hand to his mouth to hold back the words. *Too late.*

"Oh, really, eh?" said the officer, slowly and with relish. "Well, guess whose hands are going through the bars? Yours! You're going to learn a lot today, young man. Think you can walk in here off the street, eh?"

As the officer manacled Dean's hands tightly outside of the bars, Dean's heart swelled with such joy he could barely contain a wide smile. Everything he'd read about reverse psychology was true. He *was* learning a lot that day!

With a wolf-like grin, the officer slowly strutted away.

"I can't—"

"I know," whispered Dean.

Phil strained at the manacles behind his back, his face flushing red with exertion.

"Don't waste your energy," said Dean, still low. He leaned forward, resting his head briefly on his forearms, hands shackled outside of the cell's bars. Phil thought for a moment he was praying. Or utterly defeated.

"Stalemate?" asked Phil.

"Never," said Dean. "Don't forget what your dad said. Get as close to me as you can."

"I can't believe I forgot!"

"Shhhh..."

Phil and Dean pressed towards each other as Dean began to extract their secret weapon, for Gordon Hornan's presence was with them.

Brainstorming back at the Hornan home in prep for just such an moment, Gordon had helped design an emergency wire that attached to Phil's intravenous box which was attached to his chest. It looked like an organic part of the equipment. But it was in actuality a special lock pick, one with an extendable reach—for just such an occasion.

Dean took his single chance at removing the key from the intravenous box with his teeth. He wrenched his shoulders to the side and bent low. If he dropped it all would be lost. His face was running with sweat. He did not drop it.

"That was the easy part," he said.

Time did not exist. They heard their breathing, and amazingly, droplets of sweat plunking down on the concrete floor. The cold from the floor seeped up into their bodies, yet they were boiling hot. Dean worked the wire, with the most exacting control, from his mouth, down his arm, toward his fingers. The writhing was as strenuous as a marathon but as delicate as surgery. As he worked, he grunted out words softly, "You saw how I mind-controlled the officer to lock my hands out front?"

"That was hands-down the best moment yet."

"It was," said Dean, wishing life were like the movies and a nurse were standing beside him to mop the sweat from his brow. Salt water stung his eyes, but he didn't flinch. He wriggled, using every muscle in his body to move the wire key forward. "That guy was all over us with the body search. But he didn't *touch* your intravenous box. You know why?"

"He was too embarrassed. He felt sorry for me—that I was sick."

"Yes. Your intravenous box was his personal limit. Everybody has one. Though he sure didn't mind giving me a thorough pat down. And the discomfort zone is exactly why frauds and charlatans can conduct séances and get away with it. Because they hide their props up their wazoos and no one is willing to go where the sun don't shine. This is classic. It's pure Houdini, Phil."

"He thought he was being sorry for me. But he was actually underestimating me," said Phil, looking down at his intravenous box with a sudden pride.

"Exactly," said Dean.

Straining slowly and painfully, he conveyed the wire along and delivered it to his fingers. He worked the cuffs, contorting himself for another fifteen minutes working on the locks. His position was bad, the worst he'd ever had to work with. "This is giving us something practising at home could never do. This is invaluable."

He stopped whispering, didn't for a moment waver from his aim. It was like being under water again. Pure concentration. Nothing but what he had to do.

Finally, the cuffs flew open. Freedom.

The pain rushed all through his body. His back throbbed and his fingers ached and felt as swollen as sausages. He quickly stretched his cramped and crooked frame, and then besieged Phil's handcuff locks with a white-hot intensity.

"That's more like it," Dean said, tossing the manacles on the cot after three minutes. "I was starting to think I'd lost it."

"Lost it? You saved us."

"Houdini would be proud of us," said Dean.

"He'd be proud of *you*. I was useless."

"If it weren't for the skeleton key you were hiding, we wouldn't have had a chance. We're a team, Phil, never forget that."

They shook hands. Then Dean threw himself headlong onto the cot. "If my fingers were any shorter, we'd still be in there, though!"

Phil sat more carefully down onto the other cot. "It's skill, planning...and luck. Isn't it? What happens to a person depends so much on luck."

They both went silent then, feeling the sweat dry on their bodies and resting until they began calling out to the officer, as they sometimes would, "We give up! Let us out! Help!"

And the officer got a surprise he'd never forget.

When they got into the car, they were uncharacteristically quiet. Marilyn lifted her nose over the edge of her book.

"You guys okay? Everything go all right?"

But the boys were looking at each other.

"We're living our dream—right now. Aren't we, Dean?"

"Yes. That was the one. That was the test," said Dean. "Now we know for sure."

"Know what for sure?" called Marilyn from the back seat. "Hello up there! What happened?"

"We were born to escape, Mom," said Phil.

Phil and Dean escaped from every bind at every jail they visited on their trip to Regina and back. With the one exception of the zealous, Houdini-informed officer, they escaped their binds so fast the officers got whiplash from their double-takes. Dean and Phil walked out with typewritten letters affirming their escape. And more often than not, they were given the handcuffs they

escaped from to keep as a trophy. Because more often than not, the officers thought, if they were young again, they'd like to be doing just what Dean and Phil were doing.

And Marilyn got to lie in the sun reading and listen to her boy be happy. She was making up for years of overwork. She wanted the trip to last forever. Her books ran out. At one stop, she picked up a *Reader's Digest* to read out of desperation, and found a very interesting article. And again she began to think about how she could save her son's life.

CHAPTER 16

This time, she was going to be more careful.

Shortly after they returned, she called up Doug Henning in L.A.

"I found something interesting in the latest *Reader's Digest*. The article is all about this work being done by specialists in N.Y. and L.A. where they inject oxygen into the cells that bursts the cancer out. I'm going to call them, but I need to ask a favour. Could you ask around too, to make sure they're reputable? I'm not making another trip like last time. Neither of us could take that."

"I've heard of them too. You call them, and I'll make some inquiries. How are you all, Marilyn?"

"We're still fighting. We won't give up fighting."

Soon Doug had responded with the nod: The people from the article were the real thing. With the number of the clinic tracked, Marilyn made the call. Phil was listening on the other line. She wasn't ever going to make another step without his full approval. Miraculously, within a half hour of trying, she was talking to the man featured in the article.

"Thank you very much for taking my call. My son has terminal cancer. I understand you are experimenting with a process

that knocks the cancer out. I want to know if you can help my boy Phil. He needs help fast. Now. We're in Canada. Giroux, Manitoba. Do you know it?"

The doctor didn't know Giroux. But he wanted to study Phil's most recent X-ray and medical history. Marilyn was an expert at getting her son's medical records now. Swiftly, everything was express posted to L.A. and into the doctor's hands.

Just a few days later, he called her back. This time, she knew the doctor had thoroughly read the package.

"He's too sick to come all the way to L.A., Mrs. Hornan. But I have a colleague at Johns Hopkins who's agreed to receive him right now. If you can bring Phil there now, he'll do all he can for him, at his own expense. We want to help."

Phil sat in the next room listening on the spare line. When Marilyn had hung up, she came and sat down beside him. "Phil, what do you think? They're standing by to try."

He was quiet for a moment. Then he shook his head gently. "I'm not going, mom. It's too late."

She kneeled before him in an instant, taking his hand and squeezing it, trying to send an electric current of her faith through him. "We can't give up, Phil."

"I'll never make the trip."

"We can do it together!"

"It's not that I don't have faith, Mom. But I can't do it."

She skipped a few breaths. "If you say so, Phil."

"It's nice he cares, though. Isn't it? He really cares."

"Yes. He does care," she said, fighting to control her voice.

"It's okay, mom. Don't be sad. I really want to be home."

"All right, we stay home. But I'm not ready to give up," said Marilyn.

"Neither am I," said Phil. He reached his arm around her shoulder and gave her a squeeze. "There's still hope, I know there is. But I want to tell you, you're really the best mom anyone could have."

CHAPTER 17

Phillip and Dean drove slowly under the lush canopy of trees in the North End of Winnipeg, an area unfamiliar to them. Dean was navigating with the Winnipeg city map. They'd left early for their appointment to be sure they could find the place. It was an inauspicious sight when they'd finally tracked it down: a tiny, squat bungalow that seemed to list to one side.

The woman who answered the door looked remarkably like her little house. She too was lifted straight out of the 1950s and leaned a bit to one side. She was wearing pink curlers tightly wound in her greying hair with a babushka tied around the back of her head. She wore a striped housedress with a flowered apron and worn slippers. "Come on in, gentlemen," she said, waving them in casually. "I'm just getting the tea." She instantly disappeared and the visitors walked inside, timidly. There was the smell of something delicious baking in the oven, but the acrid hint of a dank basement lay just below. Dean and Philip looked at each other, eyebrows lifting. Their mothers would never greet scheduled guests in curlers. But their mothers weren't psychic.

When you were psychic, maybe other things mattered more than outward appearance.

The two stood in the living room, unsure of where she wanted them, as they heard the tinkle of cups and cutlery through the swinging kitchen door. She banged back in, hitting the door with her hip in a well-practised move. "I know which one you are," said looking straight at Philip. "The spirits are all around you, telling me 'that's Philip.' Good. Let's not stand around, eh? Hot tea and cookies." Dean felt his face flush hot with indignation; it was obvious who was the one with cancer. He gave his head a slight shake. Don't judge too soon. Must keep an open mind.

Orange pekoe tea out of a Brown Betty teapot and hot homemade chocolate chip cookies set the visitors more at ease. Everything was so very homey and regular it was hard to remember why they were there.

"First of all, for any of you who may be wondering, I was born this way. This is a gift. *Au naturel.* I thought it was curse when I was a little girl. Well, imagine! Spirits talking to you, telling you things that no earthly person knows, when your friends are telling you about their dollies. You can get in trouble for being psychic with the grown-ups, let me tell you. But over the years, I figured out how to reign it in and make it work for me. Now remind me, how did you hear about me?"

"A friend of my grandma's neighbour..." began Dean.

"Word of mouth. Not surprised. That's how I get everyone. I don't need to advertise. It all comes to me. That's 'cause I'm the real thing. Let's get started. You like the cookies? They're good, aren't they."

They nodded.

"Everything that is or ever was vibrates at a certain frequency. Souls live on, and they're drawn to me. I vibrate at a higher

frequency than most, 'cause of my gift. Spirits come to me, my frequency slows down, and theirs quickens. That's how we communicate. And sometimes if the frequencies are right, they can do things. As I told you, there are spirits here already, all around Philip."

Now Dean felt cold ice shoot right through his veins. Were there really spirits there?

"What do they look like?" Dean asked.

"People," she said. "Just people."

"Philip has cancer," said Dean, "I told you on the phone. He has a tumour."

"I don't need you to tell me," said the woman. "They told me. They say Philip is very, very sick. Can you help this boy?" she asked the room in a booming voice.

Everyone was silent, as if waiting for a voice to respond. By the psychic's facial expression, they were responding. She nodded a few times, like she was listening to someone on the telephone.

"Yes. They can help," said the woman after a minute. "This is good news. They're going to vibrate their frequency onto his and shrink the cancer tumour. They're doing it right now. I command this tumour to shrink!"

The woman bowed her head and slumped into a pose of deep relaxation. Fifteen minutes passed as Dean intermittently observed Phil, who had closed his eyes, the resting woman, and the little room. A valuable-looking dark wood sideboard. Decorative plates mounted on the wall. A dirty dishtowel hanging from a TV table in the sitting room. Eventually she rose her head and coughed.

"That's it. The spirits say you're going to be fine."

"I am?" asked Phil.

"Let's double-check your tea leaves." She took Phil's teacup off its saucer, pursed her lips and aimed her nose at the bottom of the cup. She sniffed a few times. "You have nothing to fear from

this teacup. The good outweighs the bad. There's going to be a journey. Lucky boy! I could use a trip. Why do you guys look so depressed? Let me check the tarot as well."

She reached over to the sideboard with a slight groan and grabbed a greasy cloth bundle by its knot. She unwrapped the cards in two quick, unceremonious moves.

"Cut the cards once to the right," she said brusquely to Phil, shoving them his way.

He did so. She refolded the deck and placed the card from the top face up on the table.

"The magician," she said. "That shows you're sick."

"It does?" asked Phil, surprised.

"Look at his belt. It's a snake eating its own tail. What's next?" She drew the next card and placed it face up. "Four of Wands. Good luck. It also shows you live in the country. One more."

She drew. "King of Pentacles. That means courage. It's just as I said. You'll be fine. You just have to be brave." She wrapped the deck up again, and placed it back on the sideboard with another moan. "But I have one little gift for you as well."

She hoisted herself, slowing down and rapidly looking more and more weary, over to the sideboard. She slipped open the deep top drawer and returned with a flat stone on her upturned palm. She snatched Philip's hand which rested on the table and shoved the stone forcefully onto his palm. "When you feel that tumour pushing you, you push right back into this stone, okay? You push back, and you push it out. The spirits have already attacked the tumour with their frequencies. They say you're going to be okay. But you may have to push a bit yourself. Got it?"

Philip nodded. "Yes, ma'am. So I squeeze the stone?"

"Squeeze it, rub it, whatever feels best. Okay, it'll be $25 for everything," she said to Dean. "I'm tired now, I'll need to grab ten winks. Takes a lot out of me. I've got another client coming in a bit. Come back and see me again soon. It was a pleasure."

Dean counted out the two tens and a five he'd withdrawn from the bank specifically for this, and the boys walked quickly to the door, knowing when they had outstayed their welcome.

"Oh, hey. Either of you know a guy named Sir Arthur Conan Doyle?"

"Yes," Dean and Phil said in unison. Of course they knew the author of Sherlock Holmes.

"He's here. He's saying everything is going to be okay. In fact, all the spirits are now waving goodbye for now."

"Well, goodbye, then," said Phil, looking around the empty room, wondering how many souls were waving.

They drove off and away mostly in silence. Hoping for the best, but perhaps thinking the same thing: A nice little lady with curlers and fresh baking wouldn't lie about something that important for $25, would she? No. That would be too horrible a thought to entertain. Philip turned the smooth stone over and over in his hand, tossed it up, caught it and gave it a squeeze. At the first red light, he and Dean shared a silent look. Dean knew too well Philip would say nothing to upset his hopes. But there was no question Philip was thinking of Houdini—because Dean was, too. They'd become that close.

"Funny how she mentioned Sir Arthur Conan Doyle," said Phil. "His connection with Houdini and séances..."

"I know.

Houdini was their idol and the boys knew the story well.

After the death of Harry Houdini's beloved mother Cecelia, he tried desperately to contact her in the spirit world through psychics and séances. Each new hope was crushed as he met with fraud after fraud producing spirit phenomena that amounted to easily exposed magic tricks. When a psychic produced a Christian symbol that made no sense for the Jewish Cecelia Weisz, Houdini declared war. With his specialist's insight, he

could see these charlatan's gimmicks that regular people were duped by. Worse, people's emotions were being toyed with while they were handing over their hard-earned money for the privilege. To Houdini, mediums became a focus for the rage he felt at his mother's death. They were the scourge upon the grieving, vultures at prey. As his physical prowess was slowly making his daredevil escapes more difficult, he found his second career: debunker. He stopped going to séances with the hope of penetrating the veil, and began go with the express purpose of exposing crooks. He was a great success. Humiliating so-called psychics over and over, damaging their reputations and ruining their ill-gotten income, word spread. Mediums barred him from attending their séances. He was turned away at the door. Not a man to be deterred, he gained entry to séances by wearing a disguise of false beard, cane, glasses. Invariably, the fakers met their reckoning. He went as far as to offer ten thousand dollars to anyone who could prove their psychic abilities. Houdini never found one person to cash in.

So what were the chances Philip's tumour had been pummelled by the spirit frequencies?

Or to put it more boldly, what would Houdini have thought about the wellness clinic in Boston? Not much. And would he have humiliated the psychic in curlers? Of course he would have. History was coming alive in the worst way. Houdini's friendship with Conan Doyle died over his stubborn belief in psychics. But Dean wanted so badly to believe. He shuddered with sudden cold.

Outside of the city limits they accelerated toward home. The big Manitoba prairie sky spread out gloriously before them. And then the pink, orange, and blue faded away to darkness.

"We had to try," said Phil quietly, answering the unasked question.

"We have to try everything," said Dean. "Tonight I thought we could do some brainstorming. Maybe some sketching. A new

twist on the Chinese Water Torture, like we've been talking about. Let's get our ideas down."

"You sure you want to stay? It's a Friday night, after all."

"No question. I want to focus on escape."

Dean had an growing, unpleasant feeling. "Let's just focus on our show tonight."

The performance was for twenty people at a rural basement rec room house party. They were rowdy, the alcohol flowing, and they were so close the boys could smell the booze on people's breath, feel their body heat. All eyes were glued to the small tricks, yet the audience was fooled every time. That was a victory, but Dean couldn't get comfortable. They were too close and the big trick was coming up. Some magicians say performing for children is the worst. Dean contended the worst was a room full of beer-drinking men. They were the hardest to win over.

"Houdini rose to fame performing an escape from a wooden box and changing places with another person in three seconds. He called it Metamorphosis," shouted Dean over the drunken din. "It was Houdini's first signature escape and magicians around the world still perform their versions of it today. Phil and I will perform this for you, now!"

Garry Gunnarson had built Dean the trick crate around the time he'd built the coffin for the failed underwater escape. Dean would get locked in handcuffs, tied in a large bag, and locked in the box. Phil would draw a curtain in front and step inside the curtain. When the box was unlocked seconds later, it would be Phil inside. But Dean was always worried about Phil's central line, which was a clunky box sticking out of his chest near his heart. In such a small, dark, confined, space it could get damaged or dislodged.

"Metamorphosis: a profound change in form from one stage to the next in the life history of an organism, as from the caterpillar

to the pupa and from the pupa to the adult butterfly," Phil hollered as he swooshed the curtain shut. Dean heard his friend's muffled voice from within the bag and crate and he smiled. Phil had developed a true showman's delivery. He'd come so incredibly far. "Prepare yourselves for a miracle!"

Phil disappeared behind the curtain. In moments, Dean was free and Phil was gone.

Members of the audience leapt to their feet cheering and clapping. Even Dean and Phil were amazed by how smoothly they'd pulled off the Metamorphosis.

"Bigger and better things are around our corner," said Dean, as the boys packed up their equipment.

"I feel it," said Phil.

The next time they drove to Winnipeg with Marilyn.

"We should just see the thing. If it looks okay, we could try," she said.

"Doesn't hurt to try," said Dean.

Marilyn had heard about an evangelical, charismatic church where if the mood was right, you could become empowered with supernatural gifts. It was common to see people so overflowing with the holy spirit, unknown languages spilled out of their mouths as they began speaking in tongues. She'd heard stories of healings that happened right there in the aisles, right before your eyes.

They got there early to suss it out. Friendly people filing into pews, taking a moment to greet the new people. For a time it was like a regular church. Maybe people were a bit more chatty. Then in a moment, the place was packed. There was buzz in the air that reminded Dean of attending a concert. Or a magic show.

CHAPTER 18

"You want pizza *now*?" asked Marilyn, checking the clock to confirm what she already suspected. "It's after midnight!"

"I need hot, gooey mozzarella and pepperoni the way a fish needs water," said Phil.

"How could I deprive a fish of water? You got it," said Marilyn with a new kind of zeal. "Sounds so good, I wouldn't mind a slice of that myself."

All through the illness she'd stringently treated him like every other boy. He'd have to put some of his own money if he wanted to buy something special. Treats were modest. Who'd let their teen put in an order for pepperoni pizza after midnight on a weeknight? After all, the doctors didn't want him ruined, and neither had she. But now, all rules were tossed straight out the barn door and the farmhouse window. It was pizza and presents and pop and any strange cravings Phil had at any hour.

Marilyn wiped a tear from her cheek with her apron as she rolled out the pizza dough. Why oh why hadn't she bought him anything that had caught his eye all these long, painful years? Made him Philip and the Chocolate Factory and given him the

golden ticket to stuff himself with every creamy, delicious con-
fection she could find. Why had she ever listened to the doctors?
As if Phil could ever have ever been ruined. In whatever moments
they had left, he was going to get everything on earth he desired.
Maybe she could make up for acting like he had had time.

"Mom, I think I'm going to buy a motorcycle with some of
my money," called Phil from the living room, the TV roaring with
screams from the Chiller Thriller horror late show.

"Sure, Dad can take you shopping tomorrow."

"Tomorrow?! Fantastic!"

Saying "yes"—it was that easy. And was he ruined? Absurd.
He was her good, special, polite, loving boy. His head was peer-
ing in the kitchen door.

"Thanks, Mom. And Mom? I've been doing some thinking
about things."

"Anything you want to tell me?"

"I'm not quite done thinking yet. But soon. I just wanted you
to know I'm on it." He tapped his temple with a smile and went
back to his movie.

"Mom, Dad, I'm going up to my room to write my will. I don't
want to be disturbed."

An organized boy. He liked to have things laid out, like his
school clothes, matching socks and homework. Phil liked to pave
a rocky road. He knew it would be hard enough, didn't want his
parents to have extra details to bother with when he died. After
several hours, he emerged and showed Marilyn a sealed envelope.

"This is what you'll find in my desk when I'm dead," said Phil.
"If you try to open it beforehand, I'll know."

"I wouldn't do that," said Marilyn.

"Good." He flipped the envelope to reveal his signature across
the flap. "This will ensure it. I'll check the integrity of this envel-
ope daily."

"Phil!"

"Nothing personal, Mom, people get curious! Besides the will, there's something personal for each person in the family here. I want you to read the will to immediate family only, please. No aunties and grandmas. And by immediate family I also mean Dean. He's my brother, Mom."

"I know, Phil. Whatever you say."

Dean stopped going in and out from Giroux. Like a fifth son, he became part of the everyday Hornan troupe. All the brothers moved back, or stayed there most of the time. The house rattled under the stampede of adult men, eating, talking, running in and outside. By the time all the guys at the Hornans' had had their showers, the water was ice cold. Marilyn didn't care. Time was passing. Having everyone around was like when the boys were young. And her youngest boy was dying. She didn't want to consider the time when the house would be quiet and her shower hot and luxurious. Once the boys had run her ragged. She could visualize the most frightening thing in life for her would be a quiet house.

Bill Brace had been a regular visitor to their home ever since Phil had been given the news. Bill and Phil talked and practised magic. Now Dean was there, it was like a small Giroux Linking Ring had sprung up in the middle of the prairies. Bill would often bring vintage handcuffs to practise escape on. They all took pleasure in discussing the workings of the old locks.

"That's why I had my museum for so long," said Bill that day.

"Had?" asked Phil.

"That's what I said."

"You had an actual museum?" asked Phil.

Bill relaxed back, and put his feet up on the coffee table. "It was more like an old cabin, to tell the truth. It was near Clandeboye, but for years and years that was my—unofficial

mind you—RCMP museum," he laughed deeply, perhaps thinking of the red tape of an *official* RCMP museum. "I did it my way. I've been collecting old RCMP stuff ever since I was a young officer. I never thought it should go to waste. Cuffs, scrapbooks, all forms of ephemera I thought people would have an interest in. It was open to the public by appointment. Couldn't keep it going as I'd have liked."

"So you've got all that stuff in your apartment now? That's what I do, too!" exclaimed Dean.

"I've heard about your place, Dean," said Bill. "It's not like that. I've been giving stuff away to good homes for years. And speaking of which, I'd like you to have these cuffs, Phil."

"Thank you, Mr. Brace, but if I were you, I wouldn't give them to me. I won't have them long. Then what will happen to them?"

"Keep them," said Bill. "Don't worry about tomorrow. It would make me happy."

Gordon and Marilyn were downstairs watching television late into the night. They were tired but didn't want to sleep. If you sleep, you miss things.

"Mom! Dad!" called Phil, and Gordon and Marilyn were up the stairs in an instant. Phil never cried out. But when they arrived, he looked snug and comfortable in his single bed, the room lit in a cozy yellow glow by the small bedside lamp.

"What are you doing, honey?" asked Marilyn. "I thought you were fast asleep."

Spread out on before him on the homemade quilt were an array of handcuffs.

"I was thinking," said Phil. "Then I had to look at the cuffs. Check these out, you guys."

Gordon and Marilyn sat on the bed. Phil handed Gordon the new addition from Bill Brace.

"Dad, these are from the '40s!"

"That's the kind they used on me back when I was your age and got arrested."

"Very funny, Dad."

"Bill is a very generous man," said Marilyn. "Look at all these. You've got a real collection now, don't you?"

"It's about all this stuff, Mom. After...after..."

"Don't you worry about it, sweetheart," she said.

"That's for us to worry about," said Gordon.

"But I *want* to worry about it. And I don't want the two of you to have to figure this out when you'll be upset about losing your son."

Marilyn and Gordon were silenced. Phil continued. "I didn't set out to get all this stuff. I bought some magic tricks for practice, people have been really good to me and given me things to cheer me up, and all of a sudden I have a collection. And a really, really good one. These handcuffs from Bill are vintage. Look at all these others, too. I have rare posters, tricks, super rare books, cool things Dad has made for me that are one of a kind. I have things Doug Henning gave me. I have a coin that belonged to *Houdini!* How many people can say they have something Houdini owned? Not many. It just hit me now: I would like a room in the house with all my stuff set up, so other people can enjoy my treasures."

"In the house?" exclaimed Marilyn, envisioning a train of strangers trudging through her living room and up the stairs, using the washroom, pulling up a chair to the dining room table and filling up a plate when the meal appealed. "I don't know how that could work."

"Bill gave me the idea. He had a tiny little cabin that he called his unofficial museum. It wasn't big or fancy."

"So it was a little museum," said Gordon.

"Do you think...I could have a little museum?" asked Phil.

Husband and wife looked at each other, both of their faces in shadow.

Gordon nodded, "Yes, that would be possible," he said.

"Really?" asked Marilyn. "How?"

"Things can be done," said Gordon in his plain way that made you believe his simple exterior hid deep capabilities.

"Dad knows how to make anything, Mom! If there were a museum, then people from all over could share in all these amazing things," said Phil. "They could share in my good fortune."

"Your good fortune, Phil?" choked Marilyn. In the wee hours, her defenses went down. She found it hard to see anything good in the nighttide. She began to cry. Phil took her hand and squeezed it gently.

"I'm not afraid to die, Mom, don't be upset for me when I'm not upset," he said. "I am going to my reward. How can that be bad?"

"How do you see dying, Phil?" asked Gordon. His son's grasp of his situation so far outweighed his, he needed to hear.

"I'll be with God in his castle, waiting for you all there. I'm just going ahead of you so you have someone to welcome you. Think how great that will be. And when it's your turn to die, you don't have to be sad or scared, just think of it as coming home—to me."

Gordon took his son's hand. Now all three of them were linked. "Maybe we should make your magic museum a castle," said Gordon. "Not a castle big enough for a king, mind you. But a castle still, just a little bit like where you'll be in heaven. And kids who come to visit always remember it. Kids love castles."

"Dad, could you?" said Philip. "That's exactly what I'd like."

"Yup, I think I could do that," said Gordon.

"Well thank God your father is handy, I always say. Though I still can't see how—"

"There could be magic shows there, too, and magic meetings," said Phil.

"That would be a great thing," said Marilyn. "Here, in Giroux though? People don't really come to Giroux unless they have to."

"It would be the reason to come to Giroux," said Phil. "I loved living here, Mom and Dad. It's the prettiest place on earth. Thank you for my home here."

The family was silent for a time.

"What'll we call it?" asked Gordon. "Your castle."

"That's easy, Dad," said Philip. "'Philip's Magical Paradise'."

"You're right, that's it," said Gordon.

"You think so too, Mom?"

"Yes, you got it Phil, that's the name."

With that, the boy became tranquil and settled back on his big feather pillow. They were sure he'd begun to snore, when his eyes popped open, and he said with a sleepy urgency, "Dad! Remember the player piano at the Magic Castle, Emma? Could we have an Emma for Philip's Magical Paradise?"

"Ha! I'm handy, as your Mum says, but I don't think I can build a piano. But I promise you one thing: If I can find you an Emma, I'll get you an Emma."

"Your promise is worth a lot, Dad," said Phil. With that, he was asleep.

Marilyn leaned over and switched out the bedside lamp. They sat for a few minutes in the dark, listening to the sweet, regular rhythm of his breath, holding hands.

"You just volunteered to build a castle," whispered Marilyn.

"Sure looks that way."

"Gordon Hornan, you never cease to amaze me."

"I can't believe we're going to be without him," said Gordon.

"I know."

"I figure I'll need something to keep me busy. Might as well build a castle."

"Good point, my love."

CHAPTER 19

Gordon Hornan said to Dean, "Well, son number five. It's time we put you to work out here. What are you going to do?"

"Anything you'd like me to, Mr. Hornan. I want to help."

"Has anyone taught you to cultivate a field?"

"No sir," said Dean, stretching and flexing his muscles, "but I'd be happy to try."

Gordon and Dean sauntered off into the fields. A few hours later, Gordon and Marilyn observed Dean diligently driving the tractor from afar.

"Well, he sure is trying," said Marilyn.

"Yup. It's not what I'd call straight lines," said Gordon.

"Not what I'd call straight, either. Now I think of it, we probably don't need him to work anymore," said Marilyn.

"Just what I was thinking," said Gordon.

When Phil's motorcycle arrived, though, who could get anyone to do anything practical anymore? Dean borrowed Mike Hornan's three-wheeled Honda trike and the two blasted all over the coulee and the fields. Nothing but curves, sun, fresh air, dirt, trees. Lungs full of fresh air like they were running faster than

they'd ever run and would never get tired, no matter that Phil limped, these wheels would never quit.

Phil and Dean skidded to a stop, taking in the Giroux sunset.

"I'll never understand why our sunsets get that bright pink here," said Phil in awe.

"Me neither."

"It makes me think about all of our plans. 'Cause our plans are so beautiful, you know?"

"That's a nice way to think of it," said Dean with a slight double take. "But our plans are happening. They're not just something pretty to look at."

"I know," said Phil. His eyes were locked on the sunset.

"And speaking of which," said Dean, "I think we should make a timeline. For our big show, the way Doug Henning did it with his first big show, but ours will geared to escape instead of magic. He broke out with his show and became a household name. That's just what we need to do. Start shaping all our ideas into one big stage show. Find a producer. A choreographer. A musician to write us an original score. We could try to make some links with stage people in Toronto. If we make this dream come true, everything else will open up."

When Phil didn't answer, Dean added, "Right?"

Phil was absentmindedly holding the Houdini coin on his necklace. "Once you told me that you used to see Houdini all the time, and then he stopped appearing to you. Have you ever seen him again?" asked Phil.

"No," said Dean, scuffing the earth with his sneaker.

"I wonder why."

"I have faith I'll see him again," said Dean. "You've got to have faith."

"Yes," said Phil softly. "You do, don't you?"

"Faith can make anything come true."

"Let's make our dreams come true," said Phil. "Let's do it."

"Let's do it!" said Dean.

They looked back out at the sky's waxing palette, deep yellow streaking through the pink. Phil's Casio watch screeched through the silence, and both boys jumped. Laughing, Phil said, "I think the watch is saying it's time to ride one more time before nightfall."

Sometimes Phil's brothers would join in on their bikes, sometimes some other Giroux friends tore up on a motorcycle, weaving in and out amongst the boys, laughing with them. Life was fun, and resolutely normal, like a summer holiday. They all rode together, children playing in a unified group for a perfect moment in time.

Then one of them left the group and the moment was over. The brand new motorcycle sat parked in the barn and a spider's web appeared on the handlebars. A fly struggled in the sticky silk. Dust settled on the seat. Phil took to his bed. The growing tumour pressed against his lungs so he was hooked onto an oxygen machine. The family organized a watch, taking turns sitting with him.

Phil barely spoke, but his Casio watch continued the conversation, beeping out through the silence, calling out the times for his meds. Phil held his Houdini coin. Friends from all over came knocking on the Hornan door. They wanted to spend a bit more time with him. Phil now refused visits.

"No," he rasped. "Just family. You, Mom, Mike, Rob, Darrell, Bill Brace, and Dean."

"Honey, you know you don't have to be anything but yourself for people who come by, right?" said Marilyn. "It's just Donna from next door. She's known you all your life. She doesn't care how you look,"

"I know she doesn't mind. But I don't want her to remember me this way. I want her to remember me riding motorcycles on the coulee."

His Casio watch rang out.

He sank down further into deep hibernation. His hand dropped lazily to his side, his grip on the coin loosening. He laboured for a breath; the rattle of air down his windpipe among his last ties to the earth. Except in his mind he was still finalizing plans for his Magical Paradise Museum. "Dad?"

"I'm right here, Phil."

"One thing that's missing for the Paradise. We need this."

"What is it, Phil?"

"Can you make a transformation box?"

"I don't know if I can. What is it supposed to do?"

"Like if I walked into the box, closed the door behind me, and saw myself in a mirror..." Phil choked and fought to breathe.

"Take your time, boy. I'm not going anywhere. I'm listening."

"...I see me but then I gradually change into something else."

Gordon nodded slowly.

"Dad? Can you do it?"

"Yup. I'm just thinking here... It could be the size of say, a telephone box. One wall could be a trick mirror. Hmmm...the box would have to be all black for the effect to work. Then make the lights change on a timer hooked to the door. The lights go down to nothing, and when they come up they're focused from another source and that would change the mirror..."

Phil nodded, a smile tugging at his otherwise immobile expression.

"That's...it. Brilliant."

"Yeah, I could design something like that. But what should we have the person turn into?" asked Gordon.

Phil's face became grave. "I don't know."

They thought to the sound of their breathing, Gordon's soft and measured, Phil's broken and noisy.

"I don't know either," said Gordon. "I can build it, but I need you to do the imagining part for me. I always need you for the

brain work. We're a team like that." His body trembled as his fought a sob. "I can't do without you, boy."

"Dad. You were the best Dad who could ever have been for me."

Phil would never shave, terrible to think he wouldn't see his son age any more.

"My boy, my boy..." he repeated softly, like a song.

The family joined Gordon soon afterwards, all laying their hands on Philip so he would feel their warmth.

In Philip's mind, perhaps he stepped into the black box made for him with love by his father, knowing his mother was supporting the project all the way. He shut the door behind him without fear. He believed in magic. He had faith. He stood looking at himself in the mirror. *Philip Hornan—that's me,* he thought. Loved by many. Lover of the natural world, and the realm of magic. Right on cue, the lights in the transformation box began to dim. Who knew why? It was a mystery, only the master builder knew exactly how the timer was set. Everything faded to black. When the lights came up again, only Philip would see what the mirror reflected.

He died with all his family, which included his chosen brother Dean, holding him. It was September 27th, 1986.

CHAPTER 20

Like they'd all fallen to earth from a great height and survived, the family staggered, stunned, after Phil took his last breath. What remained to be done was no surprise though. They had been well prepared by friends in who to notify and how to proceed. Gordon phoned the funeral parlour to set the works in motion. They wanted things done briskly. Moving together as a family, Gordon, Marilyn, Darrell, Rob, Mike and Dean saw the funeral director.

As the meeting drew to a close, Gordon said, "Is this the part where we pick the casket?"

"Oh, no, Mr. Hornan. We don't keep caskets on site here," said the director. "We don't have the capacity. No, you'll simply choose from the catalogue."

"Oh. I'm not sure I like that."

"I'd like to give you one of my coffins to bury Phil in," Dean said. "If you'd accept it."

"Did you say 'one of your coffins?'" the funeral director asked incredulously.

"I think Phil would like that," said Mike without even looking at the funeral home manager.

"They're all trick coffins, aren't they?" asked Gordon. The focus now entirely on Dean.

"No, I collect all kinds. And Phil doesn't need a trick coffin. He's made his escape already."

"Yes, he's not in pain anymore," said Gordon. "I like this idea."

"What, may I ask, is a trick coffin?" asked the funeral director.

"Phil and I were escape artists," said Dean. "There are internal secrets, known only to escapists, regarding coffin escapes."

"I like this idea 'cause Phil would like it," said Marilyn. "Can't you just see his face?"

The funeral director stood to gain advantage. "I'm skeptical —to say the least. This isn't done. People don't just...supply their own coffins. No, no, no, not in 1986! Especially not 'trick' coffins!"

"If you think I'm going to show you how it works, you're wrong," said Dean. "That's a magician's secret."

"I don't want to know your magician's trade!" cried the funeral director. "But I have a right to know what I'm dealing with!"

No one was listening to him.

"What do you think, Marilyn?" asked Gordon.

"That it's just right," she said.

"I want this done. Let's go get it right now," said Gordon. "Who's coming with me?"

"I'm going to stay with Phil," said Marilyn. Rob and Darrell stood with their mother.

Gordon, Dean, and Mike squeezed into Gordon's truck, and they drove straight in to Winnipeg, to Dean's little Kennedy Street apartment.

"Whoa," said Gordon upon entering. "This is...unique!"

"You said it," said Mike. "Can you actually live in here?"

"I heard about this apartment—but I still didn't believe it," said Gordon.

"Seeing is believing," said Mike, spinning slowly in a full circle.

"Yeah, there is a lot of stuff I guess..." said Dean. "Phil and I were going to make a really big show. It was going to be how we got noticed by the magicians and TV people in the US."

"We'll talk," said Gordon. "Sometime soon I'm going to have a place for you to keep all your magic props, Dean—if you want it."

"Really?"

"Yup. But more about that later. My brain seems like it's only able to deal with one thing at a time today."

The men examined all of Dean's coffins and chose the one. How the escape trick worked cannot be revealed. The elevator door dinged open on the main floor, and the caretaker watched wide-eyed as the three men carried the coffin out like pallbearers and loaded it into the back of the truck.

"Dean Gunnarson," the caretaker called across the lawn, "there oughtta be a law against what you keep up there!"

"Thank you, sir," Dean waved back, jumping into the truck.

Dean decided to stay at the Hornans' place until the funeral was over. It was only two more days, and he was reluctant to leave the little nest they'd all built together. They were Phil's family, after all. It would have felt too cold, too lonely to go back to his apartment. His parents had been divorced for years, and Bev had remarried. It was too quiet at his dad's cabin. And of course, he hadn't lived with his mother for a long, long time.

As he sat in the living room in the comforting presence of other people who mourned Philip, he thought of his own mom with every sound of Marilyn's anguish. He'd made his mother cry enough times. The worst part though, was later, when she

stopped crying, and looked at him coolly, without emotion. It seemed a cruel justice to be mourning his best friend and have to, at the same time, face his own faults as a son.

"Hi, Mom," Dean said softly, borrowing the Hornans' phone after everyone had gone to bed. "It's me. Dean."

"Dean? What's wrong?" said Beverly, heavy with sleep.

"Phil died today," said Dean with a sob he wasn't expecting.

He heard her switch the bedside lamp on, and, so it seemed, struggle to sit up in bed.

"I'm very sorry to hear that. You've been living with the Hornans for quite a while, I hear." She hoped her pain at the thought of Dean living with another family wasn't betrayed in her voice. In the deepest corner of her heart, she could admit her jealousy that he had seemed to choose another family. But she knew it was not necessary to share her hurt.

"I wanted to be with Phil till the end," said Dean. "Mom, we all held him while he died."

"Oh, Dean," she said, "I'm so sorry you lost your best friend."

"Mom…" He wanted to say something more to his mother. He just didn't know what it was.

"Yes, Dean?"

"Could you come to the funeral?"

"Of course. Was there something else you wanted to say?"

"I'll see you at the funeral, okay?"

"I'll be there," said Beverly.

CHAPTER 21

The very next day, a Sunday, final respects were paid at the Steinbach funeral parlour to a coffin closed at Phil's request. An elderly relative had a very old-fashioned practice of photographing the dead that Philip had always hated. He would not be one of the collection.

The funeral was on a Monday afternoon. Phil had asked that Doug Henning be a pallbearer, but he was performing and couldn't make it to Manitoba on time. In lieu of flowers, the Hornans asked that donations be made to Ronald McDonald House.

The funeral church was packed to overflowing. With the warmth of the fall day, the congregants were sweating heavily. Dean greeted people in a blur of heat and emotion, and then sat with the Hornans. The apse and chancel were flower-laden, and the fragrance of the flowers was choking. A lone bee had survived the onset of fall and buzzed from blossom to blossom in a quest for nectar. Sobs broke out throughout the service. Dean focused on his casket and breathed deeply, trying to drive out tension. Afterwards, everyone milled about in the church, hugging and

giving their sympathy. Dean said hello to his mother and step-father but neither was prepared to come back for the wake.

"We have other obligations today," said Bev. "But your place is here."

Through a clear edge in a stained glass church window, he watched his mother walk away toward the parking lot, knowing he must leave the protective nest of the Hornan farm too.

Phil, he thought. *Why did you leave me alone?*

Voices mingled and became a cacophonous roar. How would everyone fit in the Hornans' house later? A man with dark hair and a dark brown suit flitted through the periphery of Dean's vision. Dean swung around but couldn't catch another glimpse.

"Did you see a guy in a brown wool suit?" Dean asked an elderly woman.

"I hope no one is wearing wool in this heat!" was her only reply.

The Hornan farmhouse creaked as it swelled with well-wishers, every room swarming. The kitchen brimmed high with donated casseroles, the air redolent of garlic and cinnamon. Voices booming, alcohol flowing, the tinkling of cutlery on plates. The same words rang out from all corners, for there was a lot to say, about the injustice of a death like this, and the rare qualities Philip had. *Blooming, gifted, promising, tragic, unjust, heartbreaking.*

Through the crowd, Dean saw his lady friend enter, the one Philip had liked the best. Once she'd clasped her eyes on him, she waved vigorously, and fought her way through the horde.

"Talk about a big surprise," said Dean. "I thought you said you had to work!"

"I did, but I got off early. I wanted to be with you," she said, taking his hand. "I knew how hard this would be. And after all, Phil was so great to me."

"You're a really great person," said Dean, meaning it but starting to sweat. He peered left and right, surreptitiously.

"What are you looking for?" she asked.

"Nothing!" said Dean.

"Calm down! I saw you looking left and right. Are you looking for someone?"

"I don't know what you're talking about."

Not long afterwards, another lovely young woman entered the throng.

"Excuse me for a moment," he said. He moved nimbly into the pressing crowd and disappeared from his friend's view. But he'd gained the elbow of the young lady who had just entered, pulling her aside with a "What a surprise! I didn't expect you to come!"

He steered her into the living room and into the far corner.

"I know we'd talked about me not coming," she said. "But I wanted to be with you. I knew how hard this would be."

"That's so thoughtful," said Dean.

"After all, I loved Phil too. He was such a nice guy."

They spoke for a few minutes, and Dean said, "You stay here where I can find you. I'm going to the kitchen to get you a drink and something to eat."

"That's okay, I'll come with you," she said.

"No, you stay here. This place is way too packed. Keep our place here."

"But Dean, I'd rather—"

He made his escape to the kitchen. Looking left and right, he couldn't see the woman he'd left here fifteen minutes before.

He ran his fingers through his golden hair. "Oh, man, oh man..."

Darrell came in. "Oh, there you are! Hey, your girlfriend is looking for you," he said.

"Which one?" whispered Dean.

"Excuse me?" asked Darrell.

"Blond or brunette?"

Mike entered from the other way, "Hey, a girl who isn't your girlfriend is looking for you."

"Blond or brunette?" asked Darrell.

"Huh?" asked Mike.

"Guys, I need your help," said Dean.

"Hey, you don't have two women you want to keep apart here by mistake do you?" asked Rob, entering the kitchen. "'Cause there are two very cute girls both looking for you. One's got dark hair and the other one is a blond. Both said you disappeared on them."

Dean's manager Bryant followed on Rob's heels, saying, "Ha! Let's see you escape from this one, Gunnarson."

"I've got to do something!" said Dean.

"No, I don't think you do," said Mike. "When I left them, they were both talking to each other. I don't imagine you have to do anything now except keep out of the line of fire."

Dean went outside to hide behind the barn. He sat with his back against wood, courting a distinct feeling he needed to grow up in some way, but he wasn't sure how. The big prairie sky spread before him and he felt very small. He knew the air should be sweet. Hadn't he breathed it in beside Phil out here enough times? He felt like he couldn't take in a good, deep breath. He wished he could believe his friend was looking down on him. Right now, all he knew was at least Phil wasn't in pain anymore.

"What are you doing back here?" asked Phil's next-door neighbour Donna, golden hair blending in with the colour of the fields.

"Hiding," Dean said.

"Me too," said Donna.

"What are you hiding from?"

"I don't like crowds. Isn't that what you're hiding from?"

"Yeah, sure," said Dean. He knew he sounded surly, but he wasn't himself.

"I feel sad," she said.

"We all do."

"I won't bother you," said Donna. "I guess you want to be alone. I know you were closer to him than anyone. Just wanted to say I'm sorry you lost your best friend.

"Thanks," said Dean. "I know he really liked you too, Donna. I'm sorry for your loss as well."

"Thanks."

With that, she slipped away.

Later that evening, when he heard the last car pull away, he snuck into the house and began shoving all his things in his khaki duffel bag. It didn't take long. Then he presented himself in the living room. Marilyn and Gordon were sitting close together talking about the day, exhausted but unable to relax.

"I'll be going at first light tomorrow, so you probably won't see me" Dean said. "Thank you for putting me up this long."

"You're a part of the family, Dean," said Gordon.

"You made Phil very happy," said Marilyn. "You're always welcome here."

Dean had never heard them sound so tired. He left them in each other's company and went outside to have one last walk around the fields he and Phil had roared across not even a month before.

A shot suddenly rang through the air. Then three more in quick succession. They were coming from the barn. Dean sprinted across the ground and was inside in seconds.

Darrell had a beer in one hand and a pellet gun in the other.

"Dean, check it out," he said. He aimed and shot. A barn sparrow plummeted from the rafters, thumping to the ground. "I'm five for five."

"What are you doing?"

"What does it look like I'm doing? Shooting sparrows."

"Why?"

"Who cares? They're just birds. Not little kids."

Dean saw the misery in his wild, red eyes.

"I don't care about anything tonight" A sob broke Darrell's voice. "Let them die."

Dean wanted to shout at him, *I don't care if they're just birds, what you're doing is senseless!* But he couldn't speak. He understood Darrell's need to do something. Dean wanted to let his pain out too.

He turned and ran back to the house. Gordon and Marilyn had disappeared from the living room, and only a small lamp glowed. Dean retrieved his bag, threw it into his truck, and blasted out into the night. He'd wanted to sleep there one more night. Now he knew nothing would make him feel less alone—so he may as well *be* alone.

Driving down the black rural highway in full white-line fever, the pellet gun and the blood before his eyes, the thought came to him so easily as to what he could do to ease his own pain. There was a person who had preyed on his weakness. Made him hope, despite his best instincts, despite what he was sure Houdini his hero would have thought. Phil's death was so unfair, Dean knew if there was any justice, he'd have to be the one to administer it himself. He would shoot his own pest.

But when he got home, he was so tired. He needed to rest first. For all the flack he took about his pack-house of an apartment, Dean loved his little place across from the legislative building. But in the days after Phil's death, the place felt so cold he could have sworn the radiator was out, though it felt hot to the touch. He saw his piles of tricks no longer as pieces that added together could make a great show. They were piles of junk. He rattled around the place in his pyjamas and robe for a few days mostly sleeping, noting with dull interest how he didn't appear to feel emotion. A few days later, he was ready to try to feel something.

Dean rattled his rusty truck down a familiar North End street and pulled up in front of a tiny, squat bungalow that seemed to list to one side. She answered the door wearing pink curlers with a babushka. Dean wondered if she *ever* took her hair out of the curlers. This time her housedress was pink, but the same worn slippers. "Come on in," she said, "nice to see you again. I'll get the tea." The dank basement smell was stronger than he'd remembered. This time he knew where to sit. She knocked the swinging door open with her hip. Orange pekoe tea out of a Brown Betty teapot. No cookies this time.

"You remember me," stated Dean.

"Silly boy, of course I do," she said. "Don't you remember *me*? I'm psychic!"

"How silly of me. Even if you didn't remember me," said Dean, "you'd know who I am."

"You're starting to get it," she said with a wink.

"Yes, I think I am," said Dean.

"I was very sorry to read about your friend in the paper. That's too bad. Too young to die."

Dean leaned back, closing his eyes involuntarily, feeling his pale skin flooding with blushing rage. His mind was lucid though. Something he'd lacked when Phil was alive, and so much depended on what this woman was going to say.

"Do you remember the reading you gave him?"

"I remember everything," she said brazenly. "I gave him a job too, if you'll remember. I told him to push on that stone. Everything is a two-way street."

She closed her eyes and stretched her arms out languorously like wide wings about to make a lazy embrace.

"You picked a good day to drop in. My senses are acute today."

"Great," said Dean, sitting back, aware he was about be given a show.

"I'm seeing a rural funeral. It was hot in that church. A lot of high emotions. Am I right?"

"You're absolutely right!" exclaimed Dean. "Incredible." With her eyes still closed, she smiled at her insight, and nodded.

She probably read and memorized the obituary column every morning like a student would a textbook. Anything else she could imagine. Of course this all came back to Houdini—didn't everything always? Houdini would have exposed her fraud without a moment's hesitation within the first five minutes the last time they met. They'd wanted so much to hope. But Dean was in a colder and more calculating frame of mind today.

"Are you ready for your reading?" she asked. "Everything is aligning."

"By all means," said Dean. "What method will you use today? Because last time you used just about every—" He stopped himself in the nick of time from saying "every trick in the book." "You used every method at your disposal."

"I have a feeling," she said with a low voice, "that a séance would be extremely productive today."

She leaned over and from her handy sideboard, grabbed a large box of Eddy's wooden matches with the image of a bird flying away. "Turn off the light, will you? Over there."

Dean got up and flicked off the switch by the door. She struck the match and he traced its yellow glow back to the table. He was amazed by how dark the room was at midday. Now a large white candle flickered, casting a sickly yellow hue on their faces. The mood changed. He began to feel the mystery of the moment. The inherent mystery of dark and shadow, that people in her business routinely exploit.

"Give me your hands," she said, and when she received them, he flinched. Her hands were icy and the skin felt as thin as rice paper.

"Oh dear," she said sharply.

"What's wrong?" asked Dean.

"I didn't expect this so soon. Your friend Phil is sitting beside you on your right-hand side."

Dean jumped in his seat and turned to his right. His body vibrated with unease. He wanted so much to believe. And *not* to believe this woman could use his grief so cruelly.

"Tell him I'm here," said Dean.

"Dean is here. He wants to communicate with you."

"What does he look like now?" asked Dean.

"He's looking really good. His face isn't bloated anymore. He looks downright trim!"

"Can you hear him?"

"He's trying to communicate. His voice is very soft. It's not uncommon for the new ones."

"Try—try!"

"He's moving his mouth, right by your ear, but you can't hear him. We can't hear you, Phil!"

They both held their breath, listening to the silence. Then she whispered, "At moments like this, I sometimes wonder if they are making sound and we're just not tuned in to their vibrations."

Then she called out to the spirit world, "I'm trying to hear you, Phil. Wait...wait..." she appeared to strain. "He's so quiet, he's just getting used to communicating from the other side. He says, 'Hi, I'm happy, and I'm not in pain anymore'."

"He said that?"

"Yes, and he's right beside you smiling, plain as day. Well clear—to the sensitive."

Dean looked to the right again, looked as hard as he could. The he looked into her pale blue eyes.

"Now that you can hear him, can you ask him something for me?"

"Sure, what do you want to know?"

"I want him to tell me the secret code we worked out."

"Secret code?"

"He knows what I'm talking about.'

She pursed her lips and raised an eyebrow. She didn't make eye contact with Dean.

"Let me ask him. Philip, can you tell Dean your code? Oh, really? Okay." She looked directly at Dean. "He says he's not done with his transition from this world to his new one yet, and he doesn't remember little details, just the bigger picture. And he told me something very interesting."

"What's that?" asked Dean.

"Your friend says there's no suspicion over there. No need to prove things. He told me to tell you to trust me." She smiled kindly at Dean.

"Well, that's good news, then," said Dean rising. She had broken a sweat, which gave him some pleasure. "What do I owe you?"

"Twenty-five dollars, my regular fee."

"Oh,' he said, checking his pockets, "oh, darn, I left my chequebook at home. Tell you what? I'll mail you cheque as soon as I get home. Trust me."

She closed the door behind him with a scowl. She was psychic enough to know she was the one who'd been duped this time.

CHAPTER 22

October brought a bone-deep chill and Dean wasn't feeling better about life. He no longer had a best friend. He had some women angry with him, and he deserved it. Bill Brace had called a few times, but he hadn't called him back. He hung out alone in his cramped apartment and wondered why some people live and others have to die. The phone rang.

"Dean, can you get out to my place? Winter is going to come early; I feel it in my bones. I need help putting this new roof on my house," said Garry Gunnarson, calling from his place just outside Riding Mountain National Park.

"I'll try to get out there soon," said Dean.

"Can you make it this weekend?"

"I don't know, Dad. I'm really busy right now..."

Now he was a liar.

"Your doves miss you too. You should really tend to the shed."

"Dad, you're going to have to tend them a bit longer."

Now he was slacking off in his responsibility to a whole flock of innocent living things.

When he hung up, Dean felt even worse about himself. He didn't make the drive up to Clear Lake.

Garry was truly worried about the doves, and his instincts were never wrong about the weather. When Sunday afternoon came round, he knew Dean wasn't going to show. It was a cold October day, and a light layer of snow from the night before wasn't going anywhere. He hauled out the ladder and leaned it up against the house to reach the second floor. He strapped on his tool belt and shoved a piece of wood for patching up under his arm, and climbed all the way to the top. Then he slithered up the roof, powdery snow flying into his eyes. He made it to the place he wanted to work. Just as he raised his hand to drive home the nail, he slid backwards off the roof fast like he was riding a sled. He hit the ground, his leg shattering in an instant.

He knew his window of consciousness was shutting. He lived a solitary rural life. It was more likely than not no one would call or drop by for days. He began to holler.

Then he passed out from the pain. He came to in a warm hospital bed, with the doctor clucking, "Mr. Gunnarson, you're going to be here for a very, very long stay."

"Now how did I get here?" Garry asked.

"A passerby happened to hear you yelling for help. Do you know how lucky you are?"

"Yes, I believe I do, sir," said Garry, with a deep sigh of relief.

Dean didn't take it well.

"It's all my fault, Dad," he said at the side of Garry's hospital bed. He didn't like to say it, but the sight of his dad in a hospital gown was frightening him. He'd had enough of people in hospitals, and of friends in pain.

"You need to stop saying that now, boy. Did you force me up that ladder? Huh? I could've waited till next weekend. I could've

asked someone out there for a hand. I walked into that stunt all on my own. You're not taking credit for my daredevil show."

"Okay, Dad, whatever you say." Dean smiled brightly to his father. He did believe he was responsible—but he kept that to himself. What was the point of arguing the point? He knew it sounded irrational, but it was true nonetheless. The accident was *all* his fault.

"Just get yourself out there and feed those doves, okay? Get someone to help you fix that roof. I don't want you doing it on your own. There's been too much bad luck going around lately."

"There'll be no one to mind them now you're stuck here," said Dean.

"You'll just have to talk to the neighbours. You'll find someone."

Dean drove down to his dad's place in the dark. He had fled the apartment upon getting the call from the hospital and hadn't packed a thing, or dressed for the country chill. He found his dad's worn old parka hanging in the hallway, threw it on, and went directly out to the dove shed.

He shone a flashlight over them. All those jittery little eyes on him. He pitied them. They were in his care—and he was a useless human being. He had let his own father down. His dad could have easily died. What kind of human being was he? He took a dove up in his hands. He could tell she was hungry. As if what he'd done to his dad wasn't enough, he was starving all these innocent little creatures. And now there would be no one to care for them. Dean put his hand around the dove's neck and with a simple twist and snap, it was over. No more suffering. No cold, no hunger, no pain. One by one, he picked up a dove, feeling its warmth and its heart beating impossibly fast, and twisted. He went on as if he were watching himself in his worst nightmare until there were no more coos, just blood, feathers and bodies everywhere. There was not one thing left alive in the dove shed.

Except for him. Dean collapsed to the floor, with the cold little bodies. He writhed, crying like he'd never cry enough, calling out for his heartbreak to stop.

He stayed at his dad's place for a few days, watching the fire in the wood stove burn. One morning he woke up with some energy. He cleaned out the dove shed, and then spent two more days prepping his father's cabin for winter. He hired some men to finish the roof. His last night there, he leaned against the door frame and watched the stars, the comforting heat of the fire and smell of wood smoke at his back. He cried again, but more calmly. He'd loved Phil. But he knew he needed to find his life again, because he was lost.

Bill Brace was relentless when it came to phone calls—a man not easily discouraged. You don't return Bill Brace's calls? You find Bill Brace at your door. But it didn't quite come to that with Dean. In the face of Bill's persistence, Dean finally returned his tenth call.

"You're harder to get a hold of than the last pickle in the jar," said Bill.

"Sorry, Bill, no offence, I just haven't been feeling myself lately."

"You know what cheers me up when I'm low?" asked Bill.

"What? No, I *know* what cheers you up. Going out for lunches, and dinners, or a few drinks, and being social, but I'm just not in the mood to—"

"I'm going to pick you up at 5:00 p.m. Be waiting."

Bill took Dean out to dinner at one of his favourite haunts, the Marigold Chinese restaurant on Portage Avenue.

"I know you said you didn't feel like going out to eat, that's why I've decided on the Marigold tonight," he said, driving west down Portage Avenue. "Once you get a whiff of this cuisine, you're going to change your mind about eating."

The restaurant was all red and gold glitter, the long bar lit up with lights. Bill didn't have to ask to be seated.

"Mr. Brace! Good to see you again," said the waiter, wearing his neat, black and red uniform with a Chinese collar. "We have your regular table all ready for you."

"Treated like a king, here," Bill mused, walking tall behind the waiter.

Dean saw how the whole staff smiled Bill's way, nodding and gesturing to his table like he was a celebrity. They settled into their booth. "Now—do you know your Chinese zodiac sign?" he asked.

Dean shook his head, so Bill pulled his paper placemat close to him and put on his reading glasses.

"Bill, I don't believe in the zodiac, so don't bother."

"What's your birthday?"

"January 27, 1964," Dean sighed.

"Aha! You are a rabbit, sir. Now, what does that mean? 'Gentlemen who belong to the rabbit zodiac sign always treat people politely, with a gentle smile that makes people feel that they are credible and sincere.' Yes, that's certainly you. 'When meeting trouble, Rabbits can handle it in an orderly way; when encountering tough difficulties, they are never discouraged, but are persistent to seek solutions.' Perfect! If that doesn't describe a good escapist, I don't know what does. 'So they eventually achieve enviable success.' You hear that Dean? You're going to be a successful escape artist."

"I wish I believed those things like you do," said Dean. "It's all scamming. Every bit of it."

"You sound angry," said Bill, lighting a cigarette. "I think you're misreading me, though. I love these placemats because they can be great icebreakers. For example, take a guy like you. Down so low down in the dumps, you've got to reach up to tie your shoes. Clammed right up, even though I know he's got

something to say. I agree with you about fortunes, but I have to admit—I think this reading fits. Every once in a while, the fraud hits on some kind of truth, right?"

"I saw a fraud," said Dean.

"Tell me about it," said Bill.

Dean felt like it'd been so long since he'd sat down and talked to anyone, he wasn't sure he could string a sentence together. But Bill was well able to steer a conversation.

"Start from the beginning. Take your time," said Bill. "I'm here."

Dean slowly began by telling Bill about the psychic in the North End. Now he'd remembered how to talk, he couldn't stop. He told Bill all about his mother and father as the men decimated egg rolls, deep fried shrimp, sweet and sour ribs, beef and greens, a few Tom Collins' for Bill and cans of Pepsi for Dean. And so naturally, Dean's spirits began to lighten and they began to talk about magic, too. Dean could feel his heart begin to warm and glow, like the Tin Man realizing he'd had a heart inside his chest all along. He'd agreed to the Marigold again next week because they hadn't had room to eat the lemon chicken. They'd try somewhere new the week after. No restaurant was open long enough for them to finish what they had to say about magic.

A few months later, they were back at the Marigold.

"Let's go to Vegas," said Bill, helping himself to a liberal portion of Kung Pao Chicken. "There's a magic convention coming up. Care to share a room with an old man? It'll be cheap if we split."

Old? thought Dean to himself. He didn't know what Bill meant. Dean looked at Bill and his ageless eyes. His energy and knowledge was unlimited. In fact, he was beginning to feel like he might have a best friend again.

"I've never been to Vegas," said Dean.

"I didn't hear you right. You're a magician and you've never been to Vegas? Okay, no two ways about it. We're going to Vegas."

Dean speared a chicken ball with pineapple, but he was so excited about Vegas his appetite had disappeared entirely.

"Also, I want you to be on a panel for me next week, judging a youth magic competition at Unicity Mall," said Bill. "I'd consider it a personal favour."

"Yes, anything you need. And yes to Vegas. I've wanted to see it so badly. Throw in a magic convention, and it'll be like going to heaven."

"You see? Life has its ups and downs. You just have to keep your faith when you are down."

The next week, Unicity Fashion Square was crowded with kids in glittering costumes or adult-looking suits, and parents helping them with last minute preparation. The mall, while successful for a time, was waning and had an empty wing. It was becoming known as a ghost mall. Voices bounced around the acoustically lively, empty spaces. But the seats filled up. Bill Brace knew how to get bums in seats.

Seeing the young people perform at the competition was the final intervention Dean's heart needed. They reminded him of Phil, kids with a dream and the bravery to try. He smiled and laughed, watching the simple tricks, and forgot about himself.

"Next entrant," said the smooth-voiced emcee, a radio personality with a baseball cap disguising his bald head, "all the way from Giroux, Manitoba—wherever that is—we have our first female competitor, let's hear a whole bunch of applause for Donna!"

Dean felt his heart stop.

There she was, Phil's next-door neighbour. Tiny, spunky, with her light brown hair pulled back in a ponytail. Her show was basic, but several notches above competent. What really set it

apart though was her live dove. No one else had a dove. She didn't win, but she placed well.

"Donna!" said Dean, when they shook hands afterwards. "You did great up there!"

"That means so much coming from you, thank you." Her dove sat on her shoulder.

"Where did you get that trained dove?"

"Where do you think, silly? It's one of the ones you gave to Phil. He gave it to me before he died. Did you think I'd trained it myself?"

"No, no, I'm just...glad."

"I love my doves," she said, and as if on cue, the dove cuddled up against her cheek. "His name is Norman. You should come down and see the Hornans sometime, Dean. They're all really sad."

"I will," he said.

"It's the weirdest thing. They think they hear Phil's Casio watch. They hear it beeping everywhere. I haven't heard it myself. But I think it's very understandable that they hear it. Don't you?"

"I do," he said.

"Anyway, you should come down. They have something for you from Phil. He wrote you a letter that was in his will. They're saving it for you."

"Really?"

He dropped in on the Hornans in spring.

"We've missed that mug of yours," said Marilyn as she walked him down the gravel road past Donna's house. "Strange not seeing you at the dining room table."

"Sorry Mrs. Hornan."

"We haven't had an easy time of it," she said.

"Same here."

"We figured as much," she said. "This is the place."

Marilyn pointed to a tiny old prairie church that had stood vacant on their road for so long, it had slipped on a cloak of invisibility. "It doesn't seem possible," said Dean, "but I don't think I'd even really noticed this place."

"You will when Gordon is through with it."

From inside came the sound of a one-man demolition crew, working at a leisurely pace.

"Gordon!" she hollered as they walked up the front stairs. Gordon was sliding out an old piece of drywall.

"Dean!" he said, pulling off his work glove to shake hands. "Good to see you, son. Long time no see."

"I've missed you all. And Phil."

"We miss him so much we can't really put it into words," said Gordon. "So we're going to put it into his castle."

It was a plain, little, run-down United church, waiting for…. something.

"I'd pass this place and wonder when it was going to be torn down," said Gordon. "Little did I know, it was waiting for me to give it a new life."

"Philip's Magical Paradise," said Marilyn. "It's going to be his castle on earth."

"You're going to make *this* into a castle?" said Dean.

"Hard to believe?" asked Gordon.

"Come to think of it, if anybody can do it, it's you, Mr. Hornan."

"If I can do it—I think I'll have earned my stripes as an official magician. It'll be nothing less than a transformation trick."

Its peeling white paint and buckling roof looked picturesque under the blazing blue sky. There were hundreds of similar places scattered all over Manitoba, left to decay and die a natural death.

Dean grimaced at the thought of all the work this transformation would take. "You're not doing it all on your own, are you?"

"Nope, neighbours from all over are going to help. I'm just puttering. Takes my mind off things when I have a free moment."

"I've started a magic club for kids in the area," said Marilyn. "When the castle is built, it'll be our meeting house. Gordon will build a stage, so there'll be a proper place for magic shows on the weekends."

"And, remember what I told went we went to get the coffin? We want you to keep your magic things in the castle, Dean. Phil asked in his will that it be your place, to use whenever you need. Put your stuff on display when you're not using it, come and get it when you need it. It'll be your place, too."

"That would be...perfect."

"Your caretaker will be a happy man," said Marilyn.

"You're welcome to pitch in with the building, you know," said Gordon.

"I'd like to, but I'm booked solid with magic shows for months."

"Thought as much. We've been following you in the papers. Phil would be proud of you," said Gordon. "Maybe you'll get those USA folks interested yet."

"I'm doing a fundraiser for the Rainbow Society at Tinkertown. I came out to ask Donna if I could borrow her trained dove."

"Don't you have your dove shed anymore?" asked Marilyn.

"No, when my dad went into hospital, I... set them free. Couldn't care for them."

"Wouldn't that be nice, Gordon? Phil's dove on loan to Dean for a show for the Rainbow Society. He'd just love that. Stop into the house before you go. Phil left a letter for you."

CHAPTER 23

Dean knocked on Donna's door for the first time in his life. He almost didn't recognize her from the magic show. She was growing up by the minute. She must look different partly because her long hair, usually in a ponytail, was down.

"Dean Gunnarson! We wondered if we'd see you in Giroux again. To be exact, some people wondered. But I knew you'd be back."

"It's good to see you."

He sat in their neatly decorated front sitting room while Donna got the dove from her bedroom.

"You take good care of Norman, now, I love him." She handed him the cage.

"I promise." He put his finger through the bars, and Norman pecked at it like it was lunch. Dean laughed. "He must remember me."

"If he does, I'm amazed," she said. "I barely recognize you! We used to see you all the time. What do you do with yourself besides magic shows?"

"Nothing."

"Pardon me?" asked Donna.

"I don't do anything besides magic shows and practising magic. Every single thing I do is focused on my single priority: to be the world's greatest escapist."

"Gee, that's too bad," she said.

"What's too bad?" he asked, shocked. He thought she'd be impressed.

"Too bad all you want is to be famous. Sounds kinda boring," she said.

"That's the first time I heard that I'm boring, thanks very much," he said, surprised how much this little kid had raised his temperature. "What do you do that's so great?"

"Spend time with my family and friends. Cook. Bake. Ride my motorcycle. Practise magic. Play with my dove. Sew. Learn at school. You know, a variety of things. Like, a regular life?" She stood up, and he found himself ushered to her door. "Well, have a good show, and get my dove home safe."

"I don't remember you having so much to say before," said Dean.

"I don't remember you listening much before," she said sweetly. "We all like you, so don't be such a stranger to Giroux."

Back outside again, he gave his head a shake. It wasn't just the hair. Donna was different.

He visited the Hornans once more before he left and was handed the note from Phil. "His will, and these private messages, are all intended to be kept private," said Marilyn. "I hope you'll respect that."

"Of course," said Dean.

"But you'll see—his wishes are our wishes. That you will always be part of the Hornan family. Don't keep away so long next time."

He legs were trembling as he walked back toward his truck. Marilyn called out from the porch, "Dean!"

He turned. "Yes, ma'am?"

"Remember our road trip?"

"Of course. I'll never forget it," said Dean.

"One thing I meant to ask you. Did you really have your driver's license? Or were you bamboozling me?"

"I had it, I really did."

"Hmm. I was sure you were taking me for a ride."

"No, ma'am."

"Good news," she smiled, but still looked a little sad. She disappeared inside the house.

His hands shook as he opened up the note. Dean instantly recognized Phil's neat, blocky printing, blue ink from his BIC pen. It was like seeing an old friend. Memories of good old times where they'd be out back in the barn reading over the latest magic trick plan Phil had hatched up and jotted down so he wouldn't forget. For a moment, he felt that Phil was just inside the house and would come smiling out the front door. Dean read the note, Phil's sweet words of friendship, laughing and crying. Phil had been a fond boy, never afraid of opening his heart. *My friend Phil,* Dean whispered, how he loved saying those words, and the consonance on the lips. Phil, his best friend, almost right beside him, his words and spirit in blue ink. Dean knew he had been loved, and he'd loved Phil. He read it over and over, and then folded it up and put it inside his wallet.

He had to admit, he'd been avoiding Giroux. He'd been afraid of the sadness inside him again, that Bill had worked so hard to dispel. But instead Dean felt joy. The dove cooed from the back seat, the prettiest sound he'd heard since he could remember. He started up the truck. Why had he waited so long to come back to Giroux? Now he had a license, he had no excuse. He would drive here more often.

Dean and Bill Brace became friends where Dean thought he'd never have a friend again. It was a bit of plaster over the hole

in his heart, but it felt good. Their first trip together was to Las Vegas.

"You need to meet everyone you can in the magic community," said Bill on the flight. "You need to network. The more people know you, the more they'll like you. You want them to think of you when opportunities come up."

The moment Bill stepped off the plane, he lit up a cigar that it seemed he never stopped smoking—except for when he slept. He enjoyed big meals, and good drinks.

"Nothing like a cocktail in the USA," he sighed with satisfaction, swinging his bar stool around to survey the crowd of partiers. Bill socialized with a capacity for enjoyment Dean knew he could never match. But Bill was ready for bed around eleven. Dean, who was young, fit and not drinking, could stay up all night. Vegas was glitzier than he'd imagined, and he was talking with magicians from all over the world. This sense of community, like the biggest Linking Ring meeting ever, was what he'd been waiting for his whole life.

He returned to their room about 4 a.m. and made a ruckus of it to tease Bill about going to bed early, but Bill had already anticipated this and greased the toilet bowl, thus getting his revenge on Dean without even having to get out of bed.

"Booby-trapping the toilet? That was really low," said Dean, finally crawling into his bed after a shower. "*Really* low."

"Coming from you, that means a lot. Who did you meet?"

"So many people—I'll fall asleep before I list them all."

"Good. Above all, you need to meet every single person here," said Bill. "You've got more in common with these people than just about anyone else on the planet. These are skeptics who are believers, debunkers, escapists, magicians. A city full of Houdini freaks. Some of these folks have broken a few of Houdini's records, same as you. And if they haven't broken records, they've followed in his footsteps, just like you."

"I will. I'll meet everyone."

"Good man."

"You know who I'd really like to meet? The Amazing Randi. You know him?"

"Yup. Talks like a mix between a magician and a lawyer, looks like a garden gnome."

"Shouldn't be hard to find."

"Here's not here," said Bill. "You've got a lot in common with him. He's a full out escapist, too. When he was a kid, Randi was in a full body cast for a year after being smashed into a million pieces by a car. They told him he'd never walk again. But he lay there, teaching himself magic."

"Bill, I can't help but think..."

"Yes, Phil would be going gaga for this. All the more reason to make the most of every second. Let's get some rest."

Bill began to saw logs at a volume Dean had never before experienced. But Dean wasn't ready to sleep anyway.

What Dean had been trying to say to Bill was how misfortune can bring unlikely gifts. The Amazing Randi, bones broken, lying there teaching himself magic day in day out. Teller, of Penn and Teller, was sequestered to his bed at age five with a heart condition, training himself in magic and performing for neighbourhood kids even before he hit his teens. How many other people turned to magic after long stretches in hospital or at home recovering from bouts of illness or surgery? People who hadn't made it big, but still loved the art and made it their lifeline.

Phil had never become famous. Did it matter? Magic bonded people. It was a life force.

CHAPTER 24

Burnt orange and red leaves swirled in the icy Halloween wind, as Dean walked around the legislative grounds. It was one year since Phil died, almost a year since Garry Gunnarson had shattered his leg, a year since Dean's lowest point in his life. Almost four years ago, he'd died underwater and been reborn. He was working all the time now, and had a lot of reasons to be happy. Still, he felt that melancholy October tug. As well, certainly no magician let an October pass by without also acknowledging Houdini's untimely passing.

He was twenty-three years old. He was working, networking, and working some more, but still he felt clueless. And if he had to admit it, directionless. He knew he looked confident to the world. But inside, he was afraid. He was going to L.A. A whole lot of magicians he'd met were doing a live television special, *The Search for Houdini*, and he'd been invited to escape from handcuffs on live TV. Bill always encouraged him to make friends and attend everything he could. "Networking is key," he'd tell Dean.

"Networking is key," Dean had told his then-girlfriend a few months before, as they sat eating spaghetti and tomato sauce by candlelight in his cramped little apartment.

"Then why aren't you going to this L.A. magic thing?" she asked.

"'Cause I'm flat broke."

"I will lend you $100 to go. But remember me when your networking pays off and you become famous."

He never did forget her and her generosity. He met The Amazing Randi in Minnesota. And Randi, a Houdini expert and escapist who had performed many of Houdini's own escapes, impressed, made sure Dean was included on *The Search for Houdini* TV show. This was a thrill and Dean had nothing but gratitude. But Dean knew he could escape the cuffs. Of course he could escape the cuffs—any cuffs they threw at him. And he knew he'd be a great addition to a show about Houdini. His question was—would he ever be regarded as more than a kid from Canada? After all, he'd beaten Houdini's record on his first ever escape. Would he be known as a one-break wonder? Would he ever have a real career?

Shivering with his October malaise, he went back upstairs to his apartment. Norman the dove was cooing on a bookshelf perch in the corner. It was months later and he still hadn't returned Norman to Donna, and he had no excuse. She was going to kill him. He knocked on his caretaker's door.

"Hey, could you do me a really big favour?" asked Dean.

"Does it have anything to do with coffins?" said the caretaker suspiciously.

"Oh, gosh, no."

"Well then it better not have anything to do with doves," he said, eyes narrowing. "You know you've been forbidden to possess doves on the premises. You've got a dove in there. Don't you?"

"I don't possess the dove. It's not my dove. I'm merely dove-sitting this dove for a friend of mine. And it's in a cage. Could you just feed him for the next couple days? I'd really, really appreciate it!" Dean smiled sweetly. "His name is Norman."

"Dean Gunnarson..." the caretaker growled.

Dean and his brother Todd checked into their Los Angeles hotel room. Todd was now working with Dean as his assistant and safety consultant. Dean threw himself down on the king-sized bed and Todd checked out the view. "Palm trees everywhere. We sure aren't in Winnipeg anymore. Hey, you need to cheer up, man. We've got a snazzy room. You're about to go on nationwide television."

"Yeah, it's good," said Dean horizontal from the bed. "Phil would have liked this a lot."

"But he can't be here. It's you and me now. Okay?"

"Yeah," said Dean rolling over.

They hadn't been in their room five minutes before the phone rang.

"Who'd be calling us?" said Todd. "Not Mom?"

"It's probably the manager saying there's been a mix-up, and we should have been put in the Broom Closet Suite." Dean grabbed the receiver. "Hello?"

"Is this Dean Gunnarson?"

"Yes, can I help you?"

"We hope so. I'm on the set of *The Search for Houdini*."

"We're not due for a couple more hours," said Dean, sweating straight through his shirt, though he didn't know why. There was something frightening about the sound of the man's voice that spread like contagion.

"Yes, we know you're not due. The Amazing Randi has had an accident. He was going to perform Houdini's Milk Can Escape,

but he's in hospital. He says you're the only man to do it. Can you be at the here in thirty minutes? We hope you say yes."

So Randi had thought of him in the clinch.

"Yes. I say 'yes'."

"You ever do this escape before?"

"Uh...why do you ask?"

"Have you done it before?"

"Do I need to have done it before?"

"No. Just curious."

"Then—no, I haven't."

"You okay with underwater escapes?"

"Of course, why wouldn't I be?"

"I don't know, might be too much for some people. Fear of drowning."

"Not me," said Dean.

"Good. You know the ins and outs of the Milk Can?"

"I can figure it out. It's Houdini's Milk Can, right? I know all about Houdini."

"Good. It's an exact replica. But you won't have to figure it out all on your own. Randi says if you come, he'll hire an ambulance and a private nurse and come down to the studio on a gurney and teach it to you."

"Well even better!"

"Okay, I'll be waiting for you at the side door of the Orpheum theatre. See you shortly, Mr. Gunnarson. Please be there."

Dean heard a click as the man hung up. He hadn't even asked his name.

"Todd, we've—got to go. Now."

"What's going on?"

Dean threw on his best costume leather jacket, white with long fringes. He looked at himself in the mirror with a double take. Then he was off, and halfway out the door he dashed back for his swim trunks. Todd was still standing there.

"Dean! Talk to me! Where are we going?"

"I think this is what's called getting your big break," Dean said, thrusting his black shorts into the pocket of his leather jacket.

Todd was talking to Dean, about how amazing it all was, and what beautiful women walked down the L.A. streets, and how profoundly unlike Winnipeg was to L.A., but Dean only heard a dull buzz. This is it, said Dean silently to his friend as the cab sailed down clean, elegant streets lined with palm trees. Be with me, Phil. This is what we always dreamed of.

The man from the phone call, dressed in a well-tailored black suit, was standing at the stage door.

"Dean Gunnarson?"

"How did you know it was me?" asked Dean.

"Educated guess. I knew you'd be the only guy rushing up here who looks like a magician and is not already inside the Orpheum Theatre."

"Oh, right. This is my brother, Todd. He's my safety advisor."

"You ever worked on underwater escapes, Todd?"

"Underwater?" Todd asked, looking to Dean. "Underwater?"

"Answer the man, Todd," said Dean with a toothy smile.

"No, no experience with underwater escapes," said Todd.

"No problem. You're about to expand your repertoire. Let's go."

Dean and Todd were shown to into a dressing room, and Dean quickly slipped out of his jeans and T-shirt and stepped into his bathing suit. He was cold, so he put his white leather jacket on over top.

"Dean, think for a second," said Todd.

"About what?" said Dean, fluffing out his blond feathered hair.

"I hate to say anything negative but this is the first underwater escape you've done since, well, you died."

"This is completely different."

"It's a different escape, sure, but I'm afraid you might panic when you go underwater."

"I won't," said Dean.

"How do you know that? You haven't done a water escape in four years. And this is Halloween. The exact anniversary of when you drowned! Can't they give you some other kind of escape instead?"

"They want the Milk Can, I give them the Milk Can. I don't get to pick and choose for an NBC television special."

"I'm your safety advisor and I don't think this is a great idea for you."

There was a knock at the door. "We're ready for you, Mr. Gunnarson."

They followed a woman carrying a clipboard down a long, narrow hallway, through a heavy metal swinging door, on to the Orpheum main stage.

"This way," she said calmly, as if this might happen every day. She led him to the far side of the stage, where a human-size milk can was sitting. A stagehand was just pulling a dripping hose out of it.

"All full up," he said, leaving a trail of water as he retreated, followed by another stagehand, mopping up his trail.

"We should be proceeding in a moment, please stay here," said the woman, who then walked away.

"Dean, I—" said Todd.

"I need quiet."

"I'm here for a reason. You hired me as a safety advisor, and I'm going to have my say."

Houdini stepped out from behind the milk can. He put his hand on the milk can, caressing the cold metal as he did, circling it.

"Quiet, please. Todd, I'm not afraid."

Houdini is with me.

Todd instinctively stepped back as Dean approached the milk can in a kind of trance, duplicating Houdini's moves. After feeling

the texture and breadth of the can, they examined the locks. Next they opened the lid. Houdini's jet black eyes met Dean's.

"Yes," said Dean. "I understand."

"What did you say?" asked Todd.

Dean turned to his brother and smiled.

There was a commotion, and from the other side of the stage, two orderlies in hospital uniforms were pushing a wheeled gurney across the stage. Houdini had disappeared and The Amazing Randi made his entrance, covered in a blue hospital sheet.

"You made it," said Randi.

"Randi, I can't thank you eno—"

"Later. You examine the milk can?"

"Yes," said Dean.

"You got this?"

"Yes."

"Good. Now," he said, raising his voice with authority, "everybody go away. Yes, even you, my dear nurse. Magicians only. We need privacy for ten minutes. I'll give you a couple pointers, Dean. Things that I've observed doing this escape in the past."

Dean pulled the curtain, cloistering them from everyone else. Then he popped his head back out.

"Todd—come in."

Todd hesitated for a moment, and then joined his brother.

That evening, in front of a live studio audience, first Dean escaped from a pair of cuffs. He didn't know what variety of cuffs they'd be. That was the challenge. But he escaped easily. He dashed directly off stage to prepare for his second act. Bev Gunnarson had been watching him from Winnipeg. Her heart swelled for her son, his skill. He'd been in no danger. At last, she could enjoy the show. It was odd though, that he was wearing a swimsuit under his leather jacket, and the way he ran off so quickly after the handcuff escape. But that didn't fully register. She was so proud. Impetuously, she called the operator

and tracked down the number of the theatre. She managed to make it through the many channels effortlessly.

Within minutes, she was talking to a production assistant backstage.

"I'm sorry to bother you now but I need to talk to Dean Gunnarson! He's the one who just got out of the handcuffs. This is his mother, Beverly. I need to tell him how proud I am of him, right this second. It's hard to explain."

"Sorry Mrs. Gunnarson, he's preparing for his big final performance, his underwater escape at the moment. Would you like me to—"

Beverly hung up. After a stunned moment, she ran to the television and shut it off.

On a live television broadcast, introduced by William Shatner and The Amazing Randi from his stretcher, Dean performed Houdini's Milk Can Escape. Todd watched from the wings. For the first time in his life, he bit his nails. The performance was flawless.

A lot went through Dean's mind as he emerged, soaking wet, from Houdini's Milk Can. All those years he and Phil had talked about being discovered, Dean had the secret now. When you're discovered, you've seemingly been plucked out of the crowd and arrived. But all that was an illusion. You never just arrive. You prepare for the moment with every ounce of life experience you have. You crawl on your hands and knees to get there. And if you're very lucky, you're in the right place at the time you are needed.

When once you've died on Halloween, it is a must to stay awake till the witching hour in gratitude. But this year, he couldn't sleep at all. He felt like he'd been reborn. And his friend Houdini had been there when he really needed him.

On the flight back from L.A. Dean rested so deeply, it was like he was recuperating from every ounce of practice he'd put into his art since he was twelve. Instead of Houdini, he imagined Phil in the seat beside him. Dean would say to Phil, "It came down to what we learned during that big escape, on our epic road trip. You know, the RCMP man who thought he was going to trip us up. That's exactly what it was like, Phil, figuring out that milk can. I wasn't scared at all. I thought, I've been here before, and I won. I've got this. I did it Phil. I did it for both of us."

CHAPTER 25

"My dove, I never thought I'd see you again," said Donna, cooing into the cage.

"Aw, come on, you knew I'd bring Norman back said Dean. "I've been pretty busy, you know."

"I'm just kidding. We all saw you on television—of course. Everyone is so proud of you. You must have heard the cheers from here to Winnipeg."

"Thanks, Donna. That means a lot."

"So you're off to make the big time, eh?"

"First off I'll be doing some television appearances, and then I've got live escapes scheduled. There's talk, Donna, that I might be working all over the world. All my dreams are coming true. I am about to live my dream."

"It is your dream, and I'm happy for you," she said. "But do me one favour, now you're moving away."

"Absolutely."

"Okay, come outside. Come on, you'll see."

They walked out behind Donna's family home, and were momentarily speechless before the vast orange and pink prairie sunset.

"I want you to remember that Giroux sky. I'm just a country girl," said Donna. "I don't want to travel the world. This is enough for me."

"It's beautiful," said Dean. "I do want to travel—everywhere. But I know I'll miss this, too"

"Just to prove to me you won't forget your old friends, I want you to promise to send me a postcard from every place you settle as you live your dream, and write your address on it. I'm going to mail you cookies. That way, you'll always have a little taste of Giroux in your life. And you'll know no matter what, in that big wild world of entertainment, you have friends."

They shook hands. "You're a good friend, Donna."

"You too. Take good care of yourself."

Bill Brace saw him off at the airport. "This is it, Dean. You did it. You're launched."

"Bill, you're my best friend."

The two men embraced.

"I'll be back here and there," said Dean. "It's not forever."

"I'll be here waiting," said Bill.

Dean did send the postcards. Donna did send the cookies. Along his many, many stops, he grew to be an international success. The next time he came back to Manitoba for more than a stopover was to get married to a glamorous and beautiful bride. Dean didn't forget his old friends. Everyone met again at the wedding social. Donna and her husband came, but she just had to find a moment to sidle up to Beverly, watching the first dance between husband and wife.

"It's not going to last," said Donna.

"Let's just enjoy the party," said Beverley.

That night, they all danced together, friends and relatives. Then Dean disappeared again, sucked into vacuum of the entertainment world.

A decade later, long divorced, Dean wrote to his mom and dad to tell them he was moving back to Winnipeg. Before Beverley knew he was back, Dean called up her up to tell her he'd bought a house. Beverly wrote his new address on a slip of paper. They were to come over for dinner and a tour.

She and her second husband Claude pulled up, but they didn't get out of the car.

"There's no way this is his," said Beverly. "I must have written it down wrong, though I was sure…"

"Well, we could always go and knock to be sure, and if it's not him, we could ask to use the phone," said Claude.

But just then, Dean was opening the door, waving and calling, "Come in, you guys!"

"Oh my god, this can't be real," said Bev.

After the grand tour, they perched on a plush couch and sat in silence.

"So what do you think of the place, Mom?"

"You said you'd broken up with that dancer, didn't you?"

"Long broken up."

"Is there someone new in your life?"

"No. Why?"

"Dean…this is place is too big! And you'll be living here all by yourself?"

"Sure, what's wrong with that? It's a great house."

"Honey, I don't want to fight with you anymore, but I've got to speak from my heart."

"Go ahead, Mom," Dean said, bracing himself. "I'm used to it."

"You've accomplished everything you set out to do. I couldn't be more proud of your success. But the entertainment world is not the real world. And I'd daresay you haven't been surrounded with real friends the whole time, either. You've come back here to rest and recuperate, not to ramble around lonely in a mansion. It's great you can afford it, but you really need to get some grounding."

They all sat in silence.

"Have I hurt you?" Bev asked.

"No, Mom," said Dean, sinking down in his huge, plush chair. He felt overcome by exhaustion. "I'm just...really tired, and I wanted somewhere to live. You're right. It is too big. Honestly, I feel lost."

"It's very brave to say that. Why don't you reconnect with old friends? See Bill Brace. Drive out to Giroux. There's nothing like being with people who love you to rejuvenate you. You came home because you needed to find yourself again, right? It's not as easy as buying a big house."

"I've made another mistake."

"Nonsense," said Claude. "Nice thing about houses. They can hold us for awhile. And then they can be sold."

Beverly took Dean's hand and held it.

He did drive out to Giroux, the very next day. Right there on the corner of the old familiar gravel road sat a castle. Not an enormous castle, but a beautiful one. It looked sturdy, and even had turrets. Dean parked and walked all around it once. By the time he'd made it back to the front, Gordon Hornan was waiting.

"I thought that was you, but I didn't believe my eyes," he said, and he threw him arms wide open to hug Dean. "I gave Marilyn a call. She's on her way."

"You did it. You built it. It's Philip's Magical Paradise."

"We sure did. Me and a lot of helpers."

Marilyn was soon on hand, and they walked Dean slowly through the museum, pointing things out to him.

"Bill Brace donated those. Here's Phil's Houdini coin from Doug. Oh, and you'll recognize that."

"You can't be serious."

"Yes, they heard they were tearing down an old RCMP detachment, and I knew you'd boys had escaped from there, so I went

and asked for it," said Gordon with a shrug. "Yeah, they gave me a jail cell."

"This is the actual jail cell we broke out of?"

"It sure is," said Gordon

Dean held the bars and tried to bend them open. Gordon joined him. The bars didn't budge.

"Yup—they weren't fooling around," said Marilyn. "Oh, you have to try this—it's a transformation box that Gordon designed with Phil just before he died."

A black column stood in the middle of the space.

"Did you say you guys designed it?"

Gordon nodded. Dean felt a thrill, seeing an idea of Phil's he hadn't been aware of—a small communion with his old best friend that he hadn't expected. His heart began to pound as he opened the black door.

When Dean came out he was shaking his head. "I can't believe you made that, Mr. Hornan. What I turned into...that was very strange."

"Thanks, though Phil was supposed to make that part up but I had to go solo on it," he said, pleased. "I'm just happy that it works. Now look over here. We got a player piano, and we named it Emma. I heard about this at auction in the States, so I went down and what do you know, I got it."

"Just like at the Magic Castle in L.A."

"One of my other promises to Phil. He wanted an Emma."

The Hornans were like two kids, excited to show all their many toys. Afterwards, they sat together in the Hornans' kitchen and drank coffee. The house looked very different. No longer was it the abode of teenage boys. It was neat and tidy, and very quiet.

"I've seen many magic collections in my years away, but what you've got here is very, very special," said Dean.

"You've been all over the world," said Gordon. "I'm sure you're just saying that to be nice."

"No, Mr. Hornan. I'm not just saying it. The more I saw, the further I got from the purity of magic. What you've got right here—these are the things that made me believe magic could be real. Not only are they unique pieces—but they've been collected with love, and they're here to be shared."

"There's room for your stuff too, Dean. Phil would've liked that."

"I will bring in some stuff. Soon. I'm here to stay for awhile."

"Good. You should drop by and visit Donna said Marilyn, refilling the coffee. "I understand she sent you cookies all over the world. You owe her a big hug for that."

"Where is she living now?"

"At her mom's. She's divorced now too, eh?"

Dean went and knocked on her door again.

CHAPTER 26

Donna and Dean fell in love. He sold the big house and settled out at Clear Lake in Riding Mountain National Park in a cozy cabin, near his dad. He and Bill Brace stayed best friends for the rest of Bill's life. Len Vintus, when he'd decided Dean was not a flash in the pan, became a close friend too. Dean and Donna married and had two beautiful daughters. With the birth of his girls, something changed inside him. Another thing that changed: He became friends with his mother.

"Mom, did you ever imagine me as a dad?" he asked Beverly.

"The truth? You were the last person on earth I saw as a parent. And something else I never imagined: You coming over to my house for a coffee and a chat."

"I know what you mean. Now I'm going to surprise you again."

"I'm glad I'm sitting down."

"I never understood how horrible it was for you to go through my illness, and then watch me go into escapism. It just didn't register. I'm sorry for all the times I upset you, Mom."

"I'll hand it to you. I'm surprised," she said with a smile. "So does that mean you're giving up escape?"

"No."

"I thought that was too good to be true. It's hard on the people who love you, Dean, bear that in mind."

"Let's not go too far here, Mom. I love you."

"I love you, too."

Dean reached the age Houdini had been when he'd died, a benchmark for all escapists. His career was flourishing as never before. He looked back on his life and his escapes: The Hoover Dam in Las Vegas, upside down straightjacket over a pit of alligators, a handcuffed and straightjacketed leap out of an airplane and fighting to release his parachute, the Chinese Water Torture, the Shark Cage, Suspended from a Burning Rope escape, the Exploding Car escape, underwater escapes, escapes from countless coffins and oak barrels, the Punishment suit, buried alive in two-and-a-half tons of wet cement. He won the Merlin Award for "World's Best Escape Artist".

. He was the first recipient of "The Houdini Award." He was the first Canadian to be awarded "Humanitarian of the Year" by the United Commercial Travellers for raising money for charities. Perhaps his favourite accomplishment was making it into the Guinness World Book of Records—and not having broken a single bone to do it. He escaped on The Disney Channel, The Family Channel, The Discovery Channel, TLC, The Travel Channel, and, impossibly, The Food Network. He was the opening act for Aerosmith in New York City. He worked all over the world. He had done all the escapes he could imagine.

Sure, he had died in a coffin during his second big escape. But on Halloween, 2010, he dug himself out of a grave after being buried alive, an escape to again commemorate Houdini's death— and perhaps his own, too.

He thought about his strange and wonderful life. He had a few dreams still left to fulfill, but he was burning to do one single thing that did not involve escape.

Dr. Schroeder walked into the funky little coffee shop across from Assiniboine Park, and he jumped up to hug her. Despite her poker face, she seemed somewhat bemused. She was as petite as he remembered, carrying herself with immense assurance thirty years later. She wore a tidy little suit and a blouse printed with tiny, colourful canoes.

"Hello again," she said.

"It's been a long, long time," he said. "You remembered me though."

"I remember my patients," she said, unblinking. "All of them. Not just the famous ones."

"I wanted to see you again," he said after running off and returning with her steaming hot latte, "to thank you for saving my life."

"That's going a bit far," she said. "I was your doctor, and I did what any doctor would do."

"I knew you'd say that. You haven't changed. But I still think you had a lot to do with it."

She gave a little shrug and took a sip of her latte, which could have meant acquiescence, or could have meant she wasn't going to fight him.

"I wanted to let you know how well things are going for me. I've had a full career, and I just got the green light for a television series. It was one of my dreams. It's coming true, and I thank you."

"I don't want to read about you in the obituary section. You're still doing that escape stuff, are you? I've seen things in the papers over the years. Dean, we didn't go to all this trouble to save your life for you to throw it away. I don't want to read about you in the obituary section."

He ignored her comment, pleasantly moving on.

"I've got daughters now. They are the loves of my life. I keep their pictures on me, for every escape." He pulled the photos out to show her.

"They're lovely."

"They're my luck," said Dean.

"You're over fifty. Your reflexes aren't what they used to be. Think of your girls, your family, your friends. Your profession must be very rough on them. Can't you find something else to do?"

They both laughed. Then Dr. Schroeder stopped laughing.

"I'm serious. Find something else to do."

He often thinks of the quote by Sir Arthur Conan Doyle: "You know how often the turning down of this street or that, the accepting or rejecting of an invitation may deflect the whole current of our lives into some other channel."

He had walked into Phil's room on the cancer ward when he couldn't get into the room that he'd been assigned to.

He thinks of Phil every day.

He met Philip and together they tried to find real magic, but the magic was not what they thought it would be. The magic came from Phil. All along, hiding but before his eyes, Phil was the source. His good spirit united many. He brought Dean to Donna, which brought Dean his daughters. His daughters, in turn, brought a change to Dean, a softening of his heart. That could only come from one place. Magic. Because of Philip Hornan.

But Dean was an escapist well before he met Philip. His calling was forged by the first needle forced into his spine.

When he is told, "Find something else to do," he says:

"No, I can't. It's what I do. It's who I am."